This is not an art book: it is a book about a man. Rembrandt Harmenszoon van Rijn was one of the greatest artists there has ever been — some say the greatest. Towering above other painters of the Dutch School, this uncompromising genius took what he needed from Baroque and Classical art and created an entirely personal style.

Constantly innovating and improving — in drawing and etching, as well as painting — he relentlessly pressed his art to its limits to express his beliefs and concerns.

Rembrandt's concern was humanity. Unlike Leonardo and Michelangelo he did not live in the heroic world of his own imagination, but in the mire with the rest of us. His art is, in the broadest sense, a record of human experience: the self-portraits are a pitiless catalogue of what life can do to a human being. Tragedy, happiness, apathy — all are recorded with the same absolute truth.

The author tells Rembrandt's story through his art, relating it to the documentary evidence which has survived, and placing it in the context of his time — the Holland of Calvinism and expanding capitalism.

Charles Fowkes is a journalist. His special interest is social history, and he has written for various magazines and publications on a wide range of subjects from Christianity to seventeenth-century witchcraft. It was while doing research for a novel that he first became interested in Rembrandt.

THE LIFE OF
REMBRANDT

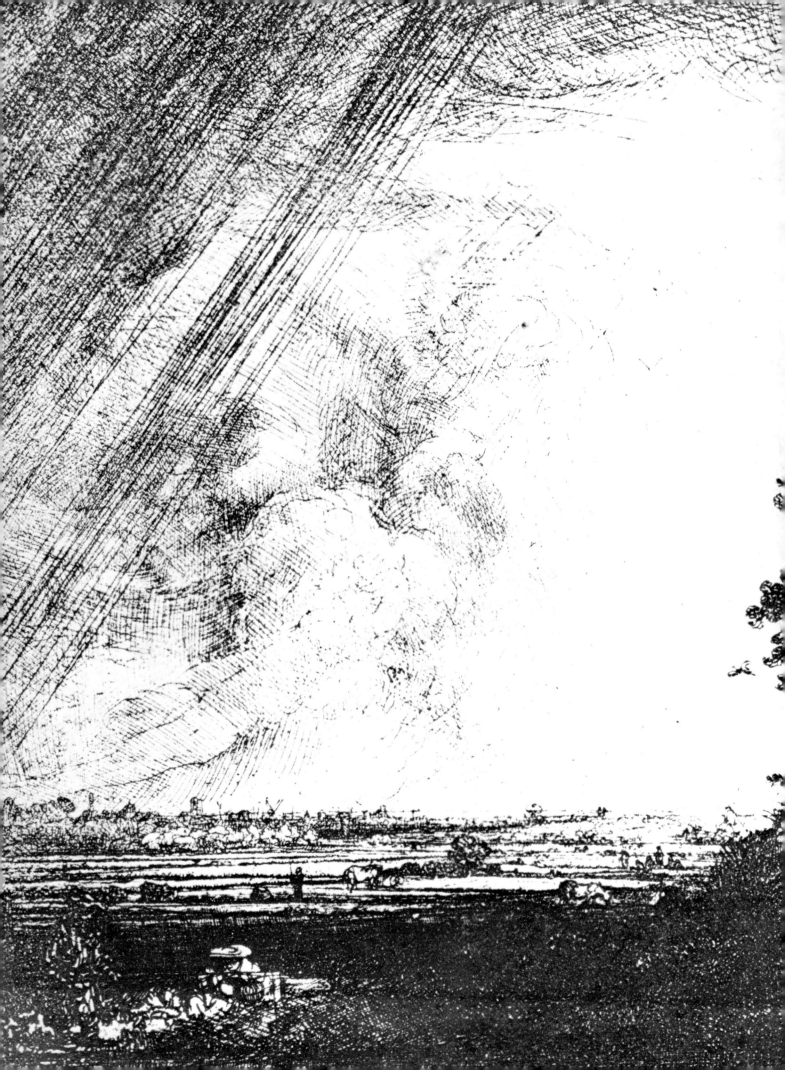

THE LIFE OF
REMBRANDT

Charles Fowkes

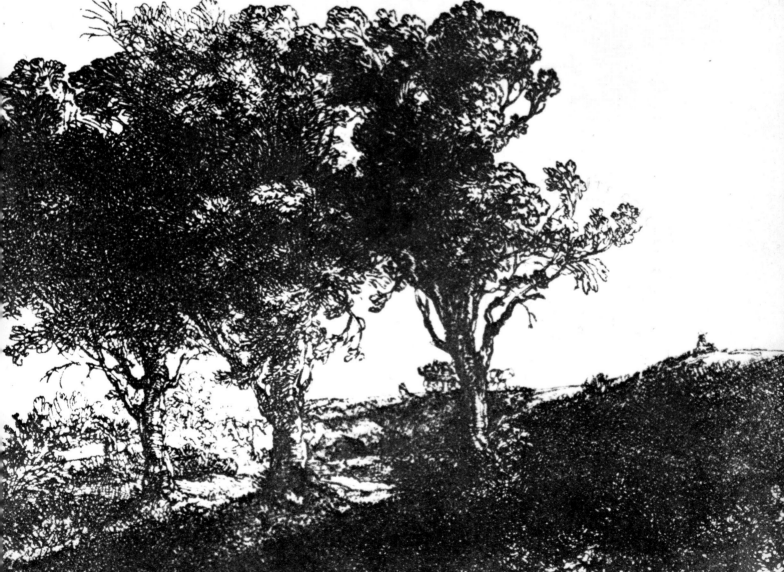

HAMLYN
London · New York · Sydney · Toronto

For my Parents

Published by
The Hamlyn Publishing Group Limited
London · New York · Sydney · Toronto
Astronaut House
Feltham, Middlesex

ISBN 0 600 37598 6

Phototypeset in England by
Photocomp Limited, Birmingham
Printed in Spain by
Mateu Cromo Artes Gráficas S.A., Madrid

Contents

Introduction

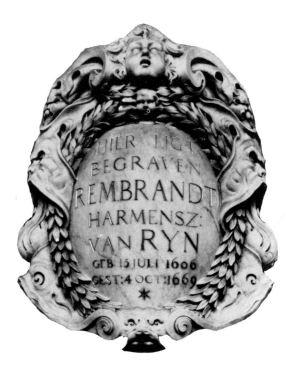

1 *left*
The magnificent Kenwood self-portrait is probably the most famous of all Rembrandt's paintings of himself–and that most frequently used on book jackets and in the media generally. Timeless and untarnishable, the painting is a cliché in the original sense of the word: it is as resilient as the metal stereotype from which engravings are printed, and remains the perfect image of 'the artist' whether it confronts us from an illustrated biography or a beer mat.

2 *above*
'Here lies buried Rembrandt Harmenszoon Van Ryn.' Less ostentatious than Shakespeare's memorial at Stratford, though about as unsuitable, the plaque in Amsterdam's Westerkerk is typical of the irrelevancies which great men often suffer after death. Death itself was almost irrelevant for Rembrandt, who completed all he set out to do and whose work is as vital today as when he finished it.

APPROACHING THE MAN

IN A BOOK-LENGTH article on Rembrandt published in 1854, Eduard Kolloff complained that the list of errors made by the artist's previous biographers is longer than Don Juan's list of mistresses. Kolloff's amusing criticism of his predecessors applies just as well to his successors: no great man has been worse served by his biographers than Rembrandt.

Kolloff's article for *Historische Taschenbuch* was the first biography based on systematic analysis of the few surviving seventeenth-century documents and of the artist's work–a method best used more recently by Christopher White in his excellent book *Rembrandt and his World*. But the inconsistencies and errors which appear in so many of the numerous biographies (the bibliography is vast: it would be possible to fill a large library with books about Rembrandt) are not the result of the way the task has been approached. Different periods have favoured different styles of biography, but in the essential matter of casting a little light on the life of Rembrandt the 'factual', analytical writers have not been notably more successful than the 'imaginative' school. The problem is more complex.

It is important to begin a new book about the life of Rembrandt with a brief look at some of the earlier biographies. They highlight the first great difficulty in achieving an understanding of the artist's life–the lack of the kind of material on which most biographies are based. Apart from church records of births, baptisms, marriages and burials, a few receipts and bills of sale, and seven formal business letters, there is almost no surviving documentary evidence. The information which has remained–as random as the detritus left after the passing of a glacier–is sterile and gives no idea of human personality. It is not difficult to understand the great significance which this places on the contemporary, or near contemporary, biographies of Joachim von Sandrart, Filippo Baldinucci and Arnold Houbraken, even though as pieces of writing these fragments are scarcely worthy of the attention which an accident of history has focussed upon them.

Joachim von Sandrart was born in the same year as Rembrandt, in Frankfurt am Main. A painter of international reputation, he worked in London, Italy and Amsterdam, before

returning to Germany where his monumental work of art criticism *Teutsche Academie der edlen Bau-Bild und Malerey-Künste* was published in 1675. The book is miserably written. Sandrart was an academic artist trained in Italy, and he viewed Rembrandt with all the prejudice this had instilled in him. Making no mention of individual paintings, he concerns himself mainly with general comments about style. But his very disapproval, which caused him to ignore Rembrandt's art and concentrate instead on his circumstances and life-style, gives his writing the only interest it could have for us today. Whatever its shortcomings, Sandrart's work is the first art history to mention Rembrandt; more importantly–since he spent five years in Amsterdam between 1637 and 1642 and certainly met Rembrandt–it is the account of an eye witness.

The abate Filippo Baldinucci was a Florentine. He was a scholar and a connoisseur with a special interest in engravings and etchings, and in 1686 while in the service of Cardinal Leopoldo de' Medici he published the first significant book on graphic art. This naturally involved mentioning Rembrandt whose life Baldinucci also discussed; he obtained his information from the Danish painter Bernhardt Keil who had been Rembrandt's pupil and had spent nine years in Amsterdam. Although interesting, and obviously benefitting from the first-hand knowledge of an ex-pupil, Baldinucci's work also contains gross inaccuracies. In one place he states that Rembrandt left

3 below
Between the 27th and the 31st January 1934, Picasso made four studies of Rembrandt. They are an attempt to master the etching technique of the old master and a tribute to his omnipresence in Western art.

The influence which Rembrandt continues to exert at an unconscious level is demonstrated by the 'accidental' way in which Picasso made the first study: 'It's all on account of that varnish that cracks. It happened to one of my plates. I said to myself, "It's spoiled, I'll just do any old thing on it." I began to scrawl. What came out was Rembrandt. I began to like it, and I kept on. I even did another one, with his turban, his furs, and his eye–his elephant's eye . . .'

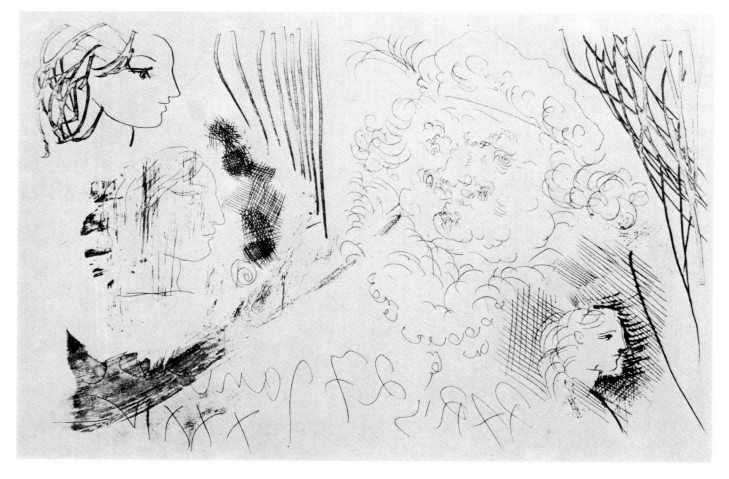

4 *right*
In the second study Rembrandt is shown in a dark Baroque turmoil of palettes and props.

5 *below left*
In the third – like one of Grimm's giants at a window – he looks in on two Classical figures (Muses?): but one has her back to him and the other covers herself.

6 *below right*
In the final study Rembrandt is in the room with the Classical figure: they hold hands, all is light, although there is still irrepressible Baroque movement in the representation of the old artist.

In four allegorical studies Picasso has outlined Rembrandt's development as an artist.

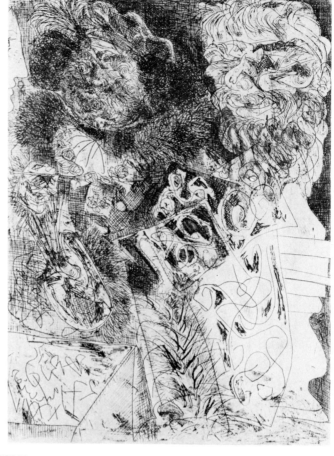

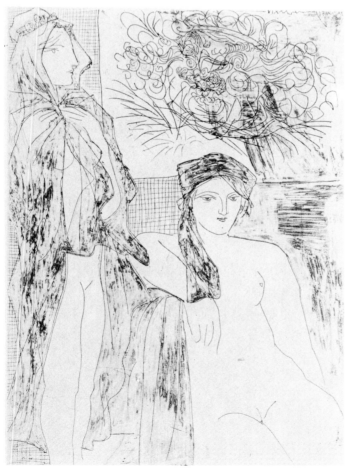

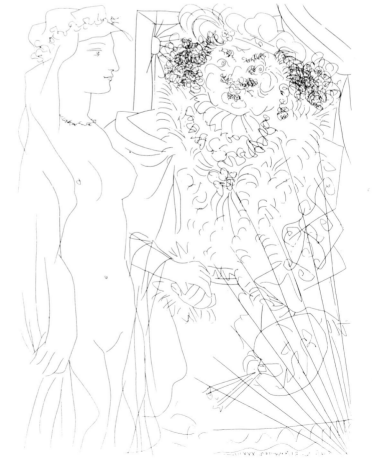

Amsterdam to work for the King of Sweden, in whose country he died miserably in 1670 – which is of course nonsense.

Arnold Houbraken wrote the longest and most detailed of the early biographies, which appeared in his work *De Groote Schouburgh der Nederlantsche Kontschilders* published in 1718. A painter like Sandrart, Houbraken had been a pupil of Samuel van Hoogstraten. Hoogstraten had been apprenticed to Rembrandt in 1642 and was an imitator of his style; obviously he was the principal source of information for Houbraken. The problem with Houbraken's biography is not that he wrote with prejudice (personal prejudice like Sandrart, or second-hand prejudice like Baldinucci) because although he disliked Rembrandt's style he evidently had considerable respect for his fellow countryman. The trouble is that he was a better writer than a painter, and with scant information supplied by the rather unperceptive Hoogstraten he produced an anecdotal and rather dressed-up biography: a later critic blamed him for his 'insatiable love of gossip'.

Apart from a page about the artist in the autobiography of Constantyn Huygens, who came into contact with Rembrandt in his capacity as Secretary to the Stadtholder of the Netherlands; some typical utterances from the 'spiteful Walloon'

7
Charles Laughton's performance in Alexander Korda's 1937 film is the 'Rembrandt' of the popular imagination. Although the script is little more than a synthesis of already wildly inaccurate biographies, Laughton's magnificent performance imaginatively photographed against Vincent Korda's sets is not easily forgotten. Carl Zuckmayer's script is saved by his inspired choice of a biblical quotation for Rembrandt's last line: alone in a darkened room Laughton softly enunciates the words from Ecclesiastes XII '. . . vanity of vanities; all is vanity.'

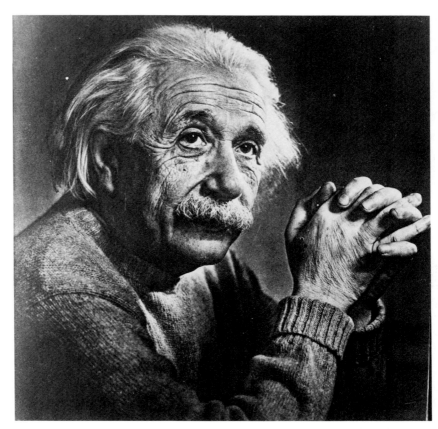

8
Kenneth Clark points out that Karsh's
photograph of Einstein is reminiscent of
Rembrandt's later self-portraits: 'when
scientists could use a mathematical idea to
transform matter they had achieved the same
quasi-magical relationship with the material
world as artists.' It is also true that mankind
still needs its prophets, and Carl Jung called
this archetypal figure the 'old wise man': the
facial similarity of two such prophets is a
coincidence which would have delighted
him.

painter Gérard de Lairesse (he called Rembrandt 'A master
capable of nothing but vulgar and prosaic subjects . . . who
merely achieved an affect of rottenness') and a paragraph in a
book on the town of Leyden, the artist's birthplace, by the ex-
mayor Johannes Orlers, these are the only significant con-
temporary statements about Rembrandt to have survived. It is
ironic that Peter Paul Rubens (1577-1640), as prolific a
correspondent as he was a painter with a well-documented
career, who lived his life as though in anticipation of a
dramatized documentary, should have attracted comparatively
little biographical interest, while Rembrandt, who has left few
clues beyond his work, has been pursued by biographers of
varying seriousness for almost three centuries. This fact, and the
reasons for it, is the second difficulty in writing about the life of
Rembrandt in the last quarter of the twentieth century.

ASPECTS OF THE ARTIST
Many writers, in attempting to describe the nature of Rem-
brandt's genius, have compared him to Shakespeare. Roger Fry
in *The Arts of Painting and Sculpture* says that Rembrandt has a
unique place in the history of European art because 'he united in
his spirit a dramatic and psychological imagination of Shakes-
pearian intensity and an equally great plastic imagination'. It
would be contrived and unhelpful to press the comparison too
far; indeed there were radical differences between the philo-
sophies of the two men as G. Knuttel Wzn. points out. Yet
Knuttel goes on to say that 'No artist before Rembrandt has
researched and understood the human soul and so movingly and
convincingly attested to it as Shakespeare'.

Writers tend to reach for Shakespeare's name when describing Rembrandt for several reasons. First, of course, a Titan, in art as in other spheres, can only be compared with another – and there are few of these to choose from. Secondly, and more constructively, the two artists are comparable in the breadth of their understanding and their sympathy for the human condition. Thirdly, and growing out of the last point, they share the quality of universality.

Rembrandt, like Shakespeare – to dispense with him finally – uses his art to convey ideas which apply to human beings of all times and all cultures. Great art is, in this sense, timeless. Élie Faure, the French art critic and historian, wrote this of Rembrandt and his work: 'His humanity is truly formidable, it is fatal like lament, love; change continues, indifferent and dramatic, between all that is born and all that dies. He follows our steps to death in the traces of blood which mark them. He does not pity us, he does not comfort us, because he is with us, because he is us.'

It is the universality of Rembrandt, the fact that each generation finds him afresh, which has given rise to the great body of biographical work. It is as if there is a need to re-interpret the man as different aspects of his work are found relevant. There are in a sense many 'Rembrandts', equally valid in the context in which they were written; this constitutes a very real problem for any new biographer looking back down the literary-historical time tunnel to the few scraps of factual information in the seventeenth century. Here, for example, is the 'Rembrandt' of the Austrian expressionist painter Oskar Kokoschka which he described on West German television: 'I was in England during World War I, moneyless and miserable. My wife, who is younger and more courageous than I am, said: "Let's go to a museum for relief." There was destruction in the whole world . . . Devastation, ruins, the annihilation of a world becoming poorer and sadder. That was bitter. I looked at Rembrandt's last self-portrait: so hideous and broken; so horrible and hopeless; and so wonderfully painted. All at once it came to me: to be able to look at one's fading self in the mirror – see nothing – and paint oneself as the néant, the nothingness of man! What a miracle, what an image! In that I found courage and new youth.' A similar sentiment is expressed by Raymond Chandler's tough-tender private detective Philip Marlowe in the novel *Farewell My Lovely*:

'They had Rembrandt on the calendar that year, a rather smeary self-portrait due to imperfectly registered colour plates. It showed him holding a smeared palette with a dirty thumb and wearing a tam-o'-shanter which wasn't any too clean either. His other hand held a brush poised in the air, as if he might be going to do a little work after a while, if somebody made a down payment. His face was ageing, saggy, full of the disgust of life and the thickening effects of liquor. But it had a hard cheerfulness that I liked, and the eyes were bright as drops of dew.'

9
Rembrandt's house in Amsterdam's Breestraat is now preserved as a museum, and the artist whose own relations with authority were so painful has become an institution. After he had sold the house the original stepped gable was replaced with the Classical cornice and pediment – an alteration which must have hurt the old man.

10
The Baroque device of chiaroscuro—the interplay of light and dark—was pushed to its limits by Rembrandt, until the next step was abstraction. 'The Philosopher' is a typical image: the individual (Rembrandt, and each of us) sits between light and dark, between enlightenment and ignorance, life and death. All he can do is seek understanding.

Of course, these references to Rembrandt in fact and fiction tell us many things. They demonstrate that the artist is important in both the intellectual and the popular imagination; they show that his art is still potent; and they add to our knowledge of Rembrandt. They also illustrate the fact that writing a Rembrandt biography is rather like carrying out an archaeological dig on a site with many different levels. But there is more to it than that.

During his career Rembrandt painted, drew and etched more than ninety self-portraits. It is the bravest and most pitiless catalogue in all art of what life can do to a human being. Jakob Rosenberg has written: 'The objectivity which Rembrandt displayed in his self-characterizations does not permit interpreting them as products of an egocentric disposition. In this constant and penetrating exploration of his own self, his range went far beyond an egotistic perspective to one of the universal significance. In fact, this rare accumulation of so many self-portraits offers a key to Rembrandt's whole approach to the world: the search for the spiritual through the channel of his innermost personality.'

In the self-portraits we see the human personality as the psychologist Carl Jung did, as a fluid and developing phenomenon, a reconciliation of many different elements. But Rembrandt made one further revelation. By crystallizing the various stages in the development of personality, the individuation process, in art for himself and us to see, he gave his 'life' universal significance and partially freed it from normal temporal restrictions. In a very real way each generation has its own Rembrandt.

Self-revelation is not restricted to the self-portraits, it runs through all his art: directly, or by using allegory and metaphor, he shows us what he has learned about the world and what he believes is truth. And all the time Rembrandt the man is there, showing us another facet of himself. The painter Francis Bacon said: 'You can of course say that if you paint something . . . then you paint not only the subject, but also yourself, just as you try to capture the object, because painting is a double and dualistic process. Because for example if you look at a painting of Rembrandt, then I feel I know much more about Rembrandt than about his model.'

It is an interesting contradiction that an artist who relentlessly revealed every facet of his changing personality should have left so little record of his everyday life. Yet the art alone is not enough: it is important to painstakingly reconstruct what fragments of his life we can if we are to understand. Art is organic, and even genius is nurtured and moulded by circumstances. The Holland in which Rembrandt lived has not been given adequate coverage in many of the biographies: it is the intention to put that right here, and by adding to this the known facts about his life, and an interpretation of his work, it is hoped to make a new contribution to Rembrandt biography.

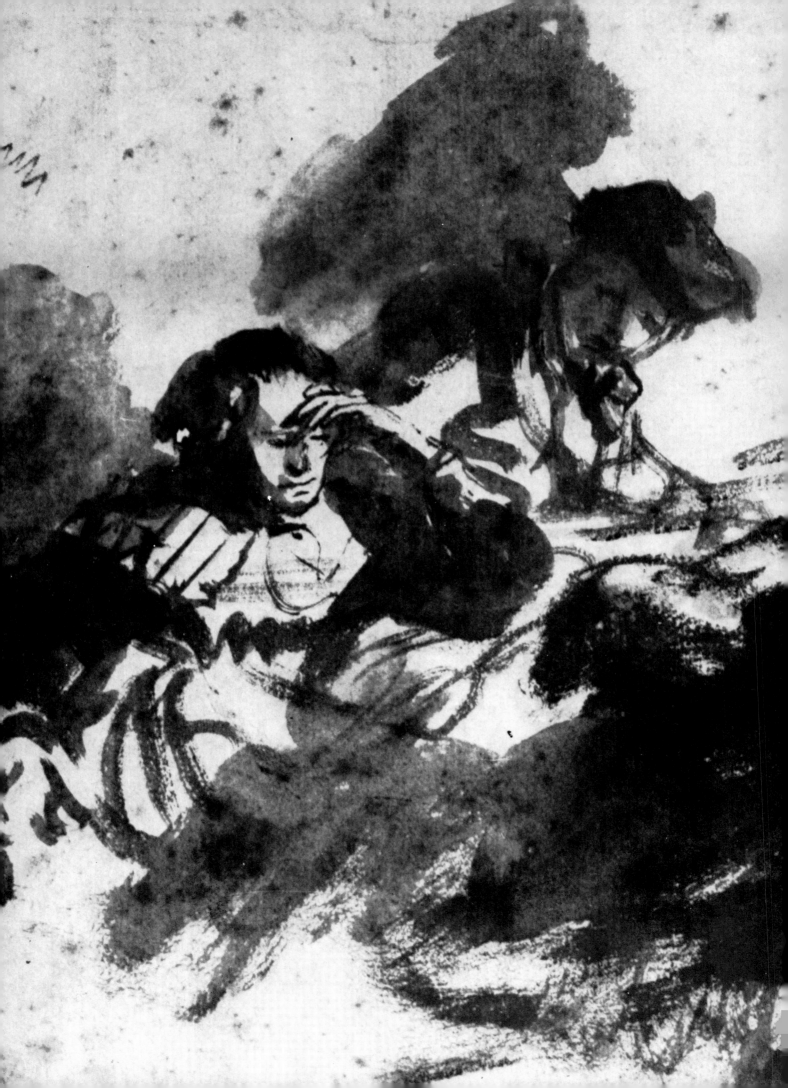

Chapter 1

Early years in Leyden

'HERE IS YOUR CHILD. May Our Lord grant you much happiness through him, else may He call him back to Him soon.' These were the traditional words which Dutch midwives pronounced as they placed a new-born baby in its mother's arms: the same words would have been spoken to Cornelia, wife of Harmen Gerritszoon van Rijn on the 15th July, 1606. The child, eighth in a family of nine, was named after his mother's grandmother Remigia – he was known as Rembrandt.

His father was a prosperous miller in Leyden, the second town in Holland after Amsterdam, with around 60,000 inhabitants. The family connections with Leyden date from 1575 when Harmen's mother and her second husband bought a windmill at the northern edge of the town overlooking the Old Rhine (whence came their name, van Rijn). They also acquired a house in the Weddesteeg opposite the mill, where the family lived until Rembrandt's aunt left to marry a bargee. Soon afterwards Harmen married Rembrandt's mother, a baker's daughter Cornelia (or Neeltge) van Suydtbroek. His new bride's mother came from a prominent Leyden family, and anxious to provide well for his wife Harmen bought the windmill in the Weddesteeg from his stepfather, together with part of the adjacent building and a newly-built house adjoining the family home. It was probably in this house, facing the family windmill, that Rembrandt was born.

Baptism among the more prosperous families took place when the mother was able to attend the church. It was combined with the normal sermon, usually in the afternoon, and as a male child Rembrandt would have worn a cap with six panels as part of his ceremonial costume. To prevent any disturbance of the quiet Calvinist service, he would have been given the traditional milk-soaked sugar stick to suck.

Although the town of Leyden had gone over to the Calvinist party of William of Orange, Cornelia's mother's family still clung to their Catholic faith. But Cornelia and Harmen both converted to the Reformed Church: here they married, and here their children were baptized. The religious beliefs of his parents, and of his mother in particular, were especially important to Rembrandt.

11 *left*
This pen and brush drawing shows Rembrandt's mother reading from the Bible during one of the long winter evenings when families gathered in the front room to read, and play games, by candlelight. Like most contemporary Dutch homes, the house on the Weddesteeg would have been heated by a peat oven which produced a dull glow, some heat and a good deal of smoke.

12 *above*
A mother teaches her child to stand, and take a few tottering steps forward in the safety of her arms.

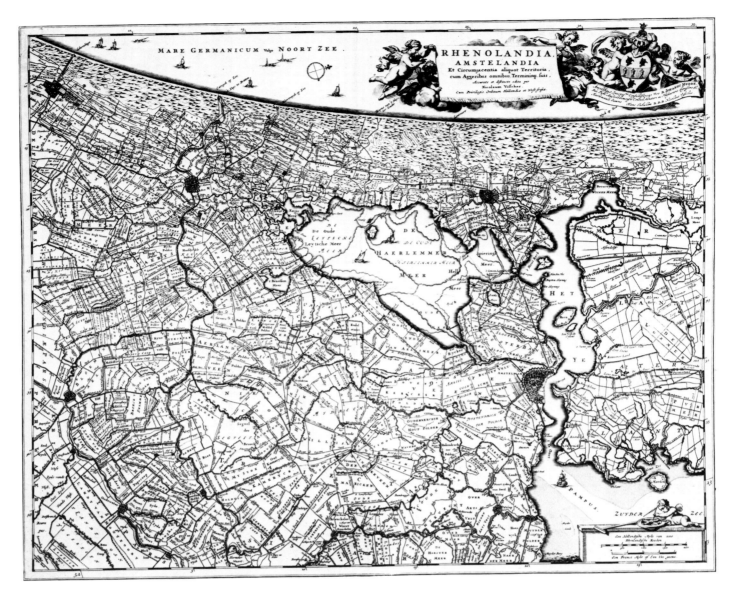

MARE GERMANICUM *Vulgo* NOORT ZEE.

RHENOLANDIA. AMSTELANDIA. Et Circumjacentia aliquot Territoria. cum Aggeribus omnibus Terminisq. suis.

Three years after Rembrandt's birth saw the birth of the Dutch nation. The seventeen provinces of the Low Countries had been under the rule of Catholic Spain for generations. But in 1609, rallied and led by the House of Orange, the seven northern provinces (Holland, Zeeland, Utrecht, Guelderland, Overijssel, Friesland and Groningen) finally won the freedom they had fought for with such determination. The United Provinces, as the nation was called, was democratic and operated as a loose federation. Each province was autonomous except for defence and foreign policy. The House of Orange, from its little court at the Hague, was unable to organize a strong central government. The federal system and other factors stimulated the development of fluid capital, and ushered in the most dynamic and prosperous period in Dutch history. It cannot be entirely accidental that this period coincided with Rembrandt's life.

Infancy followed a predictable pattern in early seventeenth-century Holland, and we can recreate an accurate picture of Rembrandt's childhood. Even among the well-to-do middle classes into which the artist was born, mothers generally looked

13
This contemporary map of the Rhineland, with its many thousands of boundaries and irrigation channels, gives some idea of the value the Dutch placed on land and the painstaking process by which they had won it from nature. The same energy and dogged determination finally brought an end to Spanish domination of the seven northern provinces in 1609.

after their children – at least until they were four or five when an old female servant would often take over. This was essential, since infant mortality was high and families were consequently large.

It was the custom to protect babies from fresh air at all costs. The wretched little creatures were bound up in layers of clothes and wrappings as if for 'pass-the-parcel', and placed under covers in a cradle (often with a hot-water bottle) which would be in a nursery with closed and shuttered windows. Water touched their bodies as seldom as air – it is hardly surprising that the mortality rate was high.

Rembrandt's drawings of his own family and other children are the best guide to his childhood. He would have been taught to walk like the infant in the red chalk drawing [12], and worn the same protective hat and clothing. From the age of three until he was seven, when he left the junior school, Rembrandt must have played in the streets of Leyden like other children. The unruliness of these crowds of children (from all classes), banished lest they soiled or disturbed the spotless tranquility of the house, appalled foreign visitors as did their manners generally. Parival wrote: 'It is partly from their excessive indulgence towards their children that there results the disorder which is often to be seen in their conduct. It is nevertheless surprising that there is not more disorder than there is, and there is perhaps no better proof of the natural goodness of the inhabitants of this country and the excellence of their dispositions.'

The Leyden in which Rembrandt played as a child was an important industrial town with a world-famous university. The

14
Number twenty-six among the students who enrolled on the 20th May 1620 was Rembrandt van Rijn.

corporation prided itself on the cleanness of its highways, although town drainage was unknown and rubbish and sewage were simply dumped into the canals–which smelled accordingly. But even enlightened Leyden was not without its slum areas, where unpaved alleys like open sewers contrasted with the scrubbed and sand-sprinkled thoroughfares of the richer districts. If childish curiosity took Rembrandt to these slums he would have seen the other face of nascent bourgeois capitalism, where profiteer landlords exploited Leyden's 20,000 textile workers who dragged out their existence in rotting, barrack-like hovels.

Very often it was from these slums that the teachers in the junior schools were recruited. Generally unable to read or write, these harrassed and underpaid women (men were less common) were forced to combine teaching with lacemaking, knitting or similar activities. In these conditions–seated on a wooden bench with a bucket which served as a lavatory in the corner– Rembrandt would have learned to recite the Lord's Prayer, the Ten Commandments, the formula of Confession and the letters of the alphabet. Because his family were comfortably off, and could afford one of the better junior schools, he may also have learned some rudimentary arithmetic and to read and write a little. Indeed it is almost certain that he did, because at the age of seven he had shown himself sufficiently intelligent to be sent to the Latin School.

Although many Latin Schools were little better than the junior schools, with mediocre teachers relying heavily on memorization, there is good reason to believe that the institution which Rembrandt attended was properly run. Leyden was the second city of Holland, proud of its university which was founded in 1575, and the authorities would have ensured that secondary education was at least adequate. Rembrandt certainly received a sound classical education there: his knowledge of the classics is apparent in his art, and seven years after entering the Latin School he gained a place at Leyden University.

Discipline at the Latin School was severe, and corporal punishment was administered freely. The premises were often convents which had been taken over after the break with Spain, and pupils (boys only, those girls who received secondary education were taught by tutors) sat in a sepulchral half-light, stifling in the summer and choking on peat smoke in the winter. Rembrandt's curriculum naturally included Latin (for twenty to thirty hours a week, out of a total of thirty-four hours) as well as religious instruction and calligraphy. The more senior pupils who were destined for university also took Greek, rhetoric and logic.

On the 20th May, 1620 when he was fourteen years old, Rembrandt enrolled at Leyden University [14]. Only a few months later he persuaded his parents to allow him to leave. Some of his more foolish early biographers suggested that this

15 *below*
The ceremony of 'Promotionsumzug' at Leyden University, where Rembrandt enrolled in 1620. The university was founded by William of Orange in 1575 in recognition of the town's heroic defence against the Spaniards; in only a few years it became one of Europe's great seats of learning, attracting scholars such as René Descartes and Guez de Balzac.

16 *bottom*
Leyden's University, and the other expressions of its civic pride, were founded on wealth derived from the woollen industry. A workforce of 20,000 laboured in miserable conditions to make Leyden cloth, Leyden baize and Leyden camlet famous throughout Europe.

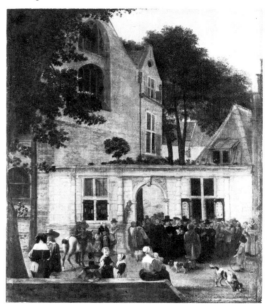

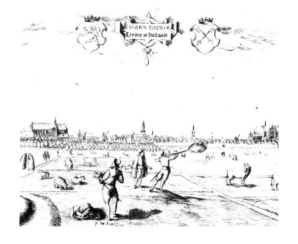

arrogant and boorish son of a miller took the step because he despised learning and culture. While it is true that Dutch humanistic learning, and the pretentious complexities of emblematic literature, were quite alien to Rembrandt, he was far from uncultured.

There was nothing petulant in his action; it was considered and sensible. Men like Rembrandt take what action they must: a university is altogether too cosy a place for genius, which needs to be exposed to the rough-and-tumble of life in order to develop. And besides, the faculties at Leyden were the traditional four: science and letters, theology, law, and medicine. Art as he understood it was not included, and it was an artist he had decided to become.

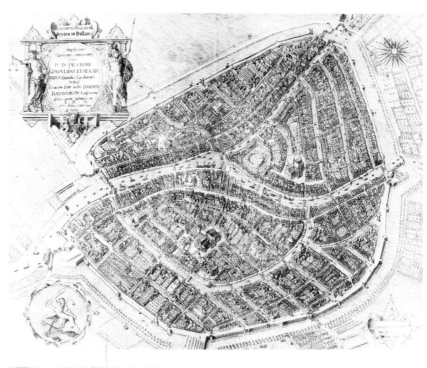

17
A bird's-eye view of Leyden shows the two branches of the Rhine which enter the city from the east and join at the centre. The Spanish siege, from May to October 1574, was relieved by the brave action of cutting the dykes so that boats could bring provisions to the starving inhabitants.

18
Only the rich ate meat more than once a week, and the fish market in Leyden was open daily. So important were the North Sea Fisheries for herring, haddock and cod, that they were known as the 'chiefest trade and principal gold mine' of the United Provinces.

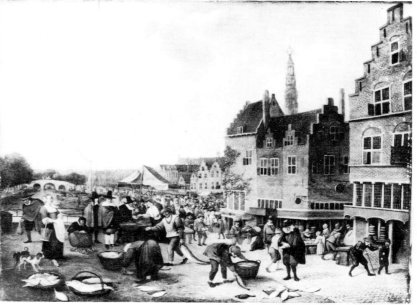

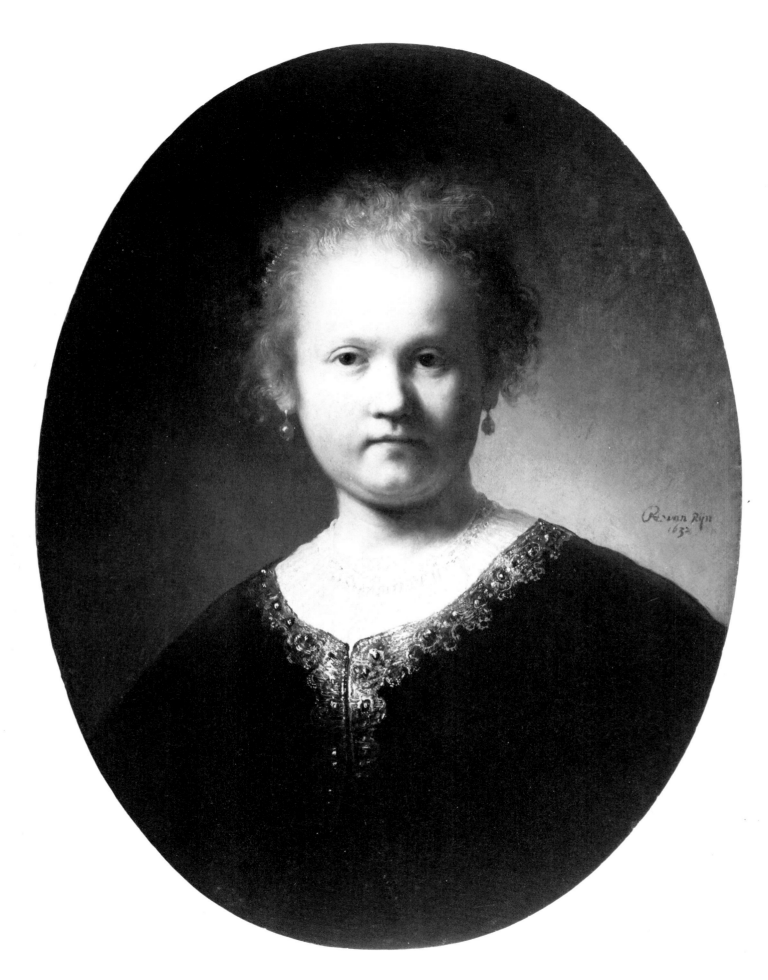

20

Chapter 2

A pupil and his teachers

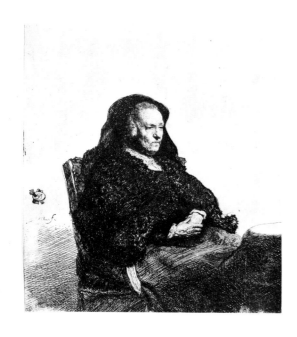

SOME NINETEENTH-CENTURY biographers had a lot of trouble with the fact that the greatest artist of the Dutch School was the son of a miller whose brothers became a cobbler and a baker. Fortunately the world has moved on, and the only problem we have to solve is how Rembrandt had the opportunity to become a painter – it is no longer necessary to speculate on how a miller's son had the qualities of mind to do so

The emergence of the Protestant, seafaring United Provinces in the first quarter of the seventeenth century marked a shift of emphasis from Italy and the Mediterranean to Northern Europe. Here was the new hub of things, in commerce and in art.

Economics and art are very closely interconnected. The first three-dimensional, 'realistic' art was invented in the Italian city states in the thirteenth century sponsored by newly emerged bankers and merchants. As Kenneth Clark says: 'Just as their economic system was capable of an expansion which has lasted till today, so the painting they commissioned had a kind of solid reality that was to be the dominant aim of western art up to the time of Cézanne.'

Realistic portraiture was a Northern invention. This development in art also came in the wake of economic change: it corresponded with the weakening of the Hanseatic League in the mid-fifteenth century, but with a general strengthening of Northern banking and commercial interests. Ironically many of Jan van Eyck's sitters were Italians, men with important positions in the international wool trade and banking. Businessmen are not just generous patrons, they change the art they commission: practical, and down-to-earth, they promote 'realism' in art.

By the time of Rembrandt the Netherlands were emerging as the strongest economic force in Europe. This strength was largely the creation of the new merchant class who had replaced Spanish domination with liberal federalism, Catholicism with Protestantism, and Church and artistocratic patronage with the greatest popular demand for 'art' in history. Their appetite for portraiture was insatiable, with the result that we probably know more about the appearance of the Dutch at this time than any other people in history before the invention of the camera.

19 *left*
Rembrandt's sister Lysbeth never married. It cannot have been easy to play the part of a spinster in a family with a demanding and strong-willed mother, and a famous son. Rembrandt was clearly fond of Lysbeth, and in all his portraits of her there is the feeling that he is setting out to flatter his rather frumpish sister by dressing her in unaccustomed finery.

20 *above*
A typical image of the artist's mother in her old age, sitting with hands clasped and her face set in almost reptilian concentration. All Rembrandt's numerous portraits of his mother give the same impression of indomitable will.

The art market was in such a state of boom in 1620 that Rembrandt's father—who had presumably noticed his son's talent at sketching or painting—might reasonably have encouraged his son to take up painting. It has been recorded (and there is no reason to suppose exaggeration) that the Delft artist Michiel van Miereveld painted more than ten thousand portraits during his career. The old miller would not have been slow to see the commercial possibilities open to a good artist. Twenty years later the English traveller Peter Mundy mentioned Rembrandt himself as one of those who catered to the need for art in the Netherlands: 'As For the art off Painting and the affection of the people to Pictures, I thincke none other goe beeyond them, there having bin in this Country Many excellent Men in thatt Facullty, some att presentt, as Rimbrantt, etts, All in generall striving to adorne their houses, especially the outer or street roome, with costly peeces. Butchers and bakers not much inferiour in their shoppes, which are Fairely sett Forth, yea many tymes blacksmithes, Coblers, etts., will have some picture or other by their Forge and in their stalle. Such is the generall Notion, enclination and delight that these Countrie Native(s) have to Paintings . . .'

Unfortunately the *catalogues raisonnés* of Rembrandt's work

21
A kermis painted by David Vinckboons. When John Evelyn visited the Netherlands he was amazed to find vast numbers of paintings for sale at agricultural fairs, and people of all classes buying them. The beginning of Rembrandt's career as a painter corresponded with the greatest art boom in history.

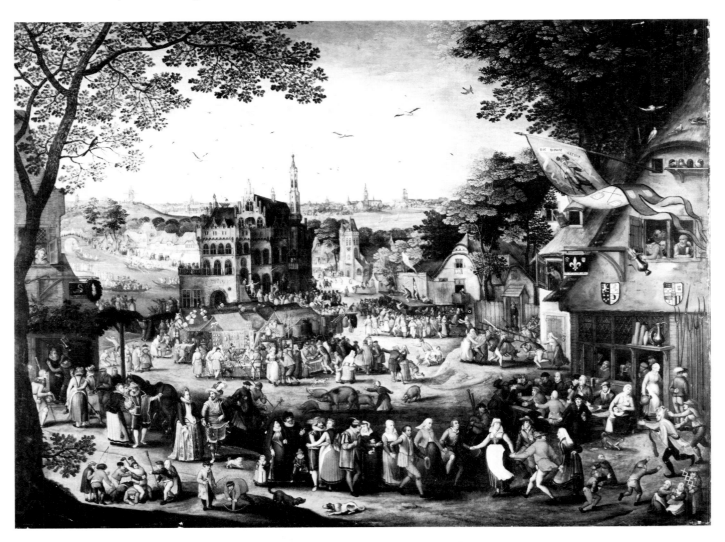

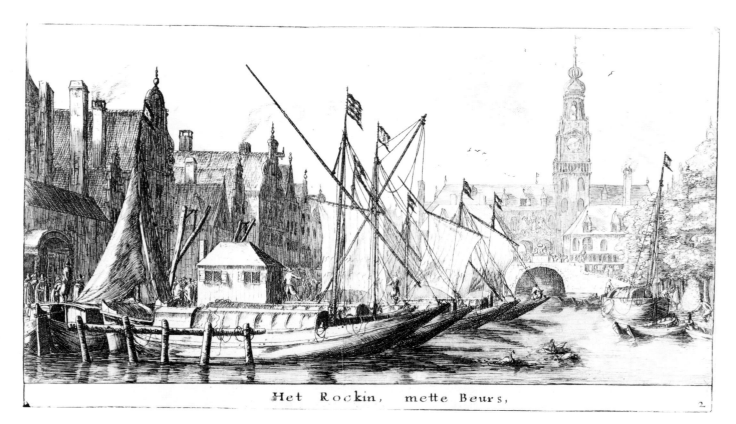

Het Rockin, mette Beurs,

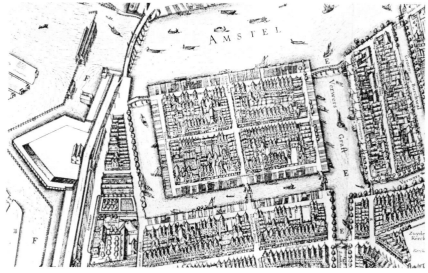

22 *above*
As the Netherlands became the principal force in world trade, the Amsterdam Exchange (in the background, behind the Rokin) exerted a powerful influence on international affairs. World prices of the main articles of trade were regulated by the Exchange, which also became the pulse of European politics.

23 *right*
Amsterdam spread out like a fan from the centre formed by the Exchange, the harbour and the town hall. An immense city for its time it was built, like Venice, on wooden piles driven into the mud:

> The great town of Amsterdam
> is built on piles, until
> the day the whole place tumbles down:
> Then who will pay the bill?

24/25 *overleaf*
Rembrandt's portraits are also paintings with many different levels of significance. The young burgher couple shown here are at the same time efficiently executed likenesses for display, the epitome of their age and class, and a powerful statement about human personality. Whatever the success of their marriage two centuries ago, the images of the preoccupied young businessman and his beautiful wife are linked irrevocably together.

begin at 1625, and we have no positively identified examples of his early output. We know that there must have been some, and it must have been good enough to persuade his father to let him leave the university and begin an apprenticeship. Probably this lost juvenile work consisted mainly of studies of his family at home in the Weddesteeg. A later drawing is evocative of this period in the artist's life [11]. A woman sits reading by candlelight. In winter it was the practice for the family to gather in the living room at the front of the house, warming themselves around the peat oven. Surely this is Rembrandt's mother reading the Bible? It was in this setting and in this way, listening to his mother, that Rembrandt absorbed the stories from the Old and New Testaments which were to be such an important imaginative source in his later art.

23

24

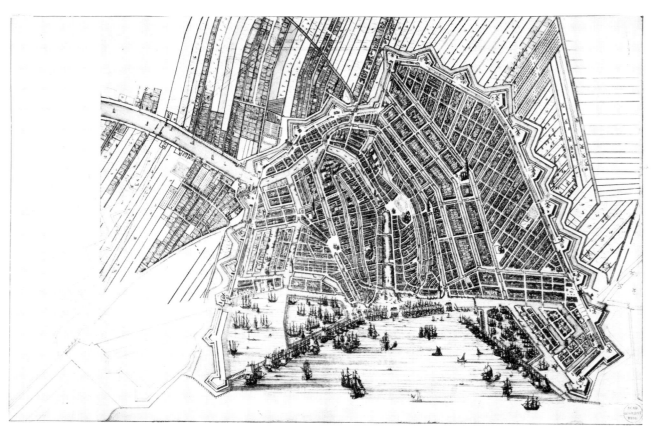

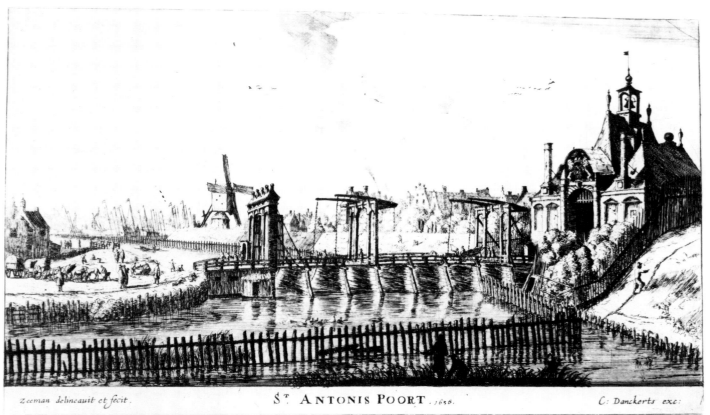

Zeeman delineauit et fecit.　　　　ST. ANTONIS POORT. 1636.　　　　C: Danckerts exc:

Late in 1620, or early in 1621, Rembrandt was apprenticed to Jacob Isaacsz van Swanenburgh who had a workshop nearby in Leyden. Van Swanenburgh's few surviving paintings indicate that his was a meagre talent—he specialized in architectural paintings and scenes of hell. The work which had established his reputation in Leyden was a series of paintings produced between 1595 and 1612 showing all the stages in the processing of wool—the town's main industry. But he no doubt taught Rembrandt something of art and life (he had travelled widely in Italy and returned with a Neapolitan wife), as well as the basic mechanics of painting, drawing and etching. Rembrandt remained in van Swanenburgh's workshop for three years, and it is not difficult to imagine how the voracious pupil must have learned everything the lesser artist had to teach him and then waited impatiently, and hopelessly, for more. According to some early sources Rembrandt received additional tutelage from the Leyden portrait painter Joris van Schoten.

Finally, in 1624, the young artist was sent to Amsterdam to study under Pieter Lastman. Unlike van Swanenburgh, Lastman was a first-rate artist and although Rembrandt spent only six months in his studio in the Breestraat he learned more than he had during the previous three years. Jakob Rosenberg compares their teacher-pupil relationship to that between Verrocchio and Leonardo, or Wohlgemuth and Dürer: 'In each case the teacher was the more robust personality and the pupil an extraordinary genius. But it was the masters' firm instruction which provided these sensitive disciples with a solid foundation before they soared to lofty heights.'

Lastman had returned from Italy in 1610, and from that moment he had no rival in Holland as a painter of mythological and religious subjects. During the period he spent in Italy Caravaggio had been raging against the cult of the beautiful and begun the fashion for painting 'ordinary' people in the drama of chiaroscuro (the interplay of light and shadow). Lastman was a link between Italian and Dutch art: Caravaggio's message passed through him to Rembrandt, who refuted the cult of the beautiful more vigorously, and employed chiaroscuro more effectively than any artist before or since.

During those urgent and vital six months in Lastman's studio Rembrandt also developed his interest in Biblical subjects, a trend quite out of step with contemporary taste. But then Rembrandt was one of those giants who is out of step with his time, who moves against fashion when it conflicts with his own inner needs and convictions. It is, in a sense, easier to look at Netherlandish art without Rembrandt. His natural intellectual and artistic heritage was the showmanship of Rubens, the traditionalism of Terbrugghen and the romanticism of Lastman. But at the outset of his career he rejected his heritage. In 1625, aged 19, he returned to Leyden to set up as an independent painter, determined to develop an art which was entirely his own creation.

26
The Singel, or 'girdle', marked the city boundary of early seventeenth-century Amsterdam. But the massive development which followed in the wake of economic expansion soon caused the city to expand beyond its traditional limits.

27
Amsterdam was built on commerce, and trade was woven into the entire fabric of the city. St Anthoniespoort stood at the end of the Breestraat where Rembrandt was to spend most of his working life.

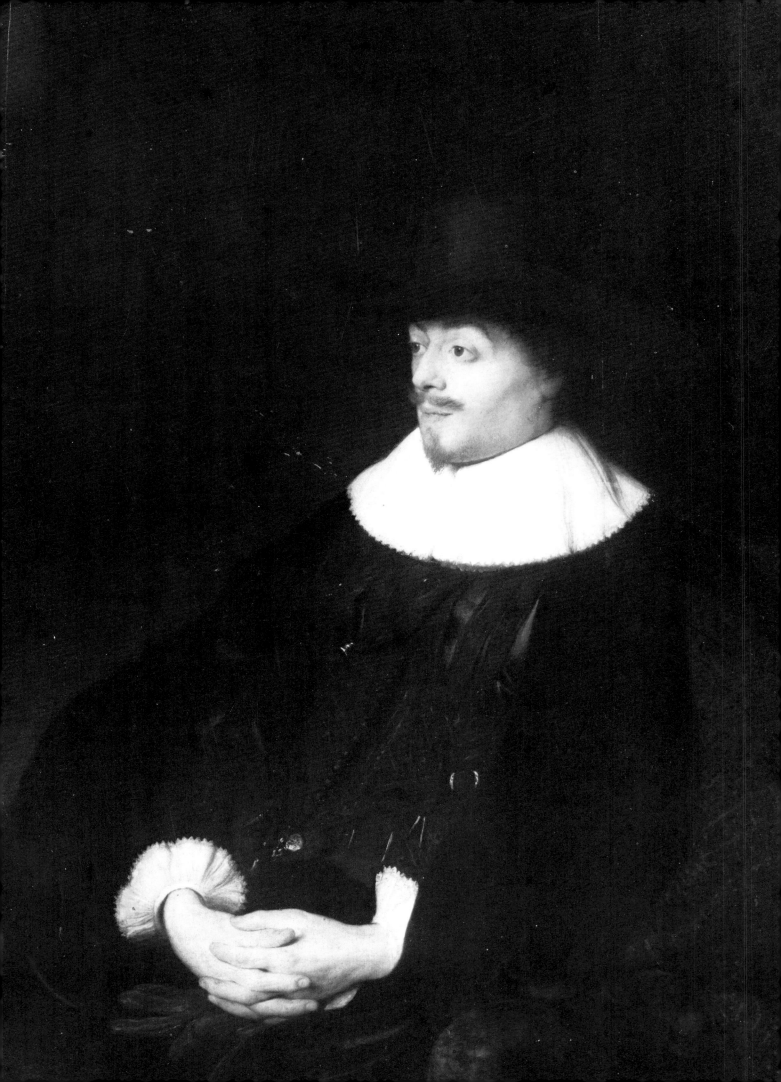

Chapter 3

Young artists

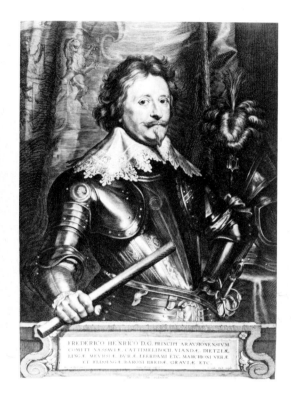

REMBRANDT's family were no doubt pleased to see him return from Amsterdam, although they must have detected a new intensity and resolution in him. He threw himself into work, producing drawings, etchings and paintings. Many of these were studies of his family, and if some are merely the records of various facial expressions which Lastman had taught him to work out for larger dramatic compositions, others are among the best of his work during this period. The only certain likeness of his father, a chalk drawing with brown wash [II], is immensely powerful. The miller is nearly seventy, which was a good age in seventeenth-century Holland, and he sits in the half-sleeping, half-waking way of the old. Although there is still a good deal of strength in the face and in the shoulders under the blanket, we know that death is not so very far away.

There is more tenacity in the features of his mother who was the subject of many portraits. Often he shows her reading the Bible or represents her as some Old Testament figure, underlining the fact that she was the source of his religious beliefs. Cornelia outlived her husband by ten years: the 1629 painting [I] shows a simple, pious woman.

Rembrandt's brothers and sisters often sat for him. Lysbeth was plump and rather plain; she must have been flattered by the exotic costumes in which her brother depicted her [19]. The portraits of Adriaen, his brother, are more significant [IV]. Not because they are great portraits – on the whole they are not – but because of the uncompromising way in which Rembrandt depicts the slow, rather ordinary bourgeois who was his brother.

The self-portraits of the period are equally uncompromising. Again, many are simply studies of facial expression copied in the mirror. But in others we can already see the beginnings of his obsession with the changing, fluid quality of human personality. And while he showed himself as uncouth and stubborn, or expressionless and almost blank [III], he made studies of old age in which all the past experience of the individual, every complexity of character, is immediately apparent. The depth of understanding in a young man which this displays, and the absolute honesty with which he depicts himself as an almost blank sheet, scarcely written upon, is awesome.

28 *left*
Jan Lieven's portrait of Constantyn Huygens, the energetic and brilliant Secretary to the Stadtholder who was to become Rembrandt's first patron and play an important part in the artist's early career.

29 *above*
Frederick Henry, Prince of Orange, guided the affairs of the United Provinces from his little court at the Hague for twenty-two years. The 'age of Frederick Henry' from 1625 to 1647 was the golden age of the Dutch republic: a time of unprecedented prosperity and expansion.

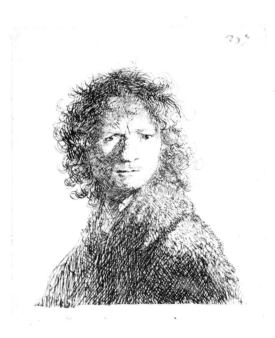

Possibly on the recommendation of Lastman, Rembrandt sought out another ex-pupil of the master on his return to Leyden. His name was Jan Lievens. Lievens, who was a fellow townsman, was sixteen months younger than Rembrandt and if the local historian is to be believed he was a prodigy. Apprenticed to the Leyden painter Joris van Schoten at the age of eight, when Rembrandt was still attending the Latin School, he transferred after only two years to the studio of Pieter Lastman. After a further two years with Lastman he returned to Leyden to become an independent painter. Lievens was then twelve years old.

Later in Jan Lievens' career the Earl of Ancrum said that he had 'so high a conceit of himself that he thinks there is none to be compared with him in all Germany, Holland, nor the rest of the 17 Provinces'. And if his only existing self-portrait [32] of twenty years later is anything to go by, Lievens did have a good opinion of himself. But he was a brilliant painter, and in the 1620s his style, like Rembrandt's, was still so much influenced by Lastman that it was inevitable they should work together.

Rembrandt probably lived at home during this period. Although his parents were not poor there were obvious financial benefits, and in any case his life was his art; it is clear that he had little time for the interests which might have made living away from home attractive to a young man. He did, however, share a studio with Jan Lievens. They did not, so far as we know,

30 *left*
A drawing Rembrandt made of himself while sharing a studio with Lievens shows his appearance at the time.

31 *above*
This early Rembrandt etching is generally considered to be a self-portrait, although the facial characteristics are closer to those of Lievens.

32 *right*
The self-portrait of Jan Lievens which he completed some twenty years after his association with Rembrandt. By that time vanity and soft living had taken their toll, and Lievens was less of a painter than a courtier.

collaborate to produce compositions but they certainly retouched each other's paintings. Having worked under the same master they could also talk out stylistic problems, and since both were interested in history painting there was the added advantage of sharing props as well as models. It is sometimes difficult to distinguish between the work of the two artists during this period. In an inventory of the paintings of Prince Frederick Henry of Orange which was made in 1632, one item is referred to as 'A Simeon in the Temple, holding Christ in his arms, done either by Rembrandt or Jan Lievens'. The two young artists soon became well-known in Leyden. Both had friends and relations in the town of course (Jan Lievens' father was an embroiderer) and there was a strong sense of civic pride which spotlighted any promising talent. But it was not all praise, and when Aernout van Buchell, a jurist from Utrecht, visited the town in 1628 he wrote in his diary: 'The Leyden miller's son is greatly praised, but before his time'.

In the same year Rembrandt received more flattering attention. Gerrit Dou entered his studio as an apprentice. After Rembrandt had left Leyden for Amsterdam, Dou went on to found the Leyden school of 'fine painters', becoming one of the most popular, and highly paid, artists of the age. But in 1628, when he was fourteen and Rembrandt only twenty-one, he was far from being the elegant and urbane society artist he became.

A painting which must have been done shortly after Dou's arrival shows the new pupil working at an easel [34]. Master painters were of course paid for taking on apprentices, and for a struggling young artist this was a useful source of income. Perhaps Gerrit Dou's parents scraped together more than they could afford to place him with Rembrandt, because his clothes have unmistakably been cut down to fit him. He has the air of resentment and self-consciousness which anyone who has ever worn hand-me-downs will recognize, and sympathize with.

The same painting is an interesting record of the studio where Lievens and Rembrandt worked together. It is a plain workshop, with bare wooden furniture and crumbling plaster. Possibly it was a room in one of the van Rijn properties in the Weddesteeg, which would explain why members of Rembrandt's family were such regular sitters. Unless the young artists preferred to work undisturbed, away from the regime of meals and bed, perhaps in the part of town where the wool workers lived and rents were cheap.

Some eighteen months before the arrival of Gerrit Dou, Jan Lievens had been commissioned to paint a portrait of Constantyn Huygens [28], Secretary to the Prince of Orange [29]. The painting received a mixed reception, but Huygens was pleased: 'Some people are of the opinion that the thoughtful expression does not give a true portrait of my character. But at the time I was seriously preoccupied with important family matters and my eyes reflected the cares of my heart.' Huygens married shortly afterwards which may explain what had

33
Gerrit Dou was apprenticed to Rembrandt in 1628 when he was only fourteen. This awful painting of his master at the easel shows the direction his art was to take: the objects in the bottom right-hand corner are brilliantly observed, while the figure is a ludicrous puppet. Dou later made a considerable fortune by painting trivial subjects with the skill and precision of a watchmaker. For him technique was an end in itself, and he was never troubled by any kind of artistic imagination.

happened. It is fortunate that he liked the portrait. He was one of the most influential and cultured men in the Netherlands, and he was to play a crucial part in the early careers of both Lievens and Rembrandt.

Constantyn Huygens was an exceptional man. He had a successful career as a diplomat in Venice and London, where he was knighted by James I, before being appointed Secretary to the Stadtholder in 1625. He combined immense physical energy— he used to mount his horse by jumping over its back, once climbed the spire of Strasbourg Cathedral, and was well-known to the ladies of the Court—with wide-ranging cultural interests. He translated John Donne into Dutch, wrote Latin verse, and corresponded with the philosopher Descartes in three languages. He also studied astronomy, law, and theology. But his main interest was the visual arts: he had seen Venetian painting when in the embassy there and he closely followed the work of every significant Netherlandish artist. Lievens and Rembrandt must have had mixed feelings when this connoisseur of art and arbiter of Dutch taste announced his intention to visit Leyden in 1629.

The meeting was an unqualified success in every way.

34
Rembrandt's painting of Dou is a curious composition, with a massive easel completely dominating his diminutive form. It is almost a metaphor for the way in which his small talent measured up to the proper business of painting. Von Sandrart summed up the relationship between the two painters: 'It is true that Gerard Dou of Leyden was planted in our garden of art by Rembrandt, but the flower turned out rather different from what the gardener had thought it would be.'

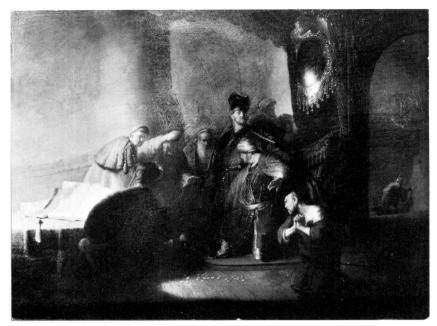

35
'Judas returning the thirty pieces of silver', which was so exuberantly praised by Huygens, is by modern standards one of Rembrandt's less interesting Baroque creations.

Huygens' reaction to the two young artists is recorded in the autobiography which he began (in Latin, typically) the following year. It is significant that in a passage describing Rubens (whom he calls one of the wonders of the world) he should also mention two young artists in their early twenties, not yet at the height of their artistic powers. Yet he has no hesitation in stating that they were already the equals of the most famous painters, and would soon surpass them. It is indicative of Huygens' breadth of intellect that he stresses the humble origins of both men, taking this as an absolute refutation of the idea commonly held in the aristocratic circles in which he moved that 'noble blood' was superior to 'ordinary blood'.

Huygens was full of praise for both artists, judging that Lievens was bolder and more inventive but detecting in Rembrandt's work a force of expression lacking in that of his colleague. Huygens leaves no doubt that he believes he has found the promise of an exceptional talent. In his comments on 'Judas returning the thirty pieces of silver' [35] he is staking his very considerable reputation on 'this beardless son of a Batavian miller'; and despite the purple prose which is inevitable from one with his humanistic background, we can detect a genuine admiration: 'As an example of his works let me cite the painting of the repentant Judas returning to the high priest the silver pieces, the price of our innocent Lord. All of Italy can be placed beside it, and the most imposing and admirable remains of the first ancients. The very gesture of this desperate Judas alone – not to mention all the many impressive figures in this one work – this Judas, I say, raging, whining, groveling for mercy without expecting it; the hope written on his face, the dreadful visage, torn-out hair, rent garment, twisted arms, hands clenched to the point of bleeding – fallen to his knees in a heedless outburst, his whole body contorted in a raging despair, this whole figure I set against the elegance of centuries.'

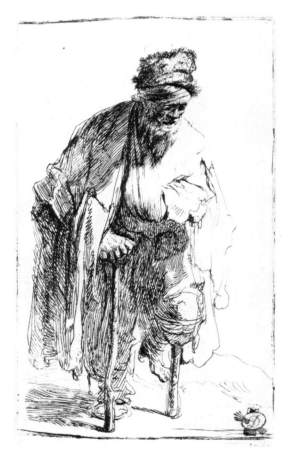

36/37
Rembrandt's interest in beggars had little to do with the fad for such subjects begun by Callot. Unemployment was widespread and the highways swarmed with mendicants – many were maimed veterans of the wars with Spain. But economics was the real cause of the problem, and in Leyden alone in 1634 twenty thousand of the town's proletariat needed free bread.

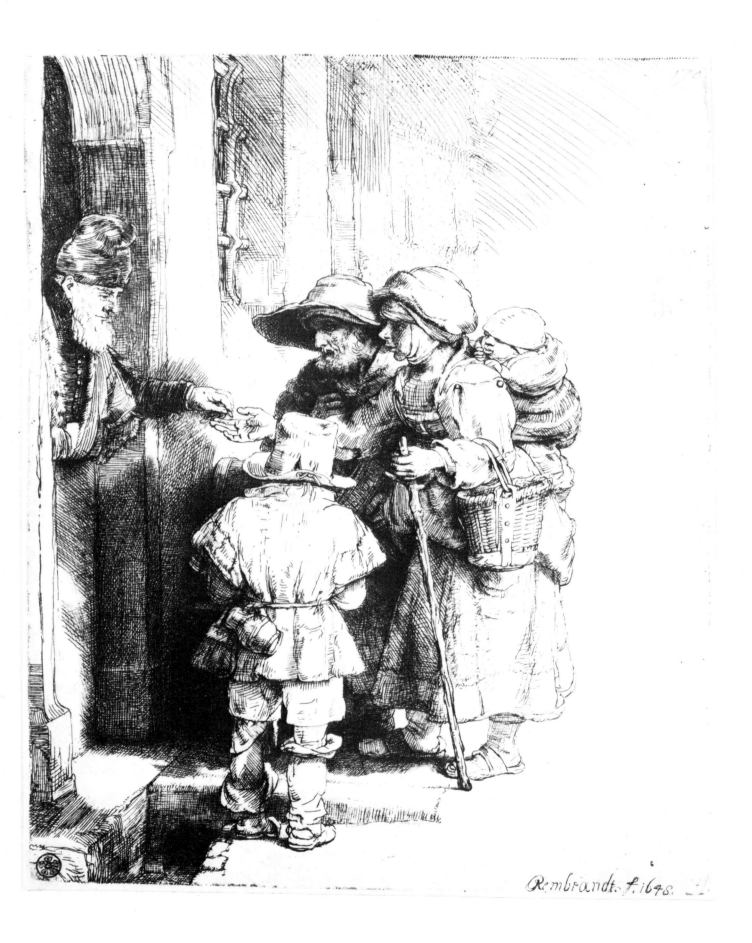

Rembrandt. f. 1648.

35

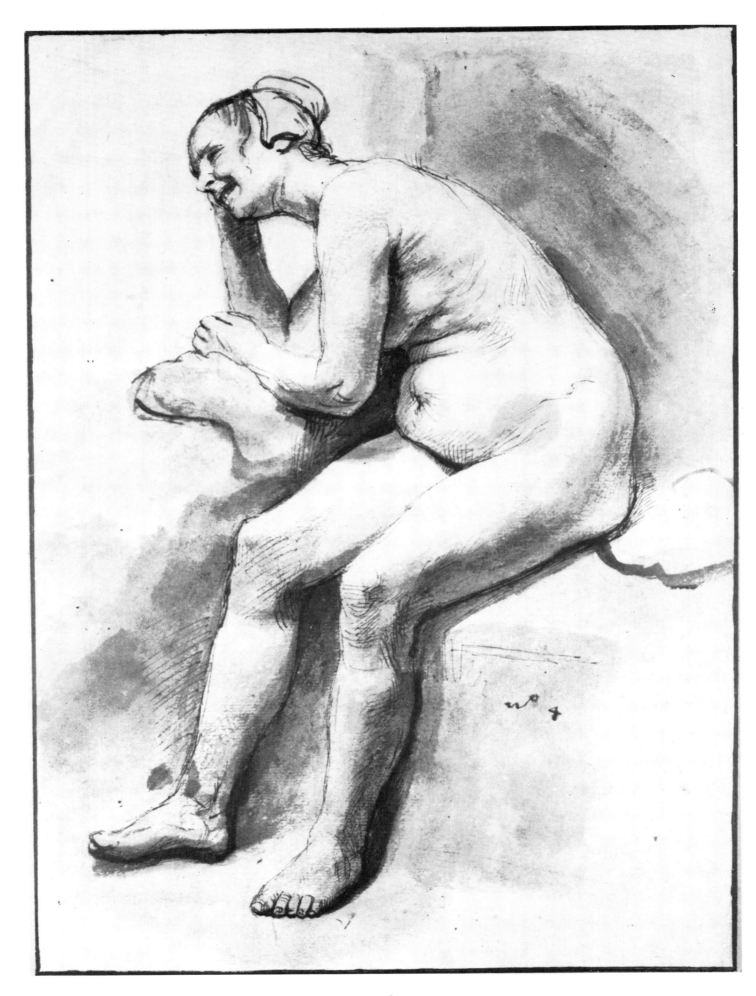

36

During his visit to the two artists, Huygens, who was evidently concerned for their physical health as well as their artistic development, suggested that they should go to Italy for a time to study the work of Raphael and Michelangelo. In his autobiography he says that they looked like boys, not even youths; they worked with an endurance and enthusiasm he had seldom seen, denying themselves the normal pleasures of young men. He records that he warned them to take better care of their bodies: they lacked the robustness which could cope with their unhealthy and sedentary life. But Huygens' advice went unheeded, and both artists said they were too busy to spare the time for the trip.

The meeting with Huygens was to open up many new possibilities for Lievens and Rembrandt: he did not merely praise them, he also helped to get them commissions. But even while his career as a painter for the rich and fashionable in society was beginning to gain momentum, Rembrandt was labouring to perfect his other artistic skills and tackling subjects

38/39
Rembrandt's early nudes are part of his broad compassion for and fascination with 'Woman' which Élie Faure analyses: '[Rembrandt] is there when the young girl appears to us leaning out of the window with her eyes which do not know and a pearl between her breasts. He is there when we have undressed her, when her firm torso trembles to the beat of our fever. He is there when the woman opens her thighs to us with the same maternal emotion as when she opens her arms to the child. He is there when the fruit falls from her, ten or fifteen times in her life. He is there when she has matured, when her belly is furrowed, her breasts hanging, her legs heavy. He is there when she has aged, when her wrinkled face is encircled with a bonnet and when her dried hands cross at the waist to say that she wants nothing of life that means pain.'

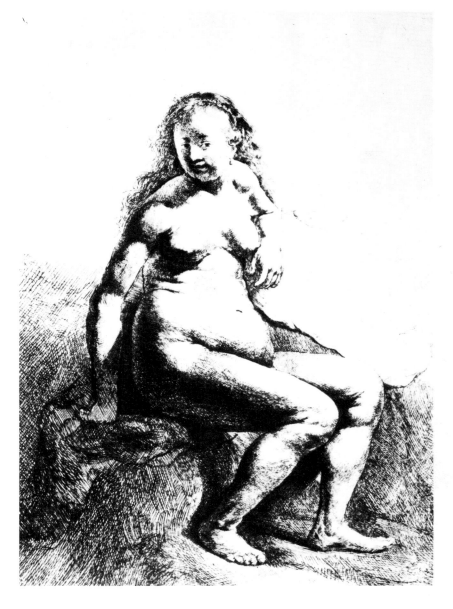

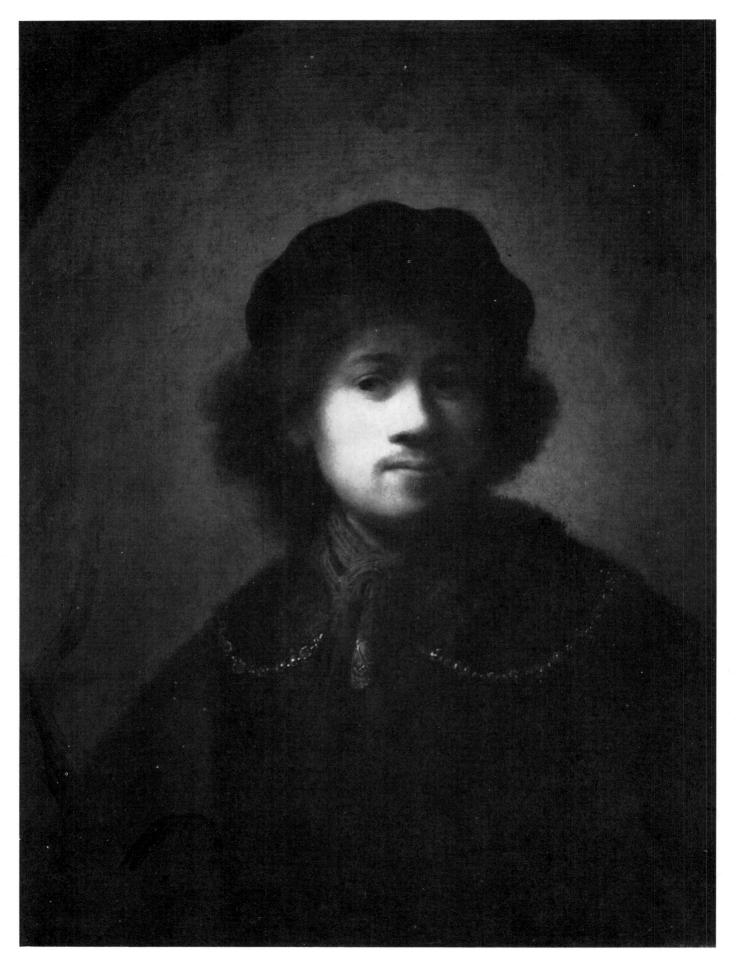

40 *left*
In this early self-portrait, painted before 1629 when he was still with Lievens, Rembrandt shows himself as callow and still a little uncertain. It is remarkable to be able to cut through all the psychological defences we build around ourselves and see himself as he really was. To have the need and the skill to show others that image is genius.

41/42 *above*
In Rembrandt's art nothing is taboo, and nothing is trivial. Every aspect of the human condition is significant and capable of teaching us something.

which – as they had no popular appeal – could only serve some inner need.

During the later years in Leyden Rembrandt produced a considerable number of drawings and etchings, generally markedly different in subject, and in style, from the paintings. Prints of beggars by the French artist Callot were popular in Holland at this time, and seeing these may have prompted Rembrandt to make his own studies [36] [37]. But what a difference! Callot's beggars are picturesque: at best sentimental, at worst designed to please those who derive pleasure from looking at people less fortunate than themselves. Rembrandt's beggars are human: life has crushed them. They are etched with understanding, and they evoke compassion in us.

Rembrandt also made several important nude studies of women at this time. He presents them simply as human beings, un-idealized and ugly. One, old and sexless, laughs that anyone should wish to draw her body [38]. Another, younger, with a great belly and sagging flesh, hopes, though she does not expect, to find some interest in her nakedness [39]. The studies are important for two reasons. They demonstrate Rembrandt's refusal to idealize the human form in any way, and his belief that all aspects of man's condition are equally deserving of attention.

This is the clue to two studies of people urinating which he made at about the same time [41] [42]. There is nothing perverse in the artist's attitude. But nor are they random genre subjects. Rembrandt was specifically interested in the activity for what it said about men and women, and he recorded it for that reason. The man is concerned only with himself, he enjoys it, almost makes a game of it. For the woman it is a necessary function like so many others, but she feels vulnerable and looks around her. Rembrandt invites the comparison, it is the reason he made the etchings. The studies are far removed from the history paintings he was working on at the same time for Constantyn Huygens and his friends, but they are no less a part of his art.

In 1630 his father died. He was buried on the 27th April. Rembrandt wrote no letters that we know of and left no diary. It is dangerous to look for indications of the event in his art – we can only guess at the effect which this, and his mother's grief, had on him. Perhaps it was one more factor in his decision to leave Leyden. Largely due to Huygens he was beginning to be offered commissions, and he had established a business connection with the Amsterdam art dealer, Hendrick van Ulenborch.

Towards the end of 1630 Jan Lievens left for England. So far as we know Rembrandt had never depicted his face, unless two of the leaner etchings completed in that year are not, as is generally supposed, self-portraits [31]. Early in the next year Rembrandt received an important commission from the Guild of Surgeons. He made the appropriate arrangements for his mother, and his pupil Gerrit Dou, and accepted an invitation to stay at the house of van Ulenborch in the Breestraat. In the spring of 1631 he left Leyden for Amsterdam where he was to spend the rest of his life.

39

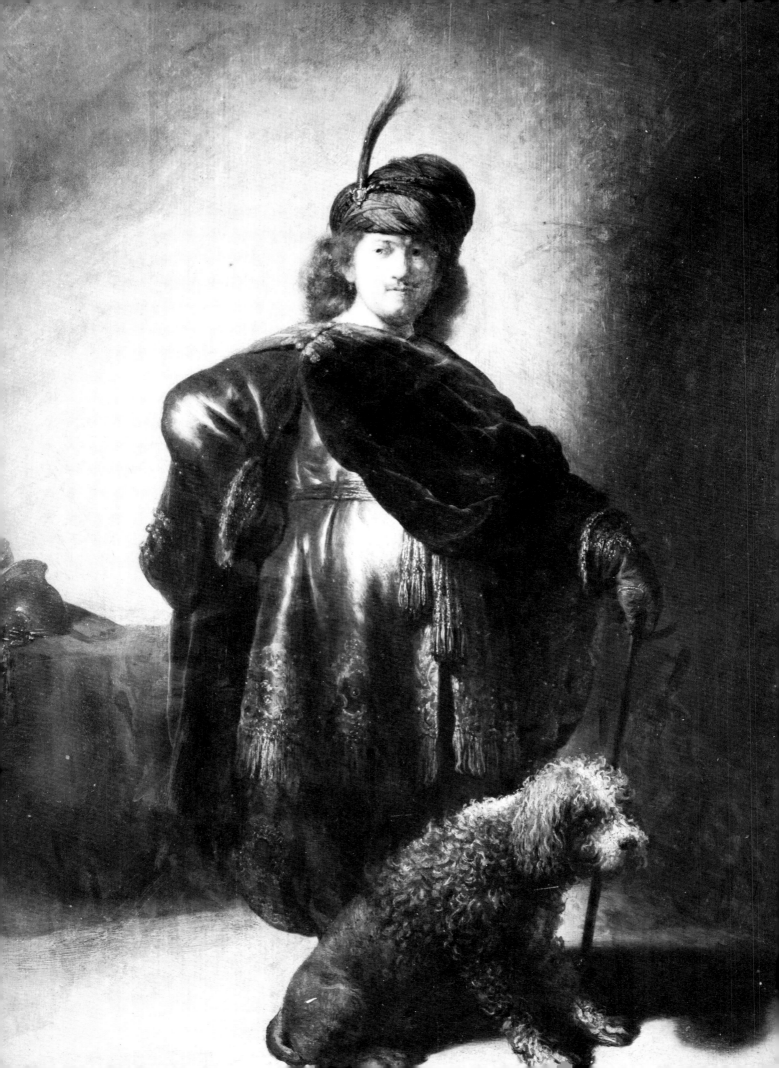

Chapter 4

Amsterdam!

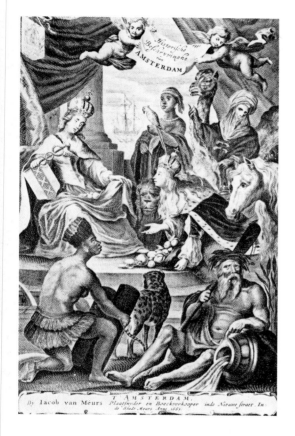

43 *left*
Rembrandt's 'self-portrait with a poodle' of
1631 is the ultimate in self-parody.

44 *above*
In the engraved frontispiece of a
seventeenth-century history book the city of
Amsterdam is personified as a queen
receiving tribute from four continents.

WHEN REMBRANDT stepped ashore from the Amsterdam
passenger barge in the late spring or early summer of 1631 he
entered a city that was fast becoming the wealthiest in
Europe. Since the disintegration of the Hanseatic League
and the gradual decline of Antwerp which had been unable to
cast off the Spanish yoke, Amsterdam had become the principal
port and main banking centre of Europe. Ideas and wealth
flowed back along the trade routes: so did people, and by the
1630s the city's cosmopolitan population numbered more than
150,000. One traveller commented: 'It appears at first not to be
the city of any particular people but to be common to all'.

Descartes [49], who had come to the city to work because
'everyone is so engrossed in furthering his own interests that I
could spend the whole of my life there without being noticed by a
soul;' wrote to Guez de Balzac in the year of Rembrandt's
arrival: 'You must excuse my zeal if I invite you to choose
Amsterdam for your retirement, and to prefer it not only to all
the Capuchin and Carthusian monasteries, to which many
worthy people retire, but also to the finest residences in France
and Italy, and even to the famous hermitage where you lived last
year. However well-organized a house in the country may be, it
always lacks an infinite number of commodities which can be
found only in towns, while even the solitude one hopes to find
there is never complete . . . No doubt there is a pleasure to be
derived from watching the fruit in your orchards grow in great
abundance, but do you imagine one cannot see at least as much
here in Amsterdam, unloaded by the vessels that bring us such a
copious supply of everything produced in the Indies and all that
is rare in Europe? Which other place in the whole world could
one choose where all the commodities of life are so easy to find as
in Amsterdam?'

Rembrandt's first major commission, and an important factor
in his decision to move to Amsterdam, was 'The Anatomy Lesson
of Professor Tulp [47]'. The painting makes two important
points. First, it was a group portrait, the most telling symbol of
the bourgeois democracy on which the wealth of Amsterdam was
based. Bourgeois capitalism depends on the division of risk and
the division of responsibility, it is founded on the idea that groups

of individuals should co-operate in pursuit of a common aim. The concept of 'corporation' permeated the whole society, and guilds, militia companies, fraternities, and the boards of charitable institutions all demanded permanent visible proof of their group endeavours.

The second point (if this isn't playing tricks with words) is an interesting coincidence: Tulp's own name, which derives from his birthplace which was probably a tulip auction. Tulips were the first classic example of boom and slump in capitalist economy ('tulipomania' was nearing its peak in the 1630s [46]); more significantly they showed that the Dutch were desperate for commodities in which to invest their new capital – and if not tulips, then paintings. John Evelyn, who visited the country some years later, noted in his diary: 'we arrived late at Roterdam, where was at that time their annual Mart or Faire, so furnish'd with pictures . . . as I was amazed: some of these I bought and sent into England. The reason of this store of pictures and their cheapnesse proceede from their want of Land, to employ their stock; so as 'tis an ordinary thing to find, a common Farmer lay out two, or 3000 pounds in this Commodity, their houses are full of them, and they vend them at their Kermas'es to very great gains.' The houses of the new middle classes also grew larger during this period, which in turn stimulated the demand for paintings which were considered primarily as wall-coverings by many.

The workshop of van Ulenborch's house where Rembrandt was living at this time, although ostensibly an 'academy' for young artists, was in fact an art factory which supplied the market demand for original paintings and copies. But Rembrandt would not have become involved in this hack work – nor

45 *above left*

The Anthoniesmarkt, where the Guild of Surgeons had its anatomy theatre. Despite a good deal of quackery the Netherlands were in the vanguard of medical progress, and it was in Amsterdam that the theory of the circulation of the blood was first accepted. Tulp himself, who does not seem to have been above a little remunerative charlatanry, made a serious contribution to medical research in his *Observationes Medicae*.

46 *below left*

The tulip trade, to which Nicolas Tulp owed his name, inexplicably deteriorated into 'tulipomania' during the 1630s. This Delftware pagoda vase was one by-product of capitalism's first example of boom and slump.

47 *below*

'The anatomy lesson of Professor Tulp' was Rembrandt's *pièce de réception*, and it proved to be a brilliant advertisement for artist and patrons alike. The young artist did not hesitate to place his signature in a prominent part of the daring composition for all Amsterdam to see.

indeed did he need to with a commission from the Guild of Surgeons.

Nicolas Tulp was one of Amsterdam's leading physicians. He was also a magistrate, Curator of the University, City Treasurer eight times and Burgomaster twice. A doctor shrewd enough to combine contemporary medical skills with the correct degree of showmanship and quackery – one cure was for patients to drink fifty cups of tea a day – he was very successful, and very rich. Tulp played Amsterdam society like a game of chance: it was a typical gesture for him to choose a young artist who was rumoured to be going places to paint his second dissection. He was not to be disappointed.

The Amsterdam Guild of Surgeons had an anatomy theatre on the top floor [45] of the south tower of the Anthoniesmarkt. Dissection, which had only recently been authorized in the Netherlands, was approached more in the spirit of carnival than of serious medical research, and large crowds crammed into the 'theatre' for an exciting *frisson*. Ironically the subject of Dr Tulp's dissection was a fellow townsman of Rembrandt, a criminal who had been hanged for robbery with violence. Perversely, when so many facts about Rembrandt have been lost, the name of the victim has come down to us: Aris Kindt.

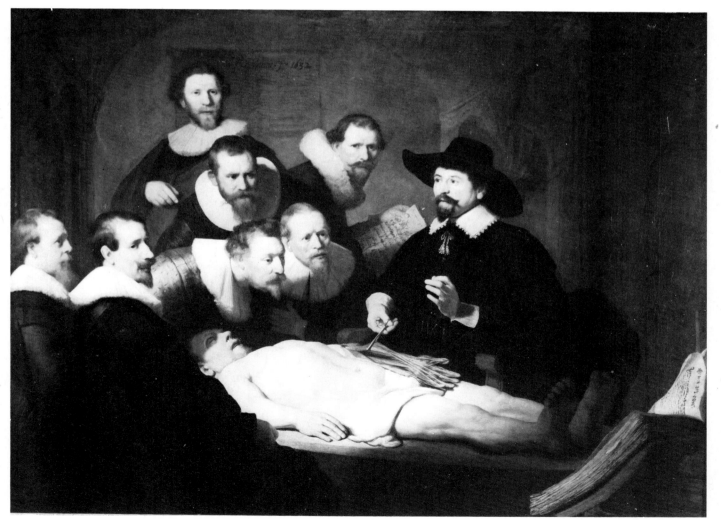

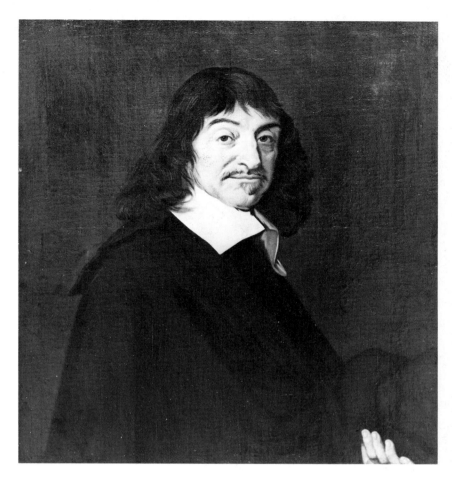

Rembrandt's painting is a masterpiece, and all Amsterdam recognized it as such. As a work of art, and as the artist's *pièce de réception*, it is a supremely skilful and carefully calculated creation. The construction of the painting and the treatment emphasize Tulp: naturally, he is the patron and it is his anatomy lesson. As the record of an event it is a cheat. Demonstrations conventionally began with dissection of the abdominal viscera, but this would have restricted Rembrandt to a run-of-the-mill composition. He shows Tulp performing the intricate dissection of the brachial musculature, and demonstrating the function of the part exposed with his own hand. Even this is a cheat, because comparison shows that the artist copied the arm from an illustration in Adriaen van den Spiegel's *Humani Corporis Fabrica*. But the painting served its purpose: in addition to being a great work of art, it also pleased its patron and provided a brilliant advertisement for Rembrandt.

During his first years in Amsterdam it was obviously Rembrandt's intention to become rich, and the way to achieve this was by painting portraits. There was, as we have seen, an insatiable demand for paintings in Holland. But among the businessmen of Amsterdam it was the portrait – tangible evidence of the importance of the individual, his wealth, and his personal significance to the Calvinistic God – which was most required. 'The Anatomy Lesson of Professor Tulp' had precisely the effect Rembrandt intended. He was deluged with commissions, more than one man could cope with even painting

constantly. Fifty paintings bear the dates 1632 and 1633, and all but four are portraits. The bourgeoisie of Amsterdam – merchants, bankers, craftsmen, pastors and burgomasters – vied with one another, schemed and implored in order to have the young artist capture their likeness on canvas. And Rembrandt became rich.

It would be a mistake to suppose that during this time Rembrandt neglected art, and for the sake of making money turned out technically competent but pedestrian portraits like the work of Nicolaes Elias, and Thomas de Keyser. It was not merely fad that made him popular: Rembrandt turned portraits into paintings [24] [15].

His study of the preacher Johannes Uytenbogaert is remarkable. Uytenbogaert records in his memoirs that he began sitting on the 13th April, 1633, the portrait [48] having been commissioned by his friend and admirer Abraham Anthonisz. The preacher clearly fascinated the young painter: this was the face of a man who had suffered for his principles. Although a former tutor of Prince Frederick Henry, Uytenbogaert was leader of the Arminians who represented the liberal elements in Calvinism, and when the Gomarists overthrew the sect he was forced into exile for seven years. A great portrait demands sympathy between artist and sitter, but it is stretching the facts to suggest that Rembrandt was himself a supporter of the Arminian cause. Some biographers have, but they miss the point – and they miss Rembrandt. He was sympathetic to all human suffering; he admired any man who opposed doctrinal narrowness with fortitude; and when he found a man of stature he transmuted the image into art to pass on the message of hope.

It is one of the clichés of worldly success that those who have achieved it tend to tell those who have not that it is a pointless exercise. Rembrandt's reaction was rather more complex: he continued to pursue wealth and possessions, because there is no doubt that they satisfied a strong need in him. But this was merely one force in his personality, not the whole of it, and with another part of him he despised the pettiness and futility of worldly ambition. This violent contradiction in a complex personality caused him to create an extraordinary painting [43]. Rembrandt's self-portrait with a poodle is the supreme self-parody painted with remorseless skill. 'Is this' he asks us, 'what it is all for?' The introduction of the clownish poodle, the epitome of the 'lap-dog', rams the point home lest the obtuse should overlook it.

But for the time being Rembrandt continued to limit most of his artistic output to the remunerative business of producing portraits for the burghers of Amsterdam. He had even invested one thousand guilders in van Ulenborch's firm. Forces beyond his control were shaping his life and the course it was to take. All this centred around a regular visitor to the house in the Breestraat: the art dealer's young cousin from Friesland, Saskia van Ulenborch.

50 *below*
Justice in seventeenth-century Holland was simple and remorseless. Rembrandt made a drawing of a woman hanging on a gibbet with the instrument of her crime prominently displayed. The gibbet is a businessman's solution, an advertisement with a simple message: 'This is what happens when you break the rules'.

51 *right*
Although the aristocracy and the very rich tended to be more flamboyant in their dress, the clothes of the burghers who formed the core of Amsterdam society were conservative and drab. Of Rembrandt's two hundred male portraits a large proportion are dressed in the typical black-and-white uniform of the middle classes. It was a rigid, conservative society with a strict morality in which good and evil were as easily distinguished as black and white.

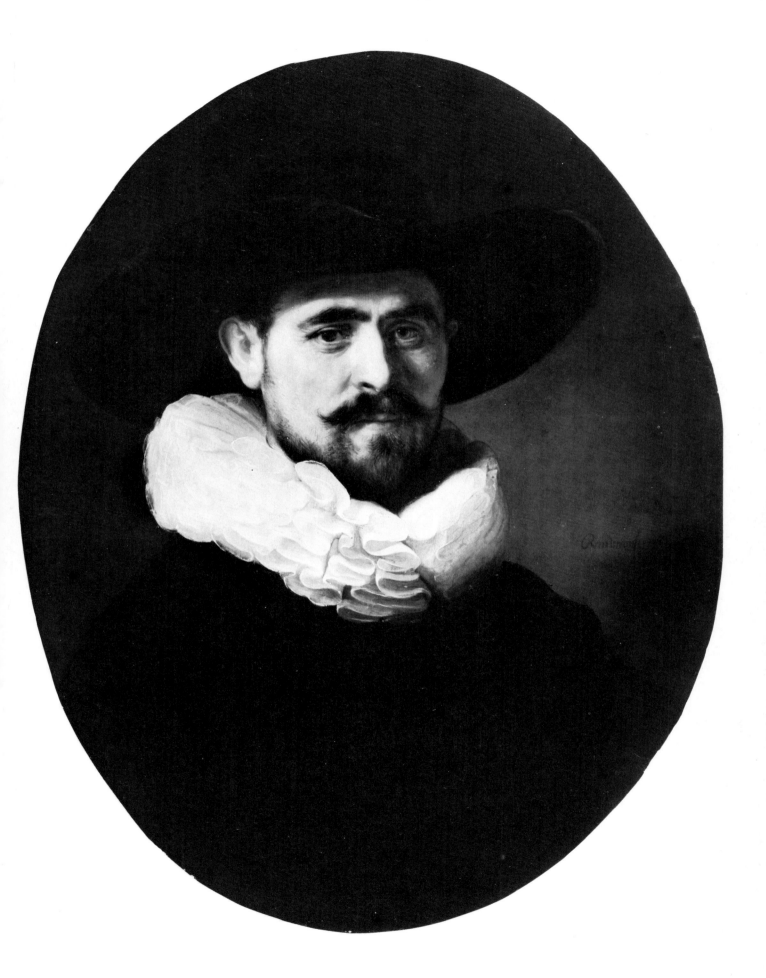

47

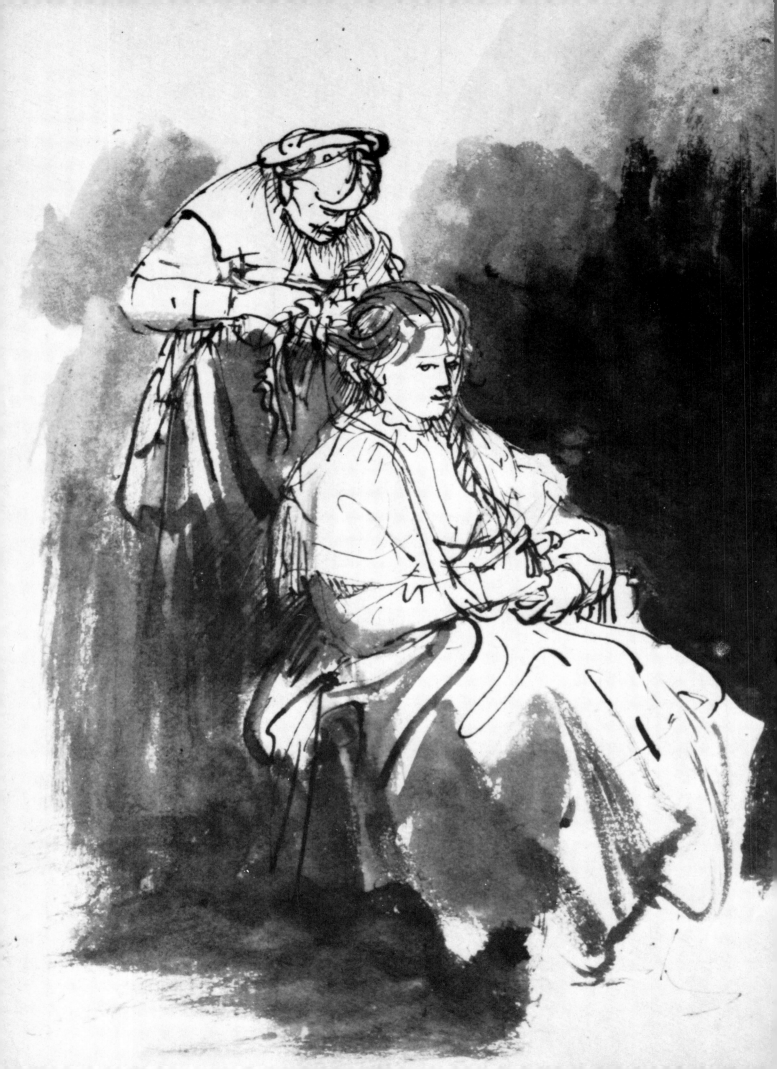

Chapter 5

Marriage to Saskia

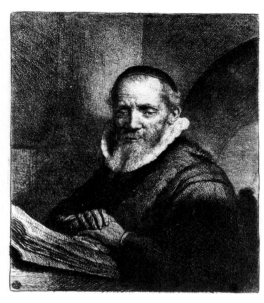

SASKIA VAN ULENBORCH was an orphan. Her father, who had
died when she was twelve, was a man of considerable wealth and
influence, and a former Burgomaster of Leeuwarden in
Friesland. She was a member of the wealthy upper class and
Rembrandt, although the most popular portrait painter in
Amsterdam, was the son of a miller. There is no doubt that she
could improve both his material and his social status, but nor is
there any doubt that he loved her. They became engaged in June
1633. To mark the occasion Rembrandt made an exquisite
drawing of Saskia [54] on which he later wrote: 'This is drawn
after my wife, when she was 21 years old, the third day after our
betrothal–the 8th of June, 1633.' He used the medium of
silverpoint for the portrait, one of the most difficult in art. This
involves drawing with a thin silver stylus onto expensive white
vellum, and allows no mistakes. But the artist had chosen the
method to reflect the importance of the occasion, and he made
no mistakes.

Betrothal was taken very seriously in seventeenth-century
Holland (to break off an engagement was an offence for which an
offender could be taken to court). An exchange of rings
solemnized the betrothal, and coming from Friesland Saskia
may have expected Rembrandt to follow the local custom of
giving the fiancée a considerable sum of money wrapped in a
linen cloth embroidered with their initials in red and the date.
Hendrick van Ulenborch, or her guardian Jan Cornelius
Sylvius [53], probably gave her the traditional gift among rich
families of a gold workbox with thimbles, needles, scissors and a
mirror. After the ceremony the couple exchanged their first
public kiss.

Rembrandt's early manhood, before he met Saskia, must have
been very lonely. Young women of all classes were strictly
supervised, and with his pious home environment he is unlikely
to have sought relief in the brothels which were numerous,
especially in the seaports. Like most young, unmarried men (and
a good many married ones) he probably found solace in the
taverns which abounded everywhere. Drunkenness was a
national pastime: Erasmus had left his native country because
'people drank too much'.

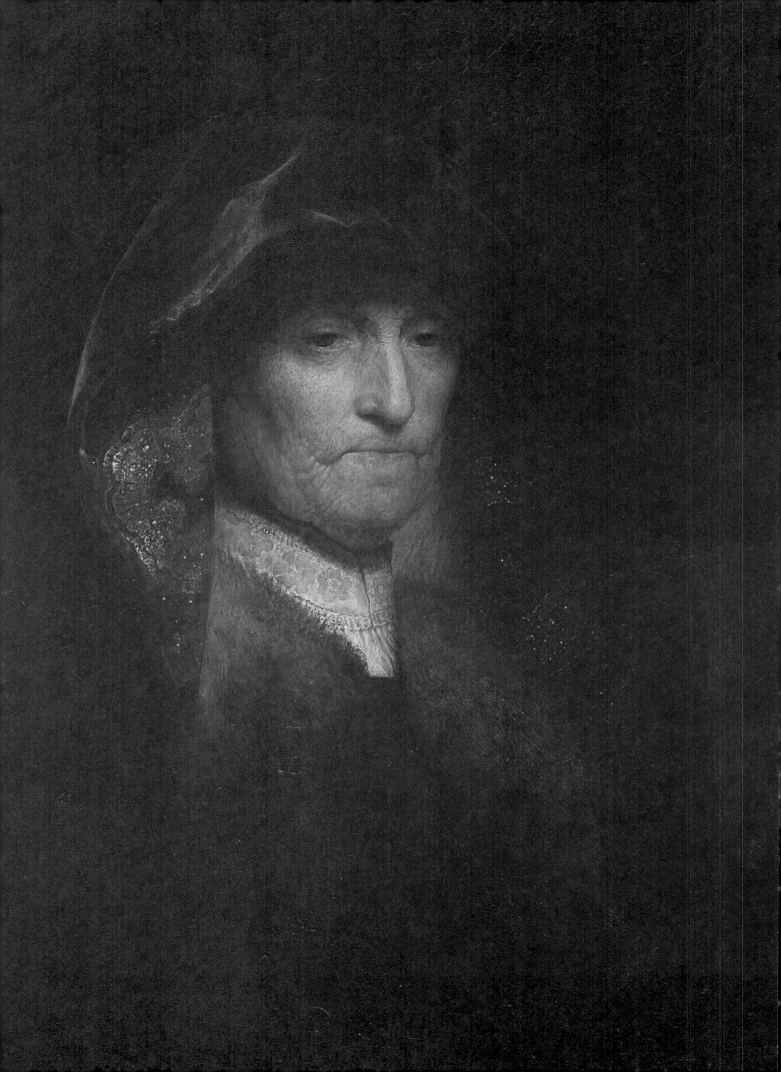

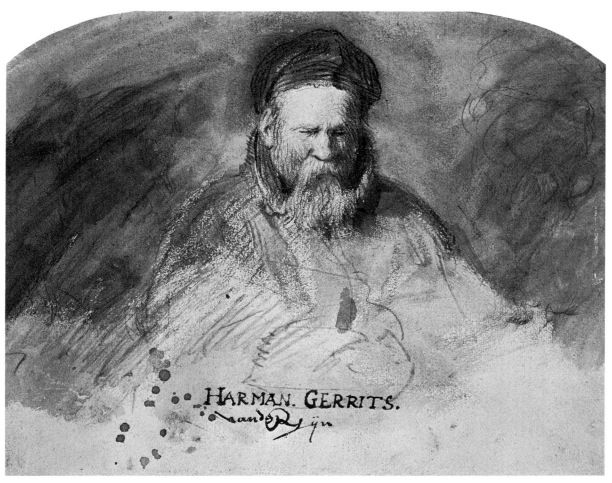

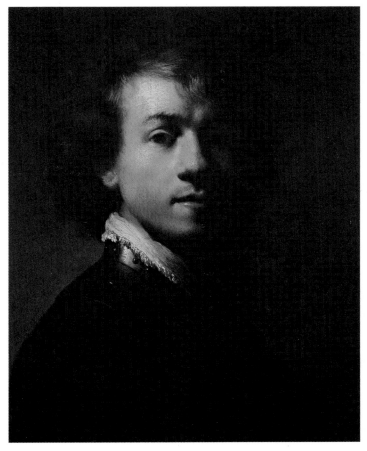

William Temple said that even young people in Holland spoke little of love, which they looked upon as 'an unavoidable rather than a fascinating subject of conversation . . . One meets pleasant young gallants, but no mad lovers'. In a society built upon the Protestant work ethic, where most men preferred business affairs to love affairs, the women seem to have suffered a certain amount of frustration, if the contemporary Parisian saying 'to make love like a Dutchwoman' is anything to go by. Although René Le Pays, who visited the country at this time, found the women as phlegmatic as the men: 'At the climax of pleasure they start eating an apple, or break nuts with their teeth.'

A year after the betrothal, almost to the day, Rembrandt and Saskia's guardian Jan Cornelius Sylvius appeared before the Commissioners to finalize the civil arrangements for the marriage. All aspects of the proceedings were regulated by the authorities, including supervision of the banns which were read three times either in the church or the town hall. On Rembrandt's side there was a stipulation that his mother should give her consent. The document still survives, and in the margin there is a note that the old lady had visited the public notary in Leyden and given her blessing and her consent to the marriage of the 'honourable Mr Rembrandt Harmensz van Rijn'.

The period between betrothal and marriage was normally brief, and the delay in Rembrandt's case may indicate some resistance on the part of Saskia's guardian–perhaps he hoped that given sufficient time in her fiancé's company Saskia would tire of the parvenu miller's son from Leyden. But most of the evidence contradicts this. Sylvius was a preacher, married to Saskia's first cousin Aalte van Ulenborch. Having held a number of provincial livings, he had finally moved to Amsterdam where, at the time of the engagement, he was officiating at the Groote Kerk. An etching which Rembrandt made a little later shows a compassionate, sensible man–it is unlikely that he intervened beyond giving the couple a suitable time to test their own feelings. Everything indicates that both Rembrandt and Saskia had nothing but affection for Sylvius: he was a witness at the baptism of their first child and baptized the second himself; years after his death Rembrandt made a painting of him.

The marriage took place on the 22nd June, 1634 in the Reformed Church of Sint-Annaparochie, the major town of Het Bilt, a polder in Friesland. Saskia's sister Hiskje was married to the Town Clerk of Het Bilt, and the celebrations probably took place at their house. In the marriage lines it states that Saskia was living at Franeker, which indicates that she had spent some time before the wedding with her widowed brother-in-law who was a professor of theology there.

Marriage celebrations followed a well-established pattern in Friesland, and we can have a clear idea of Rembrandt's wedding day. The church in Het Bilt would have been lavishly decorated for the marriage of someone of Saskia's social position, with

54
The exquisite silverpoint which Rembrandt made to record his betrothal to Saskia. He later wrote on it: 'This is drawn after my wife, when she was 21 years old, the third day after our betrothal–the 8th of June, 1633.'

IV *page 54, above left*
Adriaen van Ryn. 1650.

V *page 54, above right*
Saskia and Rembrandt the year after their marriage. 1635.

VI *page 54, below*
Winter scene. 1646.

VII *page 55*
Rembrandt's mistress Geertge Dircx was his model for 'Susanna and the Elders'. 1647.

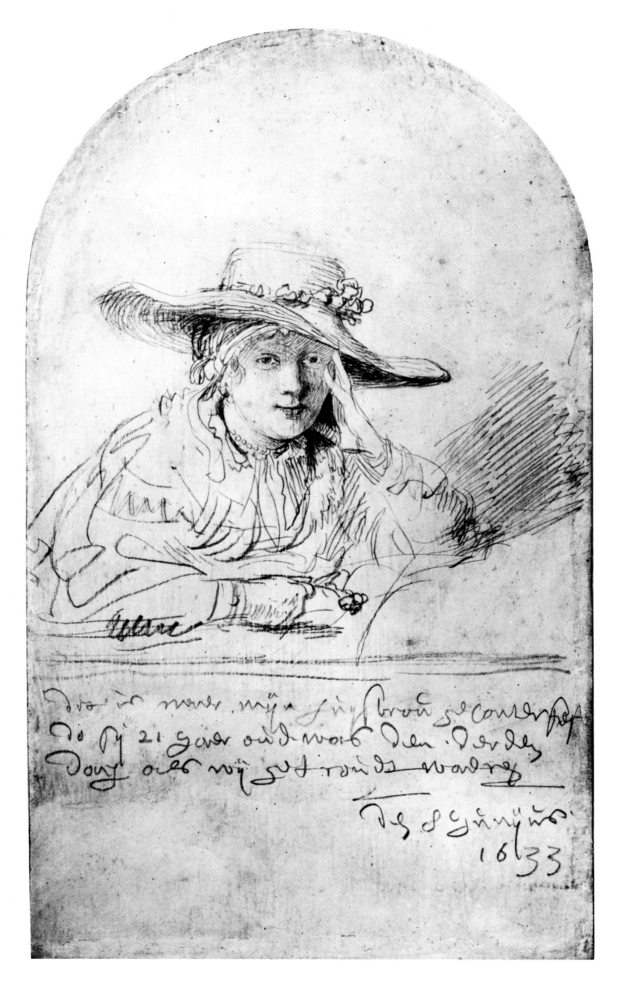

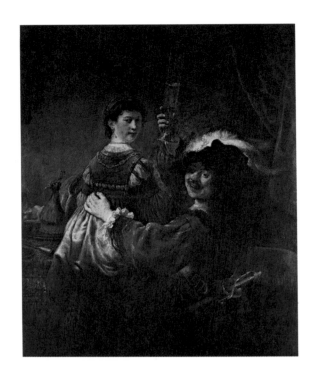

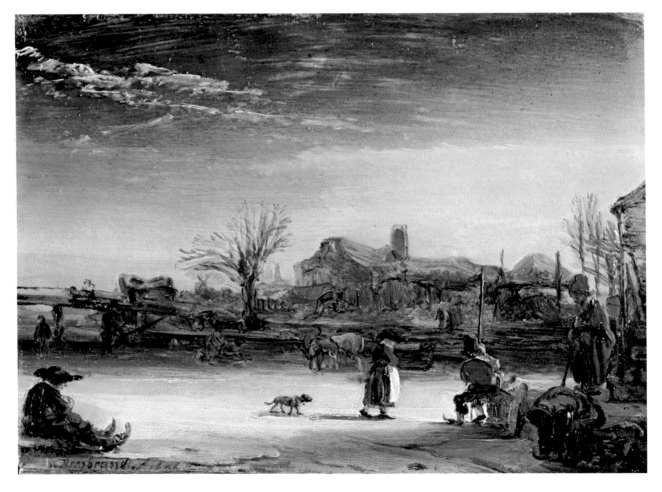

54

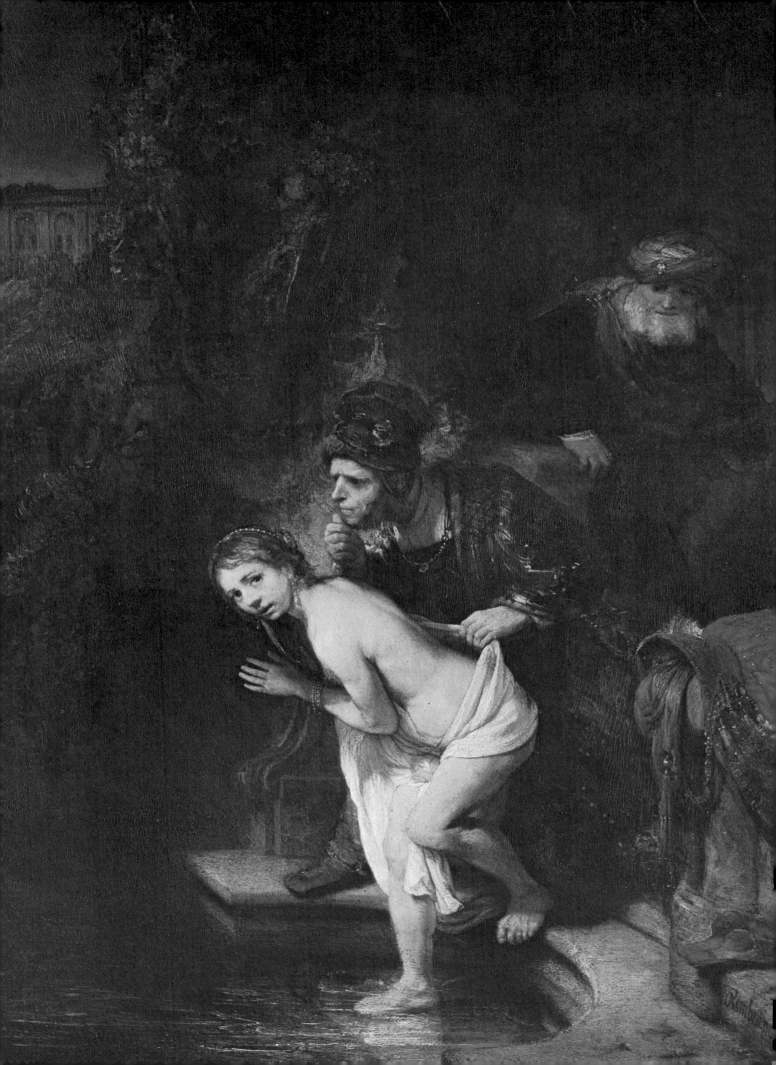

oriental carpets, flowers and garlands of greenery on the seats. Local children were chosen to strew blossom in front of the bride. At the culmination of the ceremony the groom placed his own ring on the second finger of the bride's right hand, where she wore the two from that moment.

The procession from the church to the wedding feast proceeded under a rain of flowers, with the married couple at the head in a coach. Saskia's sister Hiskje would have decorated her house in the traditional way, with all the ostentation and exuberant lack of taste of a Victorian Lord Mayor's banquet. The similarity did not end there: it was common for at least twenty courses to be served to guests at the great tables littered with gilt cherubs and burning hearts. During the meal a poem in Latin, or French or Italian, which had been written specially for the occasion, was recited by the author. This task would no doubt have fallen to one of Saskia's brothers – two were lawyers, another an army officer.

There is no record of whether any members of Rembrandt's family attended the wedding. It would have been an uncomfortable occasion for the down-to-earth Adriaen, but it is likely that his old mother made the journey from Leyden probably accompanied by his spinster sister, Lysbeth. After the giving of presents – duplicated kitchen equipment seems to have been as common then as now – the festivities ended with music and dancing. The couple retired to bed, to sleep between sheets which would not be used again until their lying in state.

Rembrandt and Saskia returned to Amsterdam soon after the wedding. For the next two years they lived in Hendrick van Ulenborch's spacious house in the Breestraat. The number of

56

55
Rembrandt was entirely frank in sexual matters, and while aware of the offence such etchings as 'The French bed' would give many people he also believed that no aspect of life – particularly such an important one – should be ignored by the artist. And since etchings are by their nature more commercial than drawings, it is probable that there was a market for such studies among the more repressed of Amsterdam's burghers.

VIII overleaf
Self-portrait at the time of his betrothal. 1633.

IX page 59
Perhaps the finest of all Rembrandt's portraits of Saskia, painted while she was carrying her first child. 1635.

paintings and drawings which the artist made of his wife during these early years of his marriage are the only record we have of their life together at this time. But the art speaks more than any written evidence could. The sheer volume of work devoted to Saskia shows her importance in the artist's life, and his almost obsessive interest in her different moods and nuances of expression. Saskia was no beauty, but again and again he comes back to her face as if trying to understand: understand her, with her patrician background so different from his own; understand himself, and the first complete sexual love he had known.

Perhaps more enlightening even than the volume of work devoted to his new wife, is the artist's treatment of Saskia. First, he uses mainly paint: these are studies for others to see, not simply private meditations [IX]. In all the portraits he invites us to look up to her, admire her, stand in awe of her – just as he does. This is true whether he is painting her as the goddess Flora with a crown of flowers, as Bellona the consort of Mars, or simply as an imposing woman, perhaps a queen, with sumptuous robes and marvellous jewellery.

During the same period many of Rembrandt's self-portraits are, in a sense, complementary to those of Saskia [VIII]. He presents himself as a noble soldier, a man of power, sometimes with a hint of the self-parody of 'portrait with a poodle'. But the image of himself most consistently shown to us – the image, we feel, he would most like to be true – is dignified and sobre. In these self-portraits his clothes are plain with the recurring element of a gold chain, symbolizing wealth and quiet authority. This is a fitting husband for Saskia van Ulenborch, and it is certainly the way Rembrandt chose to look at this time.

Although portraits still formed the greater part of his work, and continued to bring in a large and steady income, he was all the time developing the other aspects of his art. Many etchings and drawings on a wide range of subjects were completed during these years, including genre scenes and Bible illustrations. Nor had he neglected history painting, and it was props bought for these – helmets and exotic costumes – which allowed him to make use of fantasy in the portraits of himself and Saskia.

The fantasy element in the self-portraits produced in the early 1630s has been neglected by art historians who have preferred to take them at face value, thus perpetuating the 'coarse-grained miller's son with an inferiority complex' myth cycle of the early biographers. It is true that there was a good deal of vanity in Rembrandt's personality, and it is also clear that he was to some extent in awe of his patrician wife. But to suggest that he attempted to improve the world's opinion of him by presenting himself as a pantomime prince is absurd. An intellect as powerful as his has other fish to fry. The 'fantasy' self-portraits [43] are a relief from the tedium of producing austere, almost mono-chromatic, portraits of the bourgeoisie of Amsterdam; they are self criticism and self analysis; they are also a questioning of the whole process of portrait painting, and of the idea that the

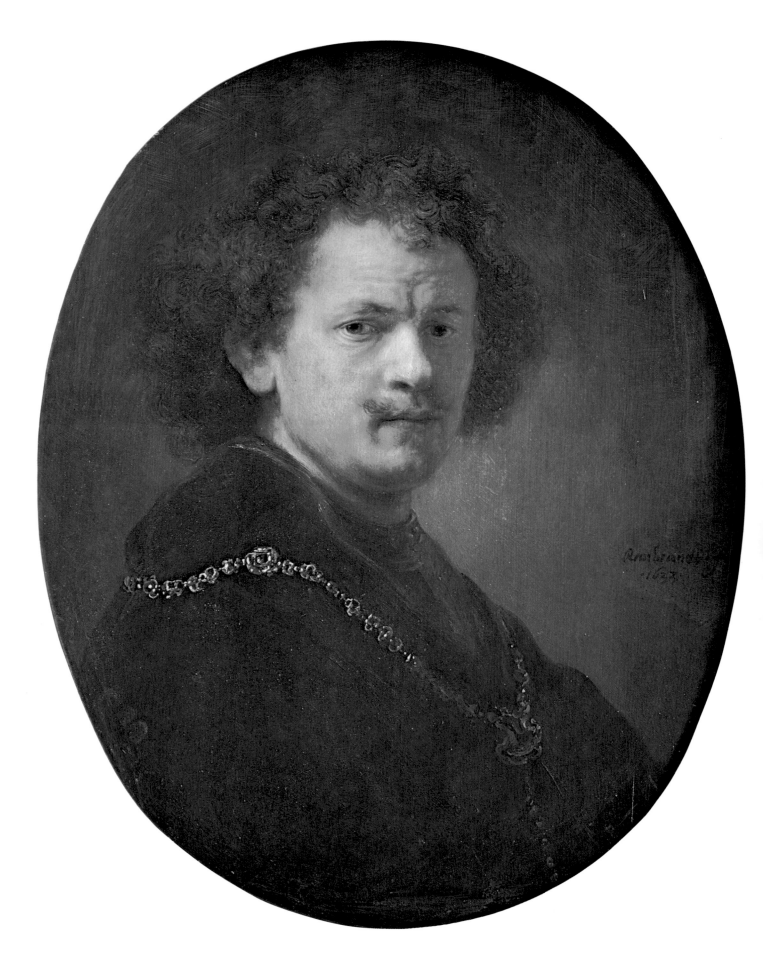

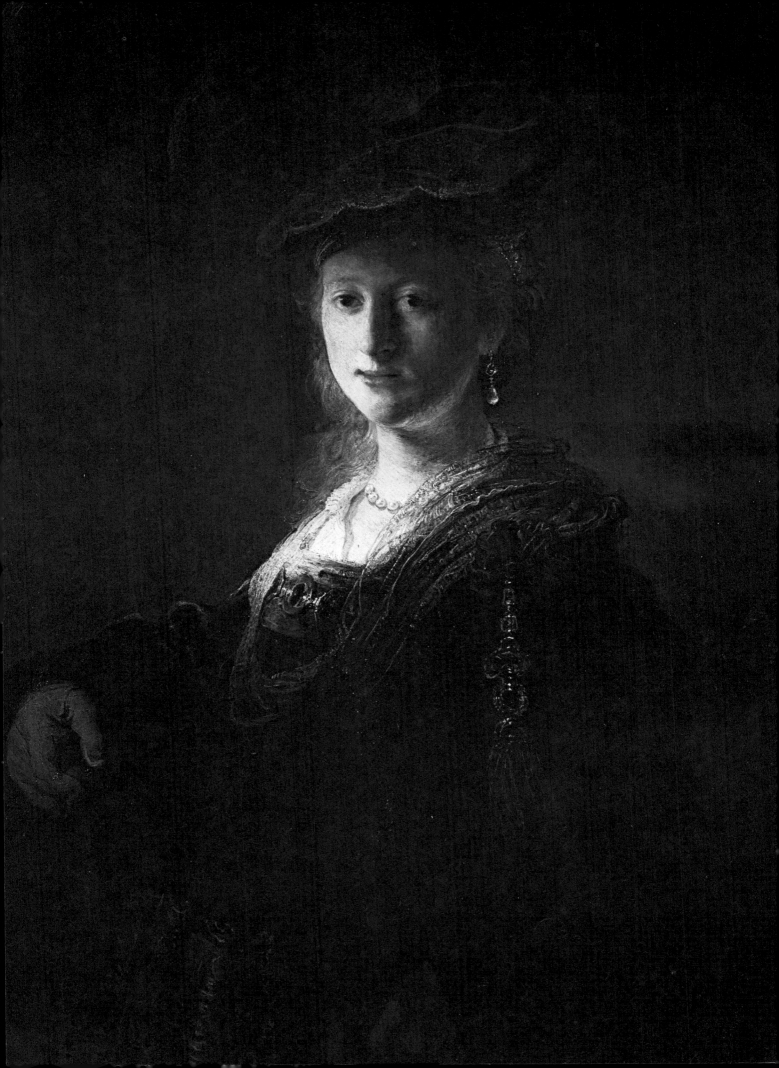

human face reveals personality and character (in art, the invention of Jan van Eyck in Flanders). Beyond that these rather uncomfortable self-portraits are an attempt to understand the nature of human personality itself.

Rembrandt's passion for collecting all kinds of exotic bric-a-brac both out of interest and for use as props was mentioned by Baldinucci: 'He often went to public sales by auction; and here he acquired clothes that were old-fashioned and disused as long as they struck him as bizarre and picturesque, and those, even though at times they were downright dirty, he hung on the walls of his studio among the beautiful curiosities which he also took pleasure in possessing, such as every kind of old and modern arms – arrows, halberds, daggers, sabres, knives and so on – and innumberable quantities of exquisite drawings, engravings and medals, and every other thing which he though a painter might ever need.'

It is significant that Baldinucci then elaborates on Rembrandt's passion for collecting art: 'He deserves great praise for a certain goodness of his, extravagant though it be, namely, that, for the sake of the great esteem in which he held his art, whenever things to do with it were offered for sale by auction and notably paintings and drawings by great men of those parts, he bid so high at the outset that no one else came forward to bid; and he said that he did this in order to emphasize the prestige of his profession. He was also very generous in lending those paraphernalia of his to any other painter who might have needed them for some work of his.'

Rembrandt spent heavily throughout this period, and his name frequently appears among the lists of buyers at auctions. His own income was considerable, but he certainly made use of Saskia's dowry in addition. This fact did not escape the notice of some members of her family who were quick to accuse him of squandering van Ulenborch money. Rembrandt was furious and sued them for slander. In court the couple stated that they were 'abundantly blessed with riches' and denied wasting Saskia's inheritance. But their case was dismissed when the relatives denied having said that they had been spending in a 'flaunting and ostentatious manner'.

In the famous double portrait [v] painted in 1635 or 1636, many of the themes of Rembrandt's life and art during the first years of his marriage merge. It is a painting with many different levels. To his critical in-laws it presents Saskia – dignified and a little embarrassed – with her ill-bred husband toasting his possession of her, parading it before them just as he parades the costly clothes and weapons, and the sumptuous food on the table, which he also owns. To the artist it is a means of self-analysis, a way of testing the validity of adverse criticism by skilfully and faithfully presenting the other point of view.

But the painting is also an allegory. The image of a laughing man with a woman on his lap had an established meaning in Dutch art: it alludes to the Prodigal Son of the parable, sampling

56
Titia van Ulenborch was Saskia's favourite sister, and a regular visitor at her home in the Breestraat. Rembrandt too was fond of Titia, and his study of her sewing with the aid of pince-nez gives the impression of a reliable, good-natured person.

the joys of the world before his homecoming. Is Rembrandt
saying at one level that he has strayed from his right course and
longs for his spiritual homecoming? Certainly, the period of his
greatest material success was also a time of inner conflict. In the
album of Burchard Grossman, a German merchant who visited
the house of Hendrick van Ulenborch in June 1634, Rembrandt
wrote:

> Een vroom gemoet
> Acht eer voor goet
> (A devout soul puts honour before gain)

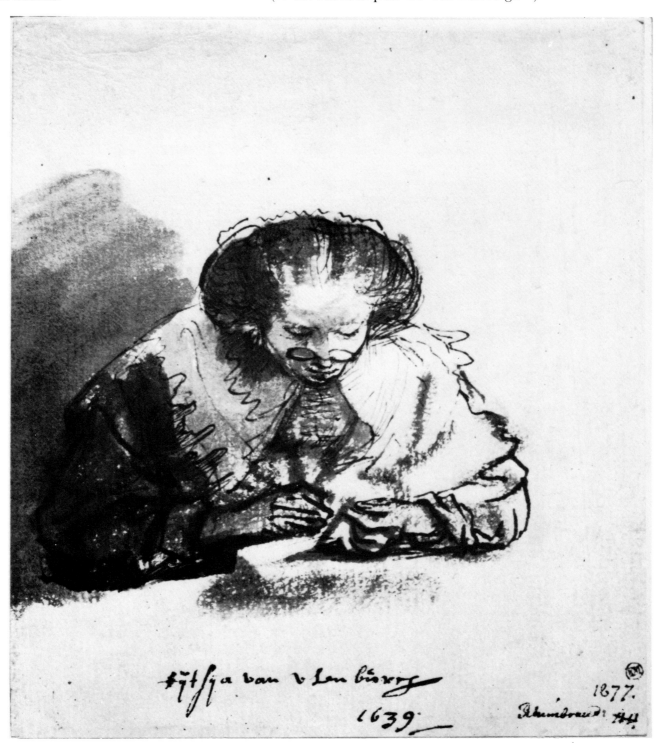

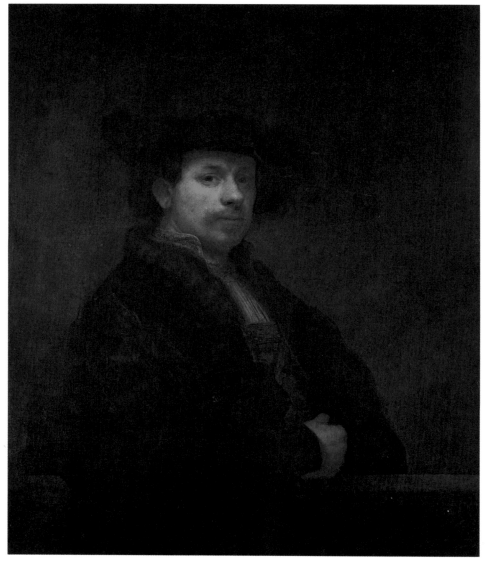

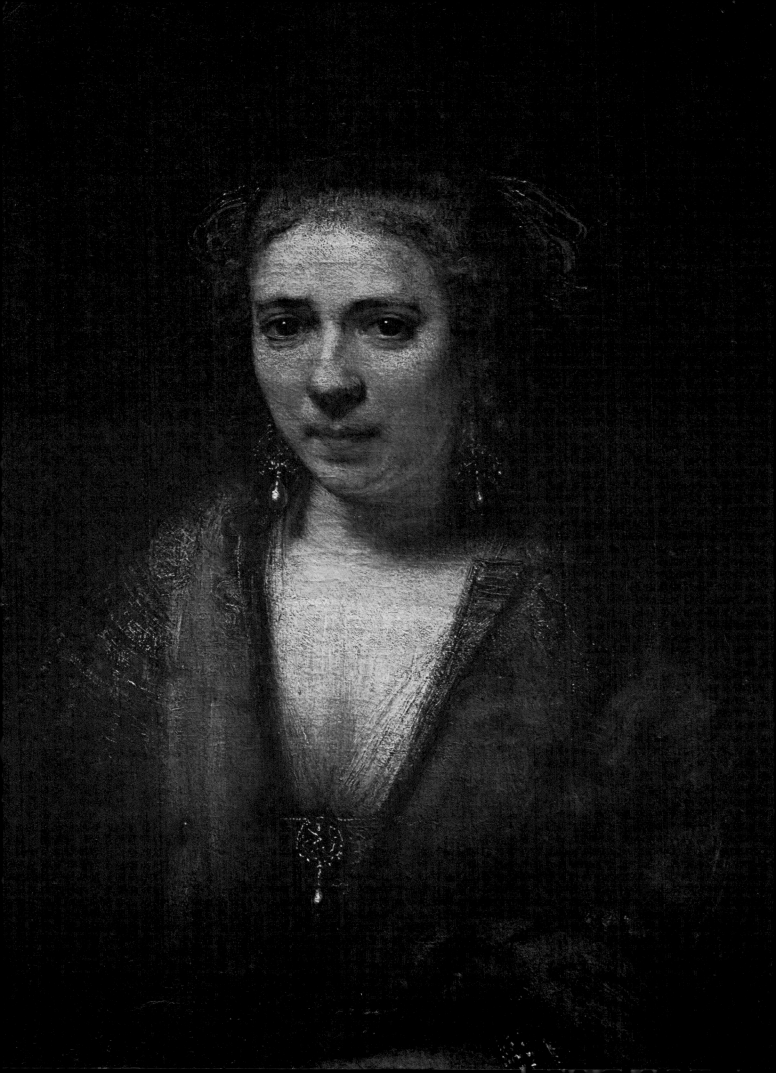

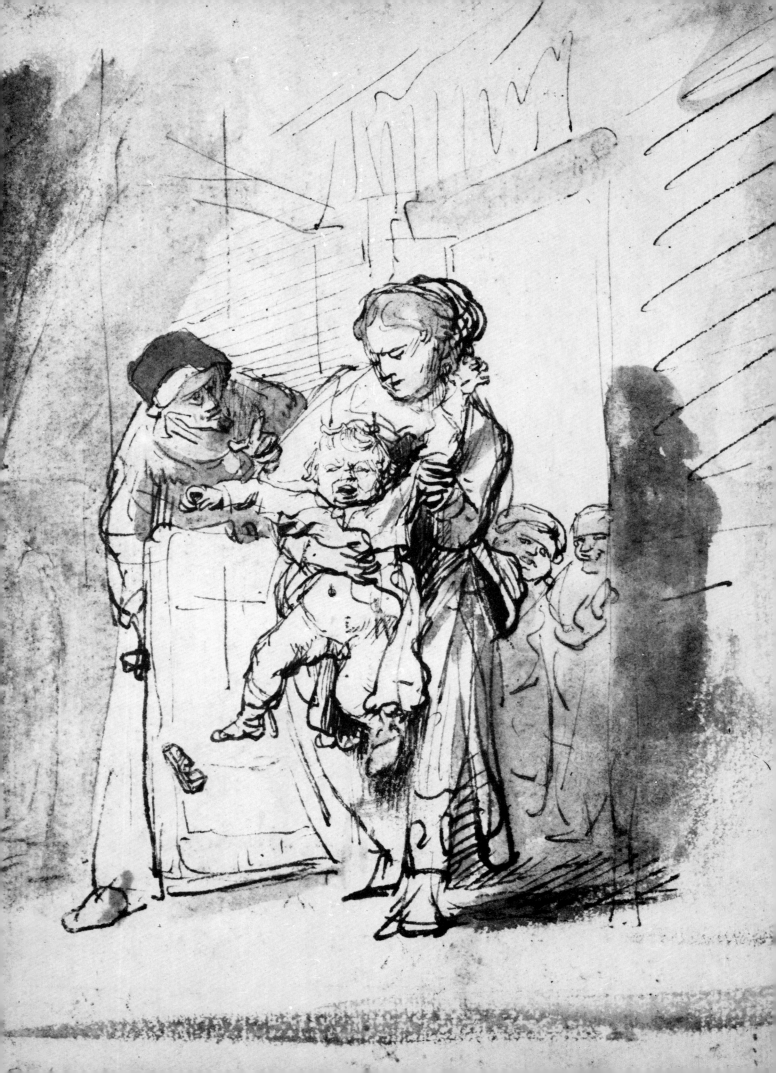

Chapter 6

Fame and tragedy

In December 1635 the house in the Breestraat was alive with activity. A constant stream of neighbours and friends called in to give advice, leave the traditional gifts, and eat the cakes and other delicacies which the servants had prepared for them. Upstairs, above all the noise and excitement, Saskia lay on her marriage bed in a dimly lit room awaiting the birth of her first child. Months earlier a smouldering cord had been held beneath her nose which had made her sick, and the local midwife had pronounced her pregnant. For six weeks she had fasted according to the normal practice, and now she lay gazing at the magnificent baptism robe, the wooden cradle and the neatly folded baby-linen waiting for the contractions to begin.

Rembrandt's first son, Rumbartus, was baptized on the 15th December. Two months later, on the 15th February, 1636, he was buried. By this time the family had moved from van Ulenborch's home to a newly-built house in the Doelenstraat which runs parallel to the River Amstel. It must have seemed a large and empty house after the death of Rumbartus [59], but they had many Jewish friends from the Breestraat to visit them and Herman Doomer the frame-maker and his wife who had six children of their own, could reassure them for the future.

At this time, and throughout the 1630s, Rembrandt continued to receive commissions, either directly or indirectly, from Constantyn Huygens. He painted Maurits Huygens, Constantyn's brother, who was Secretary to the Council of State in The Hague. There was also a dashing portrait of Anthonis Coopal who was a secret agent of the Stadtholder working directly for Constantyn. But Huygens may not have played an active part in this commission since Coopal's brother François was married to Saskia's sister Titia. Both brothers and sisters had a close relationship, and Titia was a regular guest at Rembrandt's home.

The most important commission to come from Huygens was for a series of five paintings showing different scenes from the Passion of Christ. The paintings were intended for the Prince of Orange, Frederick Henry, who was furnishing several residences at this time: it is probable that the Passion series was commissioned specifically for the Noordeinde Palace at The

57 *left*
'Child having a tantrum' is a universal image. Rembrandt has recorded a domestic incident which crosses the barriers of time, class and culture.

58 *above*
Herman Doomer was a gilder and frame-maker, and a good friend to Rembrandt. His business brought him into regular contact with the artist and one of his six children, Lambert, was an apprentice in Rembrandt's studio.

65

59
Rembrandt made this drawing of his first son Rumbartus on his deathbed.

Hague. Huygens, it seems, did not merely recommend Rembrandt to Frederick Henry, he was also responsible for supervising the work. It is for this reason that Rembrandt wrote the famous 'seven letters' to Huygens. Biographers have tended to make much of this correspondence as the only sizeable piece of written evidence which has come down to us. This literary grasping at straws has given the letters a rather undeserved importance. They are typical letters from an artist to his patron, rigidly following the prescribed rules for communicating with a superior with formality, gratitude and obsequiousness mixed together in fixed proportion like a rather indigestible cake recipe.

The sixth letter [61] is the most interesting, because having had his payment for the work ruthlessly reduced, and after making stylistic concessions to the taste of his patron which could not have been comfortable, Rembrandt's evident irritation and anger becomes apparent, even within the confines of contemporary letter writing. It is important to remember that the uncompromising artist was writing to one of the most powerful and influential men in the United Provinces (see the translation on page 68).

The letters are all written in Rembrandt's energetic and powerful handwriting, which contrasts with the characterless

66

tone of most of the correspondence. The Passion series marked the end of his relationship with Constantyn Huygens, and the final sentence of the seventh letter was to be the last communication between them: 'With this I cordially take leave of my lord, and express that God may long (keep) your lordship in good health and bless you (Amen)'.

Huygens had played a vital part in Rembrandt's career and he had been a useful and loyal admirer of his art. But there is no doubt that he treated him badly over the Passion series. Rembrandt's art was changing, and it was not changing in a way that would have pleased Huygens, but this does not fully explain the rift between the two men. He did not even want to accept as a gift Rembrandt's 'Blinding of Samson' – a piece of High Baroque *gran guignol* especially painted for Huygens who liked violent and terrifying subjects. And years later, when Rembrandt died, the fact was not even recorded in Huygens diary where even relatively minor events are noted. Whatever the

60
The newly-built house in the Doelenstraat where Rembrandt and Saskia moved in the spring of 1636.

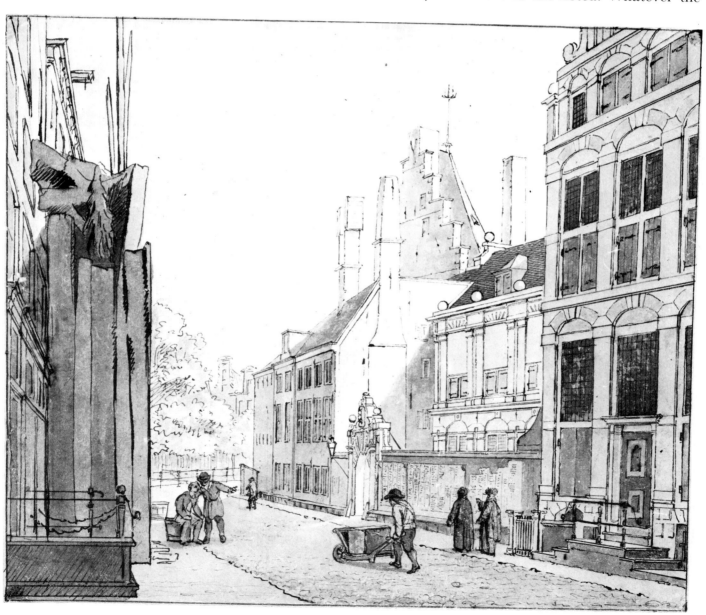

67

Honoured Lord

I have confidence in the good faith of your lordship in everything and in particular as regards the remuneration for these last two pieces and I believe your lordship that if the matter had gone according to your lordship's pleasure and according to right, there would have been no objection to the price agreed upon. And as far as the earlier delivered pieces are concerned, no more than 600 carolus guilders have been paid for each. And if His Highness cannot in all decency be moved to a higher price, though they are obviously worth it, I shall be satisfied with 600 carolus guilders each, provided that I am also credited for my outlay on the 2 ebony frames and the crate, which is 44 guilders in all. So I would kindly request of my lord that I may now receive my payments here in Amsterdam as soon as possible, trusting that through the good favour which is done to me I shall soon enjoy my money, while I remain grateful for all such friendship. And with my regards to my lord and to your lordship's closest friends, all are commended to God in long-lasting health.

Your lordship's humble and affectionate servant
Rembrandt

reason, it is sad that the first man to fully appreciate Rembrandt's genius should, finally, have failed to understand the developing art and turned his back on the man.

But if Rembrandt lost one friend during these years, he gained another. In one of the letters to Huygens he says: 'The tax collector, Uytenbogaert, paid me a visit when I was busy packing the two pieces. He wished to have a look at them first. He said that if it pleased His Highness he was prepared to make the payments from his office here.' Jan Uytenbogaert (who was related to the Arminian preacher) was the Receiver-General, and making full use of his official position he pursued the Treasury on Rembrandt's behalf. This act of kindness touched the artist and marked the beginning of their friendship. Evidence in the graphic work indicates that ten years later Rembrandt was a regular visitor at the Uytenbogaert country home outside Amsterdam.

While working on the first paintings for Frederick Henry Rembrandt completed two of his most remarkable nudes:

61
The sixth letter Rembrandt wrote to Constantyn Huygens, with its heavy scoring and powerful Baroque handwriting.

Voorde Heer

Vl vertrouwe ick alles goets toe ende sonderheijt
vant bekoomen oberdees Souts die sterken[?] vertrouwende
vl dat Hooft[?] naer der ginnst ende naer recht
ginck te aensonden geen teegenseggin inde voorschreven
prijs niet weest ende wat aengaet de voorijge
geleverde stucken en sijn niet Hooger betaelt als
600 h: guldens ider ende also sijn Hoogheijt
mee goede voogen tot Hooger prijs niet en is te beweege
also vl sijt kennelick meerijtens met 600 h: guldens
ich van ider te vreden stellen mits dat ich mijn rot gelt[?]
de van 2 lijsten en de had dat somme 99 guldens is
moght bij geordijneert werde. Soo soude ich oock
mijn seer vriendelick versoucken dat nu met den eersten
moght mijn betaelingen als hier tot Amsterdam sabben
vertrouwende dat door de goede ginnst die aen mijn
geschijt soo nu eerst danckt sal ghenieten mits
dat ich verbennelick voor alsulcken vrienschap blijven
sal ende naer mijn Hartelicke groetenisse
aen mijn Heer ende aen vl noeghtes vriende alle
u: in langh durighe gesontheijt bevoole

Vl aen ge affsionerde Diennaer

Rembrandt

dijt februarij
1639

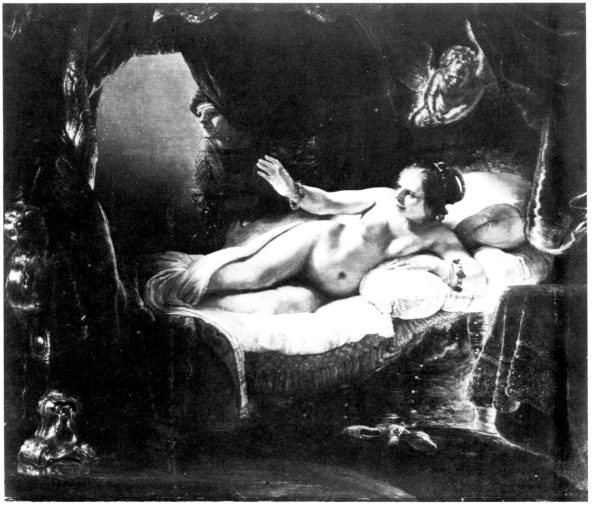

'Danaë' [63] and 'Susannah bathing'. Both are quite unlike his earlier nude studies. Although there is nothing of the 'grand manner' about either Danaë or Susannah – despite the mythical origins of the former – and they are quite believable as human beings, they are intended to look both beautiful and erotic. Rembrandt's Danaë is infinitely more erotic than Titian's complaisant creature whose perfect proportions serve only to reduce the sensuality of the scene by fixing it firmly in never-never land. Rembrandt's woman is accessible; with her half-formed breasts and clear skin she might be the girl next door welcoming Zeus, in the form of a shower of gold, to take her. The hand raised in invitation is the final detail: affirmation of female sexuality has been understood as an essential ingredient of eroticism by every expert in the genre from Ovid to Frank Harris. 'Susannah' is simpler: although a consummate work of art it is in reality 'what the butler saw'.

Rembrandt seldom painted nudes and, probably because of the puritan taste of his time rather than his own interests, his other studies of the female form are rarely erotic in tone. 'Danaë' and 'Susannah' have to be seen as a celebration of his own physical love for his wife. We know from the portraits that Saskia could not have been the model for either painting, but she was, without doubt, the inspiration for them. They are a tender statement of the joy and pleasure he found in her body.

Tragically, they were also, to some extent, retrospective. In 1638 Saskia gave birth to her second child, Cornelia, who was baptised on the 22nd July. Only three weeks later, on the 14th August, the child was buried. It is probable that Saskia was not very healthy anyway – it has been suggested that she was consumptive, and her attitude in some of the informal portraits does suggest this. Her two confinements, and the psychological shock of losing both infants, was beginning to take its toll. With great bravery Rembrandt recorded these changes in his wife.

He knew it was likely that paintings would one day belong to someone else, and multiplicity was the whole point of etching. But in his drawing, which is the most spontaneous medium, Rembrandt records both the ephemeral, unimportant things and his most intimate, private concerns. In some respects he is similar to contemporary genre artists in much of his drawing: a child having a tantrum, a procession, beggars at a fair. But he also makes studies at home: charming subjects such as 'Young woman at her toilet' [52] which is drawn with bold impulsive lines and wash. There are also, as the decade progresses, more and more drawings of Saskia in bed [69]. These cannot all be studies made during her confinements, nor is she generally sleeping – she is ill. Often a nurse sits dozing or sewing at the foot of the bed. Saskia's face is sometimes drawn and emaciated, sometimes puffy: the eyes, more often than not, have the hopeless, dull appearance of the chronic invalid [68]. With infinite pity and terrible skill, Rembrandt records the physical deterioration and gradual weakening of the woman he loves.

62
Anything and everything is the proper study of art. Rembrandt saw nothing incongruous in making studies of Saskia ill and weak in bed on the same sheet of paper with random genre studies. After all, life is the same kind of synthesis of events.

63
Saskia, during the first years of their marriage, had been the inspiration for Rembrandt's beautiful 'Danaë'. He must have hidden it as her illness progressed, and the picture became a mockery and an unbearable reminder of her physical decay.

71

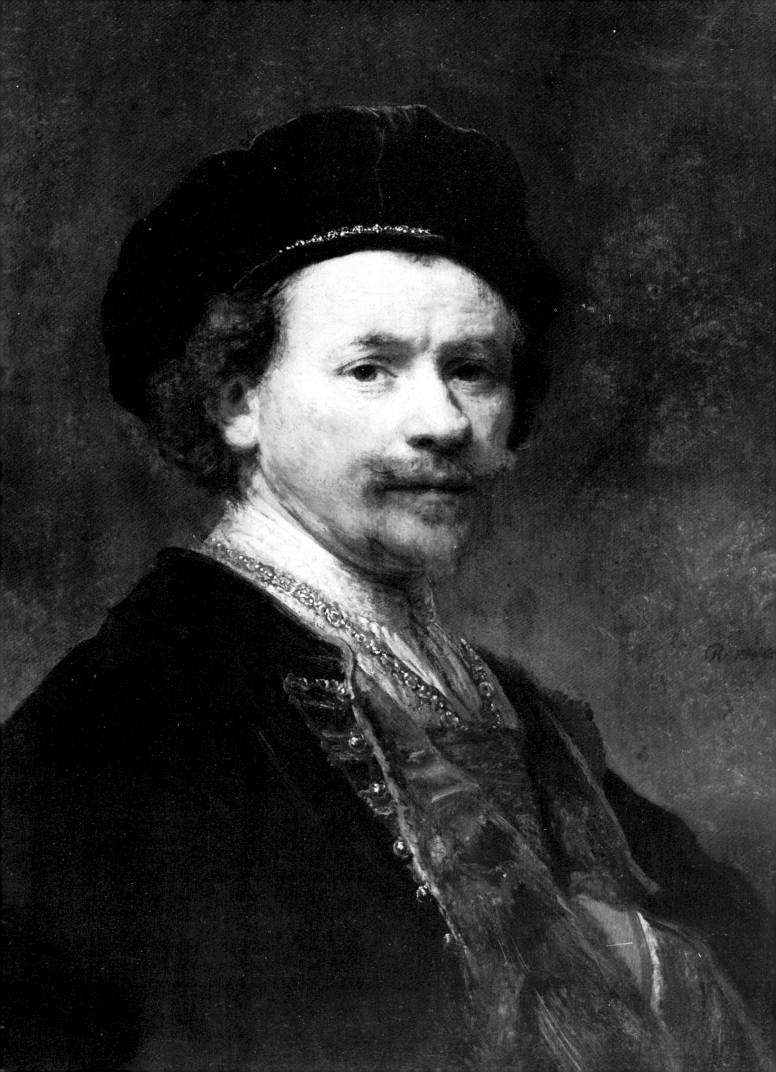

Chapter 7

Parting

ON THE 1st MAY 1639 Saskia and Rembrandt moved from the Sugar Refinery on the Binnen Amstel where they had been living temporarily to a fine house in the Breestraat. It was an extravagance they could not afford, but perhaps Rembrandt believed that it would prevent Saskia from dwelling on death and illness and give her a new interest. It was a move back among old friends, and next door was van Ulenborch's house where they had spent the first carefree years of marriage. The purchase price was very high, 13,000 guilders – Rembrandt scraped together a deposit of 1200 and took out a heavy mortgage committing himself to repay a further 1200 guilders after six months, 850 guilders on the 1st May, 1640, and the remainder over the next five years.

To augment his income at this time, and no doubt to broadcast his ideas of style and technique, Rembrandt took on an increasing number of pupils. Von Sandrart reports that fortune 'filled his house in Amsterdam with almost innumerable young people of good families, who came there for instruction and tuition. Each of these paid him annually 100 florins; and to this we must add the profit which he made out of the pictures and engravings of these pupils of his – amounting to some 2000 to 2500 florins each – and his earnings from his own handiwork. Certain it is that if he had been able to keep in with people, and look after his affairs properly, he would have increased his wealth considerably.'

Houbraken also discusses Rembrandt's pupils, but in a lighter vein than von Sandrart: 'commissions flowed to him from all quarters, as also a crowd of pupils, for whom he rented a warehouse on the Bloemgracht, in which he gave each a room for himself, often divided from that of others only by paper or canvas, so that everyone, without disturbing anyone else, could draw from life. Since young people, especially if there are many of them together, will sometimes get into mischief, so it happened also here. As one of them needed a female model, he took her into his room. This aroused the curiosity of the others, who, in order not to be heard, in their socks, one after the other, looked on through a chink in the wall made on purpose. Now it happened, on a warm summer's day, that both the painter and the model

64 *left*
Personal tragedy and a general air of preoccupation are apparent in this self-portrait. Although the clothes and bearing are those of a wealthy and successful man, Rembrandt's mind is obviously troubled.

65 *above*
The allegorical etching 'Death appearing to a wedded couple' is a terrible prophecy of what was to come, a subconscious attempt to come to terms with the inevitable.

stripped so as to be stark naked. The merry jokes and words which passed between the two could easily be retold by the spectators of this comedy. About this time there arrived Rembrandt to see what his pupils were doing and, as was his custom, to teach one after the other; and so he came to the room where the two naked ones were sitting next to one another. He found the doors closed, but, told about the thing, he watched for a while their pranks through the chink that had been made, until among other words he also heard, "Now we are exactly as Adam and Eve in Paradise, for we are also naked." On this he knocked on the door with his maulstick and called out, to the terror of both, "But because you are naked you must get out of Paradise." Having forced his pupils by threats to open the door, he entered, spoilt the Adam and Eve play, transformed comedy into tragedy, and drove away with blows the pretended Adam with his Eve, so that they were only just able, when running down the stairs, to put on part of their clothes, in order not to arrive naked in the street.' Rembrandt, who made etchings like 'The French Bed' [55], was no prude. But he obviously felt obliged to take some action for the sake of order. The humorous way in which he did so gives an interesting insight into his character.

At least fifty known Dutch artists were pupils of Rembrandt during his career, in addition to the numerous aristocratic dilettanti alluded to by von Sandrart. While inspecting their work he often made corrections, sometimes even over-painting and signing his own name. Other work was sold as the work of students, and on the back of one of Rembrandt's own drawings there is a note that he sold paintings by 'Fardynandus' (Ferdinand Bol) and 'Leenderts' (Leendert Cornelisz van Beyeren). Jacob Backer, Govaert Flinck and the brilliant Carel Fabritius all studied with Rembrandt, yet there is almost no signed work by them dating from the period of their apprenticeship. The reason is obvious: the selling of pupil's original work and copies was a remunerative business, and the paintings commanded a better price if they bore the signature of Amsterdam's most renowned artist. 'In this great city there is no one but I who does not go in for trade' complained Descartes.

Rembrandt continued to live at an extravagant pace, visiting sales and auctions, buying prints, paintings, Venetian glass, Chinese porcelain, Japanese fans – anything which caught his eye, and which he could take home to Saskia for decorating their new house. At this time Amsterdam was the centre of the European art trade, and major collections, especially from Italy, were sent there to be sold. A particularly important sale took place in 1639, at which several important Italian paintings were acquired by the collector Alphonso Lopez. Although for once he bought nothing, Rembrandt made a hasty sketch of one item [66], beside which he wrote 'The Count Balthasar Castiglione by Raphael, sold for 3500 guilders.'

The underbidder for the portrait was Rembrandt's biographer Joachim von Sandrart, but he could not hope to compete

66
Rembrandt was a compulsive purchaser of art and curios, attending all Amsterdam's important auctions. During the sale of 'The whole cargo of Lucas van Nuffeelen' he made this rough drawing of one item which particularly interested him: beside the sketch he wrote 'The Count Balthasar Castiglione by Raphael, sold for 3500 guilders'.

with Lopez – an immensely wealthy Sephardic Jew with an interest in all aspects of Amsterdam's trade, and an agent of Cardinal Richelieu. At the auction Rembrandt must have spoken to Lopez who was an important collector and already owned his early painting 'Balaam and the Ass'.

Raphael's portrait of Castiglione had a profound effect on Rembrandt, and he used it as the basis for two self-portraits: an etching and a painting. In the etching he presents a calculated image to the world: a prosperous artist, mature and self-assured. This is the persona. But in the painting [xi], which he completed the following year, although he retains the same pose the expression is radically different. The eyes and the mouth hint at personal tragedy.

In July of that year Saskia had given birth to a second daughter, also christened Cornelia. Her baptism took place on the 29th July, 1640 and she was buried on the 12th August. The death of their third child in early infancy was a bitter blow to both parents, and Saskia gave herself up to illness and despair.

67
The Mennonite preacher Cornelis Claesz Anslo belonged to the 'Waterlanders' – one of the more liberal Anabaptist groups. He was friendly with Rembrandt, who nevertheless painted this penetrating study of the man's temperament. The preacher dominates the picture, just as he dominates the discussion and his wife. She looks weary, depressed by the sheer size of her husband and the weighty Bible from which all his irrefutable arguments are derived.

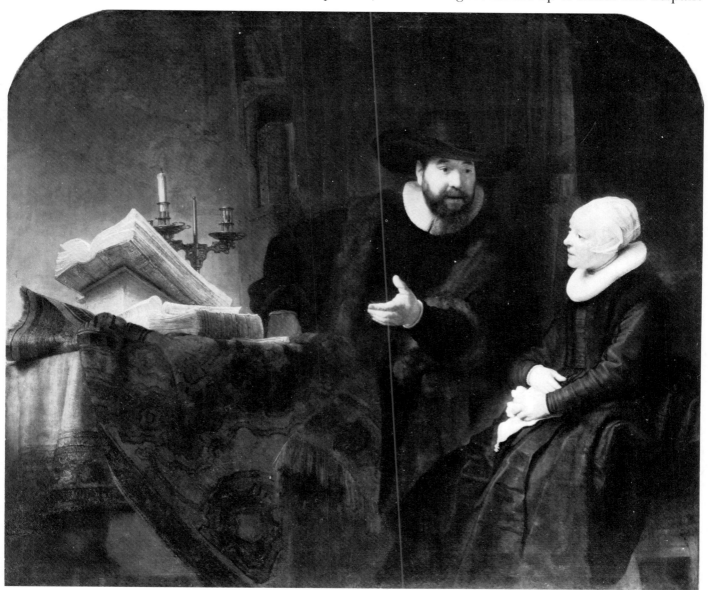

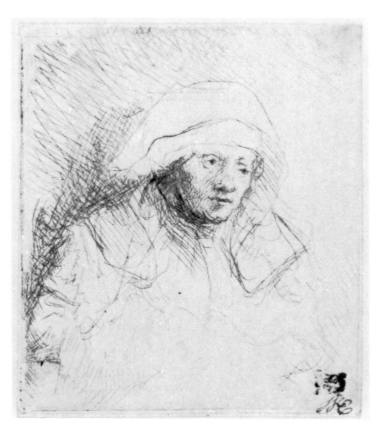

76

Drawings of her which Rembrandt made at this time could be of a woman twice her age.

Then, in September, his mother died. Towards the end of her life Rembrandt had seen less and less of her, because she appears only infrequently in his work. He had probably asked her to come and live with them in Amsterdam in her old age, but she was a strong-willed woman who knew she would be happier among those of her own class in Leyden, cared for by Lysbeth and the dependable Adriaen.

His mother was a more potent force in the artist's life than his father, and with her death he must have felt that the last link with his family and Leyden was broken (in later years he painted Adriaen's portrait once more, but they could only have been strangers to each other). To Rembrandt his mother was the 'prophetess Hannah' or some other Old Testament matriarch: time and again he portrayed her reading the Book of Books, the great family Bible which through her gave him his faith and an intensely human 'mythology' which he could use for his art. Terrible as her death must have been to him it did not mark the end of her influence, which remained active and vital throughout his creative life.

Allegory was a device seldom used by Rembrandt, but an etching completed at the end of 1639 seems to be a subconscious attempt to prepare himself for what he knew was to come [65]. 'Death appearing to a Wedded Couple from an open Grave' is unbearable to us with the benefit of hindsight but it may have helped to make reality bearable for the artist. The traditional figure of Death confronts the young wife with an hour-glass to show that her time has come. The attitude of the husband is one of affected unconcern, he conceals his grief so as not to distress his wife. For her part she seems unaware, uncertain, as if being introduced to someone. We have seen a similar hat before, and the flower: it is Saskia.

It must have been with a weary feeling of inevitability that Rembrandt and Saskia learned that she was pregnant again in the spring of 1641. Saskia's favourite sister, Titia [56], died at about this time. Rembrandt struggled to keep his sick wife hopeful and occupied. He made a portrait of her inspired by Titian's 'Flora'. He presents her as plump, and young. She is holding a flower. It is a work of imagination, designed to keep up his wife's spirits. His drawings, which Saskia would never see, recorded the truth.

Titus, their only surviving child named in remembrance of Titia, was born in September 1641 and baptized on the 22nd September. But Saskia was too weak to recover, even for her new son. All through the autumn and winter she fought a losing battle, becoming weaker all the time. A nurse had to be employed to care for the child. Spring brought no new hope, and on the 14th June, 1642 Saskia died. Five days later she was buried in the Oude Kerk. At her death she was not yet thirty years old.

68
The awful last study: it is impossible to understand how Rembrandt brought himself to draw it.

69
Although Saskia was probably consumptive, there is little doubt that her pregnancies together with the psychological shock of losing her babies contributed to her decline. The wicker basket on the floor was used by nurses, and this is clearly her lying-in room. The huddled figure on the bed is like a terrible parody of his young wife.

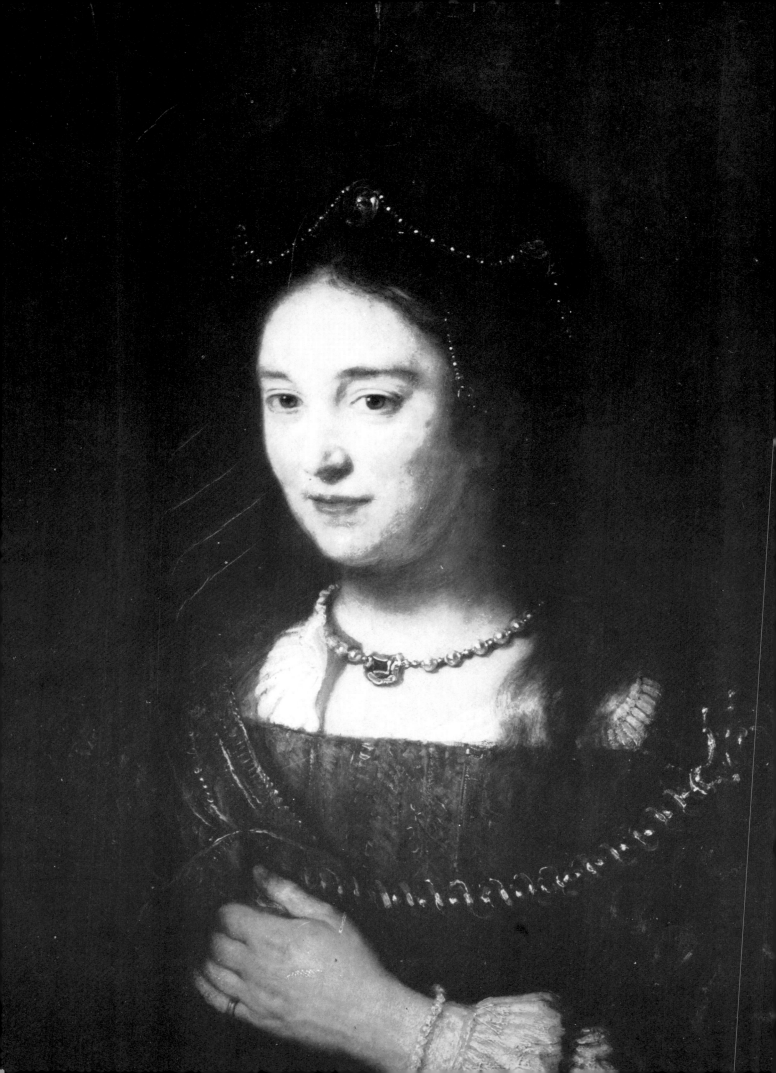

Chapter 8

Widowhood, and a new mistress

AN ARTIST's life and work are reciprocal: they give and take, to and from each other. The tragedies of Rembrandt's life changed his art. The decade following the death of Saskia was not only a time of stylistic transition: developing together with this was a new insight and understanding. Art also gave life something. In the year of his wife's death he completed the boldest composition he had ever attempted—'The Night Watch'. The painting [73] was as large (13 feet by 16) as it was revolutionary, and Rembrandt was able to totally immerse himself in work.

The correct title of the picture is 'The Company of Captain Frans Banning Cocq and Lieutenant Willem van Ruytenburgh'. By the time it was painted the militia companies of Amsterdam were no longer called upon to defend the city ramparts, they had become select social clubs for wealthy burghers. A list of eighteen names added to a shield in the background after the painting was completed suggests that these were the men who commissioned Rembrandt to do the work, although documentary evidence states that only sixteen were expected to contribute financially: 'each paid 100 guilders, some a little more, others a little less, according to the place they occupied in the painting'. All the guardsmen would have been familiar with 'The Anatomy Lesson of Professor Tulp' [47] which the artist had painted ten years before, and in choosing Rembrandt for the commission they could not have expected a run-of-the-mill group portrait. But they could not have expected the Baroque masterpiece with which they were presented: Rembrandt plucks the unsuspecting burghers out of commonplace reality, lights them like a stage producer, and sets them down in a vortex of movement, noise and colour.

The title 'Night Watch' was only given to the painting in later years. It suffered, like so much of his work, from an over-generous application of toned varnish by later restorers who attempted to both protect the painting from damage and to 'blend' the colours according to the taste of their day. When the painting was cleaned after the Second World War the newspapers renamed it the 'Day Watch'. An occasion which should have made John Ruskin blush in his grave: 'It is the aim of the best painters to paint the noblest things they can see by sunlight, but of

70 *left*
Rembrandt's posthumous portrait of Saskia had little to do with her actual appearance, but for Geertge it must have been a potent image, almost an icon, of the woman whose place she hoped to take.

71 *above*
Rembrandt's study of a peasant woman in the regional costume of Zeeland was traditionally thought to be Geertge Dircx. But it is likely that the inscription on the back of the drawing refers to an earlier nurse of Titus.

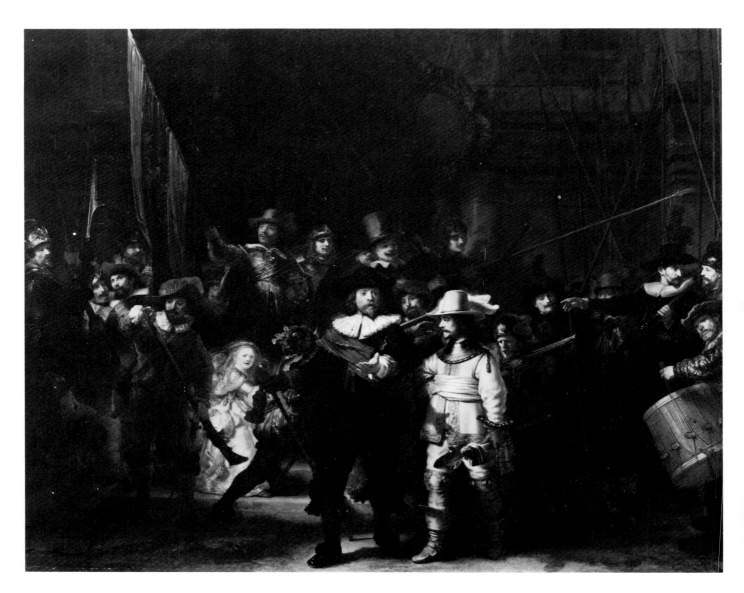

Rembrandt to paint the foulest things he could see by rushlight.'

Because the 'Night Watch' is traditionally (and erroneously) supposed to have been the turning-point in the artist's fortunes, its reception by its patrons and contemporary critics has been the subject of much research and controversy. Van Hoogstraten who studied under Rembrandt at the time writes: 'Many people were of the opinion that, instead of presenting a series of individual portraits which he had been commissioned to do, the artist took his own wishes too much into consideration. Nevertheless, whatever shortcomings this work may be reproached with, it will outlive all its competitors. It is so striking in pictorial conception, so animated in movement and so powerful that, in the estimation of some, all the other canvases which hang beside it in the hall of the Civic Guard are made to look like playing cards.'

Obviously the painting had a mixed reception. Captain Frans Banning Cocq was pleased, which is not surprising since he is the 'centre' of the vortex and is easily recognisable. Other sitters, who had all paid 100 guilders, and whose portraits were subordinated to the needs of the total composition, could not have shared in the enthusiasm which prompted the Captain to have the painting copied for his family album [72]. Nevertheless it was hung in a prominent position at the Guards' headquarters in the Kloveniersdoelen near the house in Nieuwe Doelenstraat where Rembrandt and Saskia had lived.

Saskia's death left her husband with many practical problems to solve in his grief. According to common law half of the joint estate belonged to Rembrandt; in her will Saskia left her half to Titus, while permitting her husband to use it as he wished until their son's coming of age or marriage. She specified that it was not necessary for the customary inventory of the estate to be made, because she was confident that Rembrandt would carry out her intentions. All of this was satisfactory, but Saskia did not

72
Banning Cocq had a coloured drawing of 'The Night Watch' made for his family album. Beside it is the inscription 'sketch of the picture in the Great Room of the Civic Guard House, where the young Seigneur of Purmerlandt [Banning Cocq's official title] as Captain orders the Lieutenant, the Seigneur of Vlaerdingen [van Ruytenburgh] to have his company march out.'

73
'The Night Watch' is one of the most famous paintings in art. Many of the patrons whose names were added to the picture at a later date are identifiable: the principal figure is of course Frans Banning Cocq with, to his left, the Lieutenant Willem van Ruytenburgh. Visscher holds the colours of the city of Amsterdam, with Sergeants Reinier Engelen and Rombout Kemp on either side of him. Three musketeers, whose names have been lost, demonstrate the procedures followed in firing their weapons.

74
Called 'the hundred guilder print' because of the high price once paid for it, this etching was completed towards the end of the 1640s. Paradoxically, at a time when he was persecuting Geertge Dircx, Rembrandt produced a subtle and powerful statement of Christ's compassion.

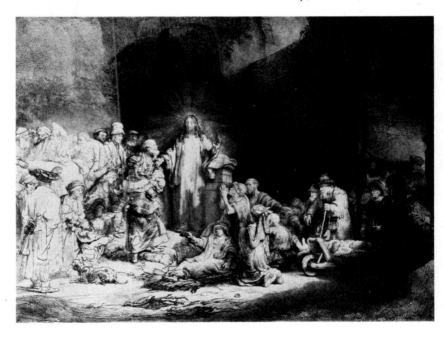

dream that her husband's popularity as an artist and consequent prosperity could come to an end. For this reason, and because it was impossible for her to imagine a situation in which he would have found it difficult to provide for Titus, she added a clause stipulating that if Rembrandt remarried her half of the estate would go to her recently widowed sister, Hiskje. That innocent and well-meaning afterthought was to cause much hardship and pain in the years to come.

In 1643 Rembrandt drew 'The Widower' [76], a wry comment on the problems facing him. It was impossible, even for a man with his energy, to paint, administer all his pupils and take care of a young baby. The answer was a nurse who would also run his household, and he found a woman who was prepared to take on the job. Geertge Dircx was the widow of a trumpeter called Abraham Claesz. Later Rembrandt was to regret the day he hired her; but she was genuinely fond of Titus (in her will, made some years later, she left him all her few possessions except for a portrait of her which his father had painted) and for the time being Rembrandt was free to devote all his energies to his art.

While he was making these efforts to cope with the practical problems raised by Saskia's death, through his painting Rembrandt was attempting to cope with his grief. He made one last portrait of Saskia some months after her death [70]. It is an intensely moving picture: beautiful, with a serene smile, this is not an image of the woman who died, but an evocation of the woman he loved, of the woman he wanted her to be, of the woman she once was, perhaps. As usual he adorns her with precious jewels and dresses her in rich fabrics, but the intention is quite different. It is a testimony of his love and respect. Another painting produced at the same time is 'David taking leave of Jonathan'. Its message is simple: a man must find strength to suppress his own grief for the good of those he loves. It is a sensitive and hopeful picture – the artist gives Jonathan his own features.

It is not accidental that a gradual loss of interest in the theatricality of the Baroque should coincide with this period in the artist's life. The house on the Breestraat seems to have become claustrophobic to him with its painful associations and domestic problems, and almost for the first time Rembrandt went out into the countryside ·around Amsterdam. It was the beginning of an interest in landscape that was to last for almost fifteen years. The suffering of the past years had served to intensify his insight and his artistic intuition. This new depth was reflected in all his art with a simplicity and naturalness he learned from his landscape studies of the Dutch countryside.

He continued to occasionally produce romantic, almost Gothic, landscapes in oils; but these ran against the mainstream of his work bearing as little relation to it as they do to the Dutch countryside. The real countryside, which he pursued with the tireless energy of that other great lover of nature, Paul Cézanne,

75
Rembrandt was fascinated by the bend in the River Amstel where it touches the Trompenburg estate, with the windmill 'Het Molentje' in the background. He walked there during all the seasons of the year to draw it in its different moods.

76
'The Widower' has all the unnecessary concentration of someone obliged by circumstances to do something for which he has no natural talent.

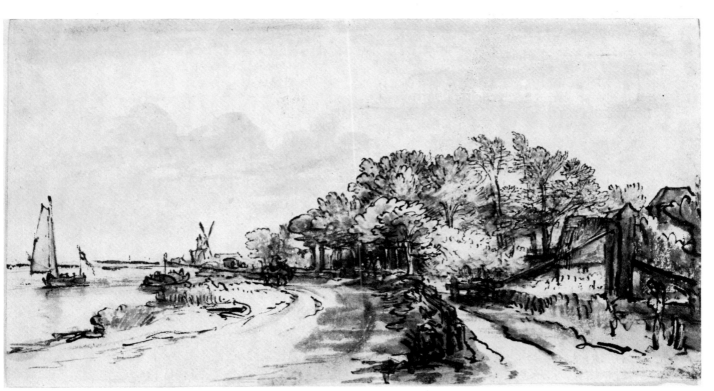

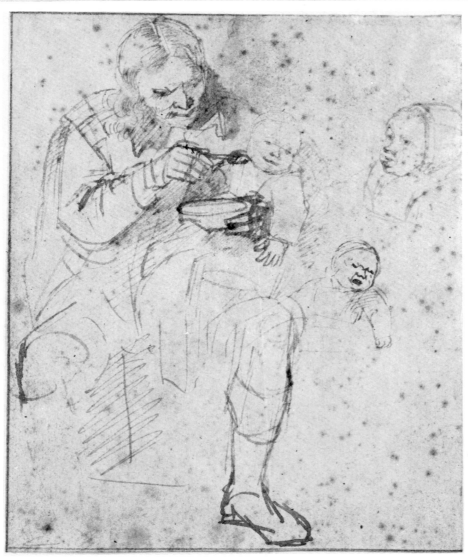

83

77
In Rembrandt's panorama of Amsterdam the only significant verticals are church spires, windmills, masts of ships, and the vast warehouses of the East and West India Companies. The international cartel is not a twentieth-century invention: the India Companies were quite as powerful as today's electronics and transport giants.

made different demands. Nature has to be simplified by an artist. Cézanne, as an Impressionist, used colour; Rembrandt used a shorthand of line and wash, which became simpler, and more intense, as the decade progressed [80]. Towards the end of the period he applied some of the 'shorthand' technique developed in drawing to the medium of oils. The result, incredibly, is reminiscent of Van Gogh, who said of him: 'In our Northern school there is Rembrandt, master of the school, since his influence makes itself felt no matter who approaches him.' Rembrandt's 'Winter Scene' [VI] is a remarkable anachronism, the kind of creative short-circuit which genius sometimes effects, and the sort of thing which prompted a comment made by the German Impressionist Max Liebermann: 'Whenever I see a Frans Hals, I feel the desire to paint; but when I see a Rembrandt, I want to give it up.'

The great volume of landscape studies made during the 1640s are also of interest as a record of contemporary Amsterdam and its environs. Rembrandt's first studies were views of Amsterdam. One, from the Kadijk, [77] shows the Oude Kerk and the mill on the Rijzenhoofd as well as the warehouses of the East and West India Companies. Their prominence on the city skyline recalls Constantyn Huygens' poem:

How com'st thou, golden swamp, by the abundance of heaven;
Warehouse of East and West, all water and all street,
Two Venices in one, where do thy ramparts end?

At the time the warehouses of the East and West India Companies stored produce brought from every corner of the world by a merchant fleet of more than 2000 vessels: business which in a good year showed investors a return of up to 500 per cent.

Later, during his transitional period, Rembrandt ventured further away from Amsterdam into the open country beyond. A favourite site was the wide bend in the River Amstel where there was a great ruined house called Kostverloren [75]. He made studies of the site at all times of the year: in winter interested by the quality of the light, and in summer by the shapes formed by the trees. It seems that Rembrandt sometimes took students with him on these excursions into the countryside. On the back of one study of his favourite spot his pupil Philips Koninck has written: 'This drawing shows the bank of the Outer Amstel, so bravely drawn by Mr Rembrandt's own hand.'

Among Rembrandt's landscapes are four drawings of English views: one of St Albans, another of Windsor, and two of Old St Paul's [79]. Although they are not topographically accurate, and are almost certainly studies of medieval architecture made for the backgrounds of some of the romantic landscape paintings which he produced in the 1640s, the English views have been linked to a curious reference made by Horace Walpole.

In his 'Anecdotes of Painting in England' published in 1786, Walpole retells a story given to him by the engraver and

antiquary George Vertue. 'Vertue was told by old Mr Laroon, who saw him in Yorkshire, that the celebrated Rembrandt was in England in 1661 and lived 16 or 18 months in Hull, where he drew several gentlemen and seafaring persons. Mr Dahl had one of these pictures. There are two fine whole-lengths at Yarmouth, done at the same time. As there is no other evidence of Rembrandt being in England, it was not necessary to make a separate article for him, especially at a time when he is so well-known and his works in such repute that his scratches, with only the difference of a black horse or a white one, sell for thirty guineas.'

George Vertue's story is extraordinary and, it should be said, unlikely to be true. But what would he, or anyone else, have to gain by the fabrication of an uncorroborated tale of this kind? Like most awkward facts relating to Rembrandt's life it has been the subject of considerable research and debate. The truth will probably never be known, and perhaps it is not very significant in any case. One irritating fact in the story is the mention of the ports of Hull and Yarmouth. Both were of course as likely to be

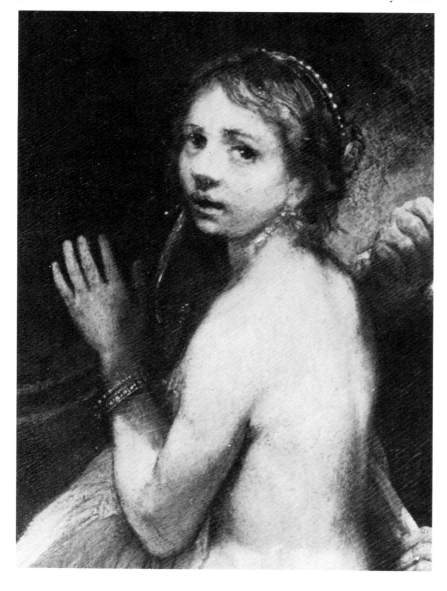

78
The face of Geertge Dircx, who bravely did battle with the memory of Saskia–and lost. Despite all that happened later, she cared for Rembrandt, and loved him, during the desolate years after the death of his wife.

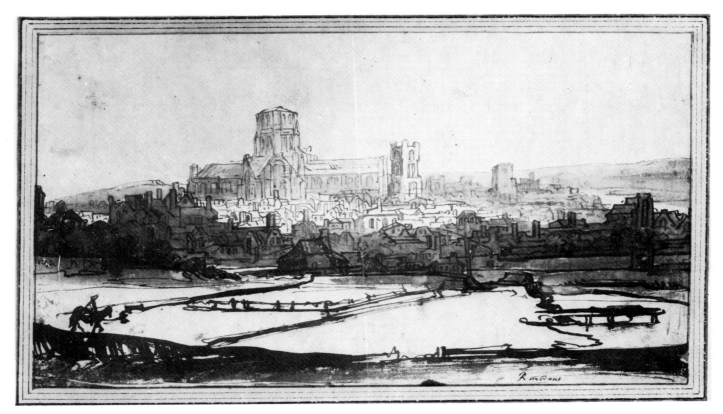

79
Rembrandt's study of old St Pauls. It is unlikely that we will ever know for certain whether the artist visited England or not.

called at by Dutch ships as any other North Sea port, but there were in fact stronger links with Holland. In the middle of the seventeenth century they were centres for the Dutch engineers and labourers who came over to drain the English fenland, and there was a regular traffic to and from Amsterdam. If Vertue's story is a lie, then it is a well constructed one.

Towards the end of the 1640s domestic problems of a different kind began to distract Rembrandt from his work. It had not been long before Geertge Dircx – who was a loving and untiring nurse to the growing Titus and a competent housekeeper – came to share his bed. The traditional representation of her is a drawing made in about 1645 [71] showing a stocky woman wearing the peasant costume of Zeeland in North Holland. On the back is written 'the nurse of Titus', but it is likely that this refers to an earlier servant who preceded Geertge. A more plausible image of Geertge is the figure of Mary in 'The Holy Family with the Angels' painted in 1645. The nurse would have been a natural model, and indeed the probable inspiration, for this intimate domestic scene of a baby being rocked quietly in his wicker cradle.

Rembrandt gives the same features to the principal figure in a new version of 'Susannah and the Elders' [VII]. The inevitable frustrations of bereavement and the thrill of exploring the body of a new lover were the probable inspiration for Rembrandt's return to painting nudes in the mid-1640s. Again, it would have been natural to use the person who had brought about this change as a model, and taken together with the evidence of 'The Holy Family with the Angels' it is probable that in the Susannah of 1647 [78] we are looking at the face of Geertge Dircx.

The biblical story of Susannah is Rembrandt's motif for expressing sexual themes. His new Susannah is far less modest than before: she has a young, well proportioned body that is not so much nude as naked. We can quite understand why the 'elder' (who looks less than senile) wants to uncover her completely, and the artist heightens the eroticism by freezing the hand grasping the loincloth in the moment of tension before pulling it away. Geertge was certainly not plain: it is a painting about the joy of discovery.

The seven years during which Geertge and Rembrandt lived together were stormy. She was a simple woman who loved Titus, and loved and desired Rembrandt. It seemed natural to her that they should marry. But even if Amsterdam's most famous painter, the widower of Saskia van Ulenborch, had been prepared to sacrifice his social position, it is unlikely that he could have raised the money which he would have been obliged to pay Saskia's relations under the terms of her will. How Geertge must have hated Saskia. The great house in the Breestraat must have seemed haunted to her, with the smiling, superior images of its former mistress – like a goddess or mythical queen – confronting her at every turn. Rembrandt, with his powerful personality, was in awe of his wife and he had used his art to make her even more than she was. All lovers fear and hate the past, but what a crippling weight little Geertge Dircx had to bear. How many of their numerous arguments must have begun because 'Saskia would have done this' or 'Saskia would not have done that'?

It is a tribute to her strength of character, and to her love for Rembrandt, that Geertge Dircx stayed as long as she did. Fate was unkind to her and so, it seems, was Rembrandt. In 1648 Geertge had drawn up the will in which she bequeathed her few pathetic possessions to Titus (the only items of any value were some jewellery which Rembrandt had given to her – it had been Saskia's). Soon afterwards the question of marriage came up again, and they argued as they had done so often in the past. But promises were not enough this time and Geertge left him.

She also brought a lawsuit for breach of promise against Rembrandt, saying that he had promised to marry her. Contemporary Dutch courts took cases of this kind seriously, and when Geertge produced a ring which she said he had given her as a token of his intent they ordered Rembrandt to pay her 200 guilders a year for her support.

Unfortunately the matter did not end there. Geertge got into debt and was obliged to pawn Saskia's jewels. When Rembrandt heard of this insult to the memory of his wife his reaction was as vindictive as it was violent. He employed a notary to take down statements made about Geertge by her new neighbours. No doubt she was promiscuous, and with a little encouragement from Rembrandt and the notary several people were prepared to say that she was. With the connivance of her brother, who was a ship's carpenter, Rembrandt brought the matter before the

80
'Winter Landscape' is executed in
Rembrandt's most abbreviated style. With
the minimum of strokes he evokes the deep
snow and sharp coldness of a winter's day in
the flat farmland close to Amsterdam.

courts and succeeded in having the unfortunate Geertge
committed to the bridewell (a kind of reformatory) in Gouda for
twelve years on the grounds of moral delinquency. She was
released five years later through the efforts of friends, but chiefly
because of illness. Eighteen months later she was dead.

The traditional picture of Geertge Dircx – an ill-tempered and
violent woman whose mental instability caused her, finally, to be
restrained in an institution – has been discredited by documen-
tary evidence which has come to light in recent years. Perhaps
new evidence will one day be found which will explain, at least in
part, Rembrandt's treatment of her. The incident highlights two
important points. First, all biography is at best a stab at the
truth, an interpretation based on facts known at a particular
time and firmly rooted in the prejudices and pre-occupations of
that time. Secondly, if Rembrandt was a giant he certainly was
no angel. The whole spiteful, sordid episode is a useful specific to
the disease of eulogy, but it is more than that. It shows that
Rembrandt did not live in an infallible heroic world of his own
imagination like Leonardo or Michelangelo, but in the mire
with the rest of us. Rembrandt, like Shakespeare (who persists in
offering himself for comparison) or Tolstoy, was an essentially
human genius, concerned with human problems and he was as
capable as the rest of us of making mistakes: 'He does not pity us,
he does not comfort us, because he is with us, because he is us.'

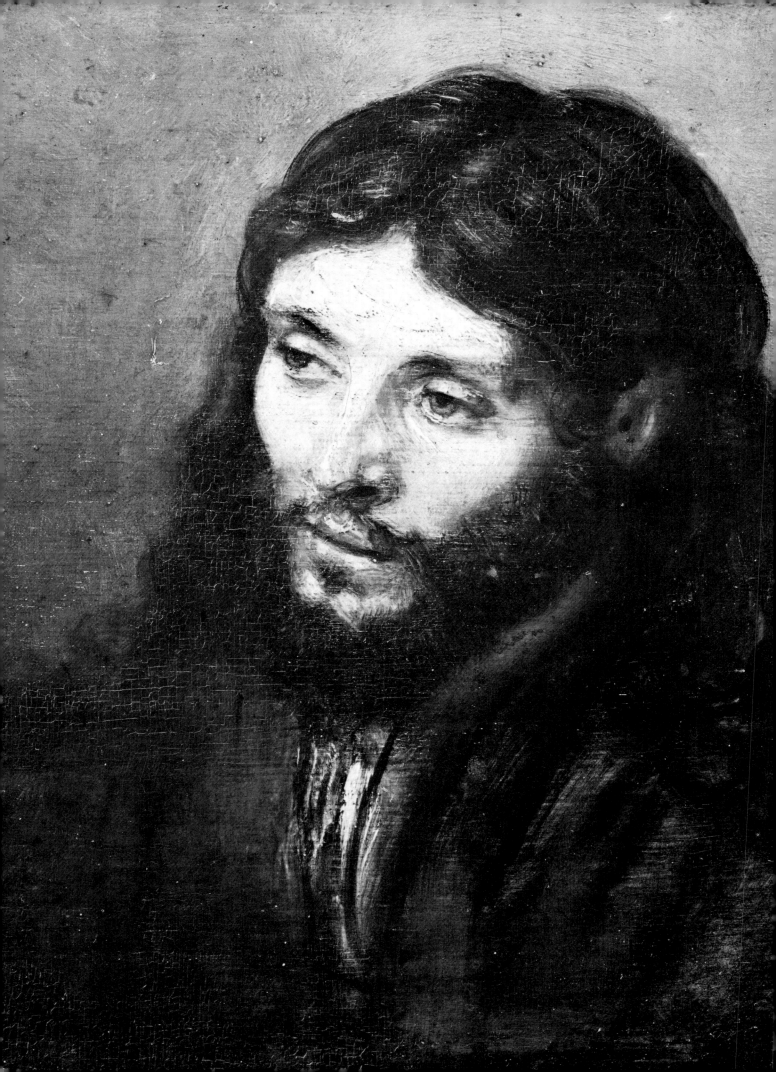

Chapter 9

A young philosopher and his people

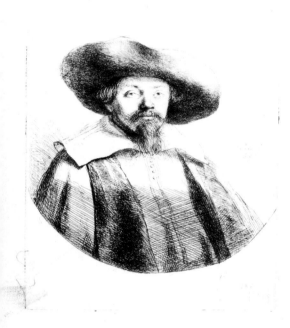

81 *left*
'Through Christ and in Christ we are all the descendants of Abraham . . . spiritually we are Semites'. The words of Pope Pius—emphasizing the Jewishness of Christ—are simple enough, although the media persist in presenting Jesus as a Nordic type. Rembrandt was the first to make the revolutionary, and obvious, step of giving Christ Jewish features.

82 *above*
Samuel Manassah ben Israel, the Chief Rabbi, was a close friend of Rembrandt. A kindly, intellectual man, he represented the best in contemporary Jewish orthodoxy.

TODAY, Rembrandt's house is preserved as a museum. What was in his day known as the Breestraat is now called Jodenbreestraat, or 'Jewish Broad-Street'. Amsterdam has traditionally had a large Jewish population (not far from Rembrandt's house is the office building where Anne Frank and her family hid from Nazi persecution between 1942 and 1944) and their involvement with the city dates from Rembrandt's time. Indeed so sizeable was the Jewish population of the city by the mid-seventeenth century that it became known as the New Jersualem—a title as pleasing to the Calvinists as to the Jews. In 1657 the Jews were proclaimed 'subjects and residents of the United Netherlands': a historian of his race later wrote 'of all the States of Europe there is not one in which the Jews live more peaceably than in Holland. They acquire wealth through trade, and owing to the friendly attitude of the Government are secure in their standing and possessions.'

Among Rembrandt's neighbours in the Breestraat were several wealthy Jews including Daniel Pinto, Jacob Belmonte and Salvator Rodriguez as well as the famous Rabbi Manassah ben Israel who lived opposite. Rembrandt had made his first portrait of Manassah ben Israel as early as 1636 and it is reasonable to assume that their friendship had continued since then. In 1654 he prepared four etchings to illustrate 'La Piedra Gloriosa': a cabbalistic work which the rabbi both wrote and printed (he was the first Hebraic printer in Amsterdam).

Another of Rembrandt's friends among Amsterdam's Jewish community was the prominent physician Ephraim Bonus—an etching of 1647 shows a thoughtful and intense man [85]. Bonus was a close friend of the Chief Rabbi (Manassah ben Israel shared the position with Molteira) and was a partner in his publishing company. Both men, through their positions, had many contacts in the city's closely-knit Jewish community and were able to give Rembrandt useful introductions. It is interesting that of 200 male portraits (excluding those of himself and his family) which the artist made thirty-seven, nearly one-fifth, are identified as Jews: a remarkably high number since Jews represented little more than one per cent of the city's population.

The main explanation for this was the wealth of the Jewish

community, and the fact that they were able to commission the leading portrait painter of the day. Among the richer merchants and bankers many were important collectors of art of all kinds. Alphonso Lopez had admired Rembrandt's work since the beginning of his career, but his relations with Jewish patrons were not always so friendly. Diego d'Andrada commissioned him to paint a portrait of a young girl in 1654, and made a down payment on the picture. But when it was finished he refused to accept it as a recognizable likeness and would not take delivery of it until the artist had made certain alterations. Rembrandt refused to make any changes until full payment had been made and suggested that the officials of the Guild of Painters should be called in to arbitrate. There is no record of what the conclusion was.

There were two distinct Jewish communities in Amsterdam at this time, the Sephardim and the Ashkenazim. The Sephardim were for the most part aristocratic, cultured and rich. They had fled from Spain and Portugal because of persecution by the Inquisition. Many were nominally Catholic, having been forced to abjure Judaism although never forgetting their ancient faith – these were the crypto-Jews, or *Marranos* (swine) as they were contemptuously called. Uriel d'Acosta who, like many, returned to the Jewish faith on his arrival in Amsterdam gives an account

83 *below*
Rembrandt chose an ordinary Dutch bedroom for his etching of the seduction of Joseph by Potiphar's wife. There is a touch of humour in Joseph's shocked refusal of her indecent attentions.

84 *right*
The features and dress of this young Jew distinguish him as a member of Amsterdam's Ashkenazi community.

of what it was to be a Sephardi Jew: 'I was born in Portugal, in the city that bears this name, generally referred to as "Porto". My parents belonged to the nobility. They traced their origin to the Jewish race, the members of which had been compelled to adopt the Christian faith in former years. My father was a believing Christian and a man of rigid honour, who laid great store upon social rank and position. In this home I was reared in keeping with the standing of the family.'

The Ashkenazim were later arrivals in Amsterdam than the Sephardim. They too had fled from persecution: pogroms in Germany and Poland. Unlike the aristocratic Sephardi Jews, the Ashkenazim were mainly poor, uncultured and illiterate. While the Sephardim were bankers, merchants and doctors, the Ashkenazim were shoemakers, tailors and street traders. But in matters of religion the Ashkenazi Jews were far stricter, not having been subjected to the same cultural influences. In his history of the Jews Basnage describes relations between the two groups: 'They are divided in matters of some of their ceremonial observances, and hate one another as though the essentials of their religion were involved.'

Rembrandt's friends were principally from among the Sephardim: Manassah ben Israel, Ephraim Bonus, Alphonso Lopez, were all Sephardi Jews. Similarly, all the commissioned portraits of Jews are of Sephardim. The reason is not financial (there were some affluent Ashkenazim) so much as religious. The Ashkenazi Jews adhered rigidly to the Second Commandment: 'Thou shalt not make unto thee any graven image, or any likeness of any thing that is in heaven above, or that is in the earth beneath, or that is in the water under the earth: Thou shalt not bow down thyself to them, nor serve them.'

Yet a high proportion of Rembrandt's studies of Jews are plainly Ashkenazi types by their clothes and features [84]. It is not simply that he drew and painted a large number of uncommissioned portraits (which we know to be true of course); there has to be some other reason because, as we have seen, Jews of both groups represented only one per cent of the population. It is clear that despite his strong friendships with Sephardi Jews like Manassah ben Israel, men with whom he could communicate at the same social and intellectual level (some knowledge of Hebrew script, and an interest in the cabbala is apparent in his work), Rembrandt the artist was more interested in the Ashkenazim. The reason is that he saw the Jews—and in particular the less racially mixed Ashkenazim—as the people of the Bible.

One reason for Rembrandt's gradual decline in popularity was his insistence on continuing his output of Biblical pictures. There are very few records of commissioned interpretations of the Scriptures, although an analysis of his work reveals 600 drawings, 80 etchings and 160 paintings on biblical themes, and these statistics do not include the numerous portrait studies of Christ and other important and less important figures from the

85
Ephraim Bonus, a Sephardi Jew, was one of Amsterdam's most respected and well-liked physicians. His friendship with Rembrandt spanned many years.

Old and New Testaments. Naturally Rembrandt hoped to sell some of this work, but the market was not large. Holland was a Calvinist country where a watered-down version of the Ashkenazi attitude, at least where religious art was concerned, held sway. The main buyers of this category of art were Catholics, of whom significant numbers remained in the Netherlands, and, ironically, the Sephardim whose interest was of course in the Old Testament.

But financial reward was not a significant motive in Rembrandt's production of Biblical interpretations. And although he was a Christian (of a humanistic and individual kind) Élie Faure is right when he says: 'If Christ had not been, Rembrandt would have found other legends to tell of the human drama, from cradle to tomb, that he lived . . .' The Old Testament was almost equally important to him. Rembrandt's mother had read to him from the Old as well as the New Testament; his personal mythology was compounded of both. He would have agreed with Nietzsche in 'Beyond Good and Evil' and 'Genealogy of Morals': 'In the Jewish Old Testament, the book of divine justice, there are men, things, and sayings on such an immense scale, that Greek and Indian literature have nothing to compare with it. One stands with fear and reverence before those stupendous remains of what man was formerly . . .' 'All honour to the Old Testament! I find therein great men, an heroic landscape, and one of the rarest phenomena in the world, the incomparable näiveté of the strong heart; further still, I find a people.'

It was natural that Rembrandt should seek out the modern descendants of those people and give their features to the personalities in the Bible. In this way he anchored Old and New

86 *above*
Rembrandt's interest in the Ashkenazi community and its beliefs prompted him to make the only known record of their synagogue. Other gentile artists had depicted synagogues, but in quite a different spirit. The German artist Albrecht Altdorfer wrote on the back of his etching of the Ratisbon Synagogue: '. . . by the righteous judgement of God, utterly demolished'. It was of course religious persecution in Poland and Germany which had caused the Ashkenazim to seek refuge in the Netherlands.

87 *right*
A Jewish bride on her wedding day—probably the daughter of one of Rembrandt's friends among the Sephardim.

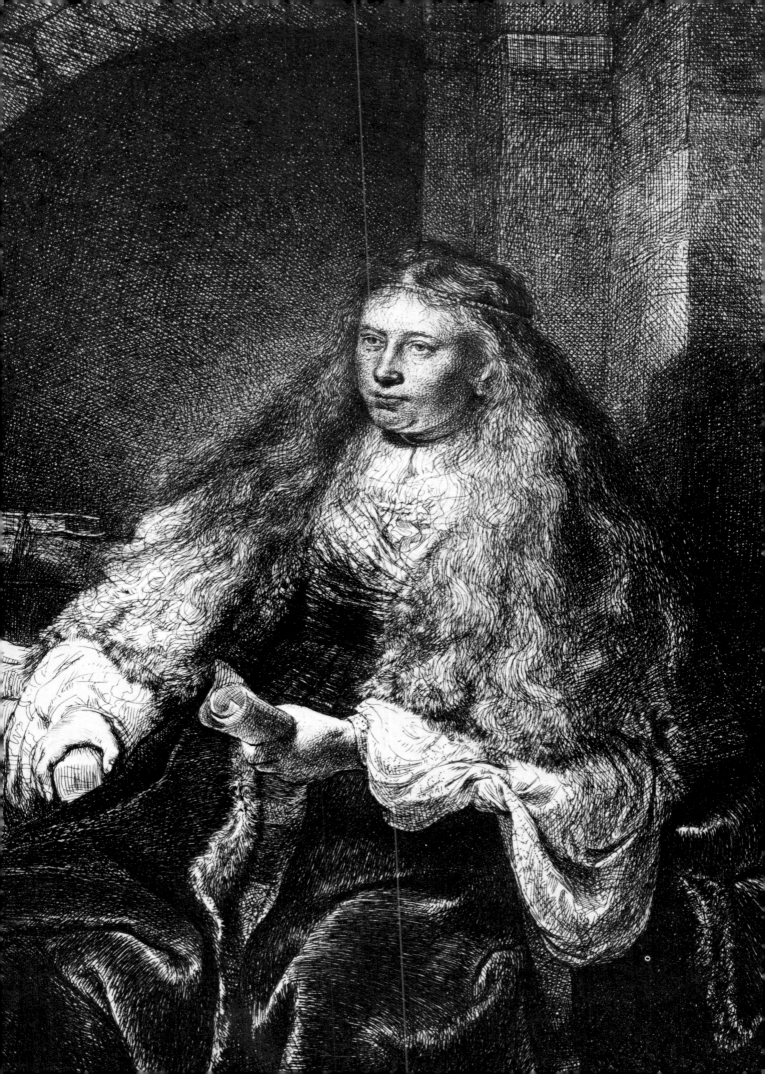

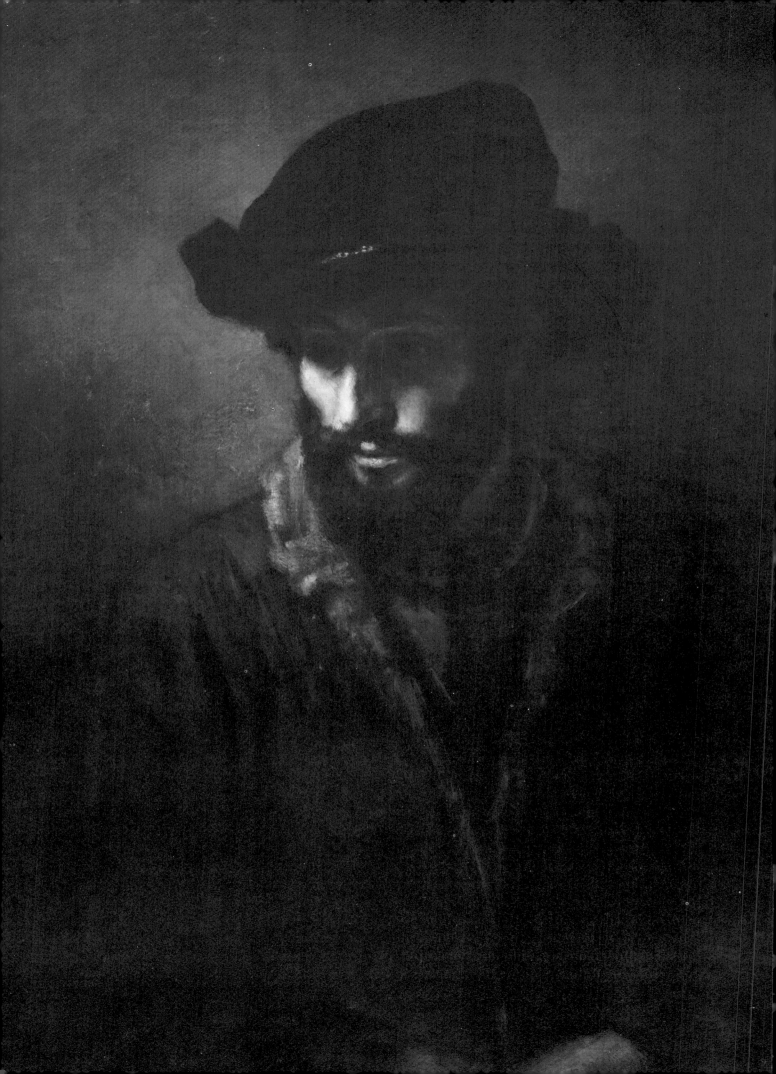

Testaments to his own time, making the dual point that not only were the Scriptural characters real people, but also that their stories were of relevance to seventeenth-century Holland.

Thus, for the first time in art [81] we are presented with a Jewish Christ: a great step forward, which seems as obvious and as natural as all such, except that it takes a genius to make the connection of ideas and take that step.

Rembrandt's illustrations of the Bible stories are the most comprehensive of any artist; they also include some of his most powerful creations. Typically of the artist he was quite uncompromising in his efforts to anchor the Scriptures to reality: this corresponded with his belief that nothing human was taboo and that anything should be shown if appropriate. The importuning of Joseph could scarcely be more explicit [83].

Rembrandt was also interested in the Jews of Amsterdam, both Sephardim and Ashkenazim, for their own culture which contrasted so markedly with the way of life of the city's Calvinist burghers. The magnificent etching known as 'The Great Jewish Bride' [87] was long thought to be a misnamed 'Minerva' or some other mythological figure. But it is quite probable that this is a Jewish bride whom the artist had seen in the home of one of his Sephardi friends. Everything in the etching is consistent with this: her hair is brushed out in the prescribed fashion ready for the veil which is draped over the chair-back; the scroll in her hand may well be the bridegroom's pledge, her *ketubah*.

His etching 'The Synagogue' made in 1648 [86] is an interesting historical record of the Ashkenazi house of worship. The long-established, and generously endowed, Sephardi synagogue was often depicted (Charles I's queen, Henrietta

88 *left*
Rembrandt's painting of a young man is thought to be Baruch Spinoza. One of the lights of Western civilization, Spinoza's independence of mind led him to question many of the principles of the Jewish faith. For example he said that the true word of God was not to be found in books, but 'inscribed on the heart and mind of man'. At the age of twenty-four, banished from his people and his birthplace, he must have wondered at his name 'Baruch', which means 'blessed'.

89 *right*
It was not Rembrandt's friend Manassah ben Israel who banished Spinoza but the joint Chief Rabbi Molteira. Rembrandt's painting shows him as a man of uncompromising belief and iron will.

XIII *overleaf*
When Rembrandt completed his famous portrait of Jan Six their friendship had already become an embarrassment to the ambitious Six. 1654.

XIV *page 99, above*
Titus daydreaming at his desk. 1655.

XV *page 99, below*
Despite the intrusion of electricity pylons the River Yssel is much the same today as when Rembrandt made his drawings of it during the 1640s.

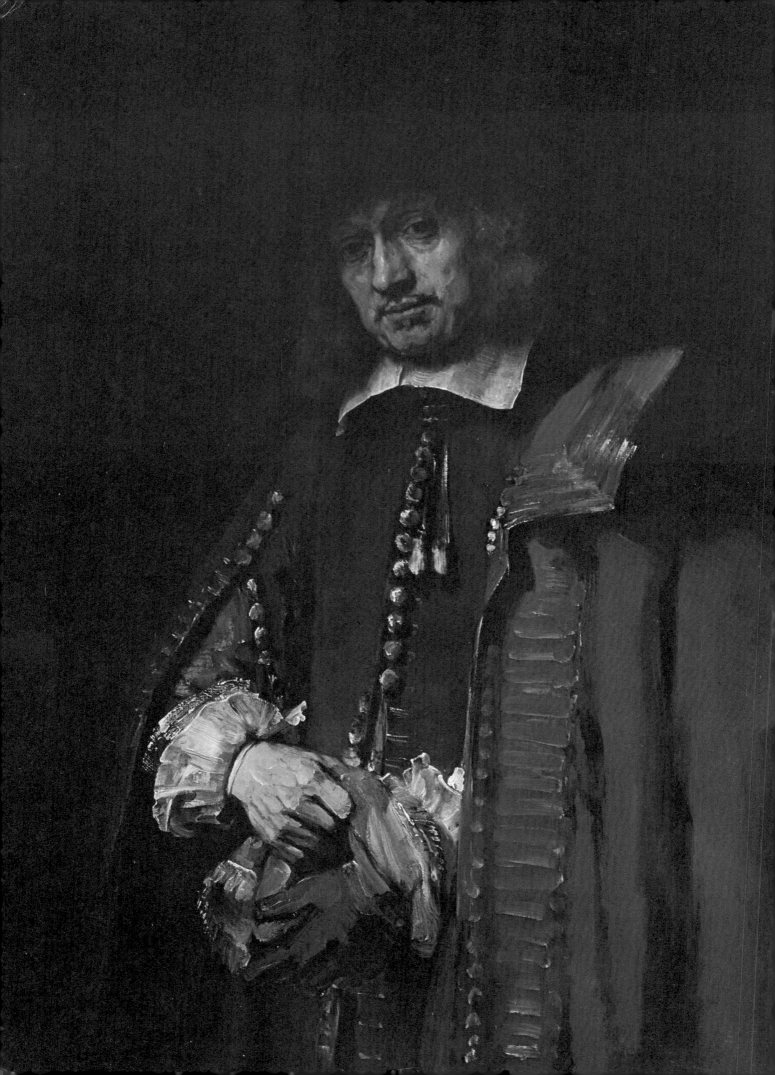

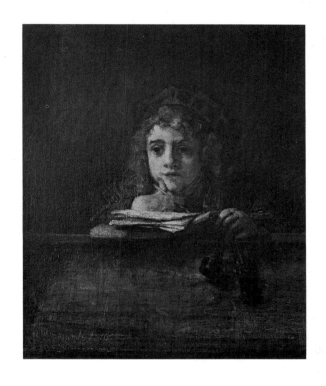

Maria, visited the magnificent building in 1642 and heard Manassah ben Israel preach). But Rembrandt's etching is the only known representation of the Ashkenazi synagogue. A *minyan*—the minimum number of ten men necessary for a religious service in Judaism—is shown, and the artist has faithfully recorded the fact that the floor was lower than the door: the strict Ashkenazim constructed it in this way in literal fulfilment of Psalm 130: 'Out of the depths have I cried unto Thee, O Lord!'

Behind the Breestraat, on the Houtgracht, a Synagogue school had been built in 1639. Living so near, Rembrandt made several studies of the building. One was dated 1648, a time when the school housed a pupil whose analytical intelligence and powers of concentration indicated that one day he would become a great rabbi. That he did, but not in the way the orthodox Manassah ben Israel and Molteira could have hoped. The pupil's father was Michael Despinosa, head of the Misvah do Emprestina or

90
Jacob Ruisdael's melancholy painting of the Jewish cemetery where Amsterdam's Sephardim were buried.

91
Rembrandt's painting of 'Jacob blessing the
Children of Joseph' was probably
commissioned by a Jewish patron. The
artist's treatment of the subject shows an
understanding of the significance which the
incident has for the Jewish people.

'Good Deed of Lending', a Jewish loan bank. His son is better
known to us as Baruch Spinoza.

The chronological and geographical closeness of the greatest
artist and the greatest philosopher that Amsterdam ever
produced has led to much speculation as to whether they met. It
has even been suggested that Spinoza, who was a competent
draughtsman, was taught to draw by Rembrandt. But it is most
unlikely that a pupil as famous, and in his time notorious, as
Spinoza would have studied under the master without some
record of it having survived. It is, however, possible that
Rembrandt painted Spinoza's portrait. His painting of 'a young
Jewish student' [88] is the most likely candidate, and there are
strong similarities with the only authenticated likeness by an
unknown artist. Rembrandt's sitter has the same highly-bred
Sephardi face, with its arching eyebrows, long sensitive nose and
sallow skin. The clothes, too, are right. If Rembrandt's painting
is of Spinoza he probably made the preliminary sketches at the

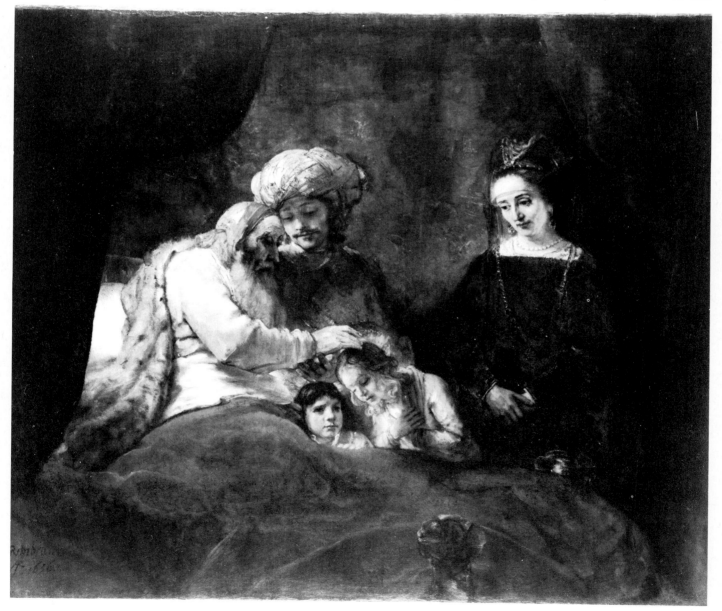

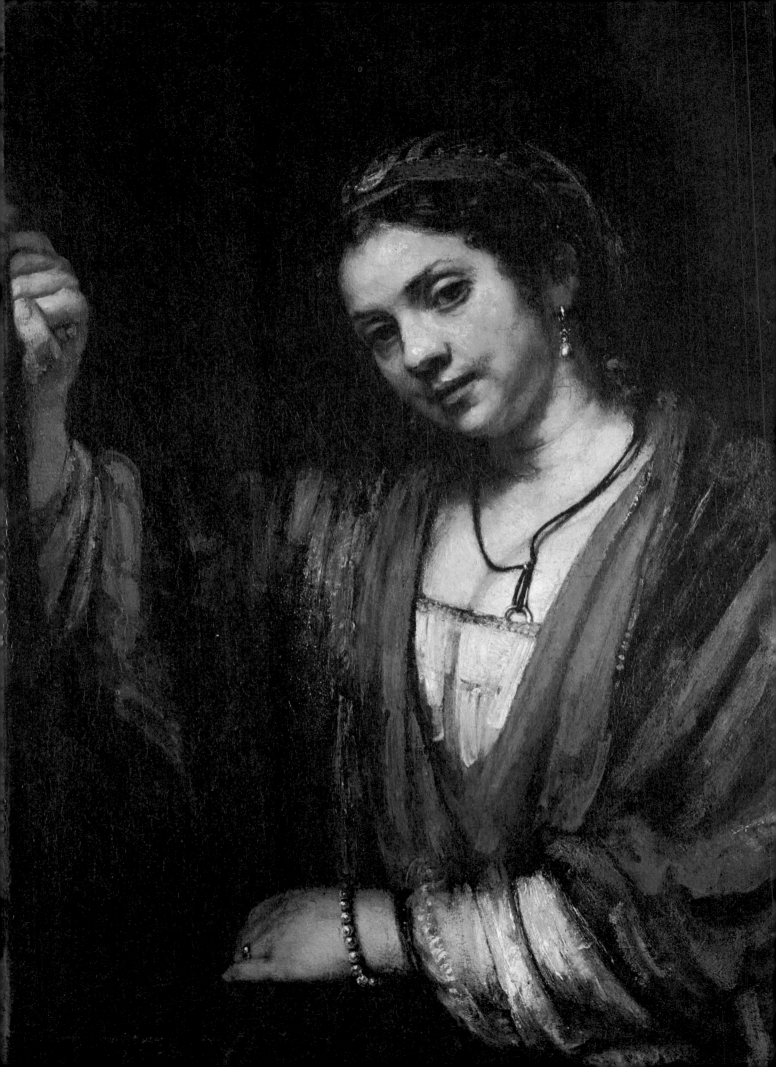

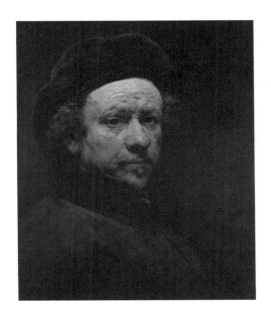

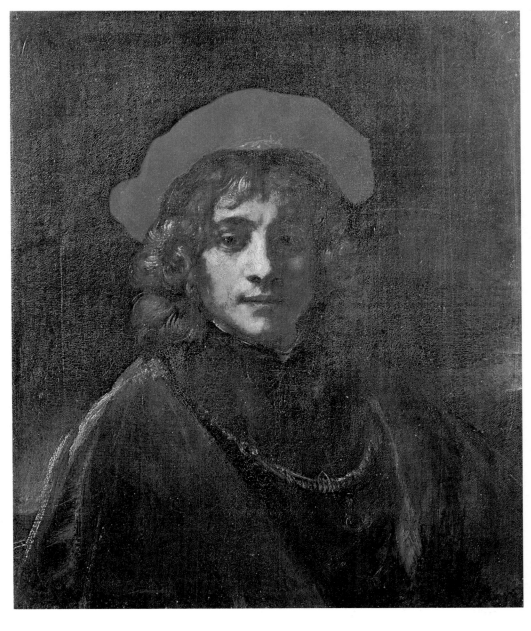

103

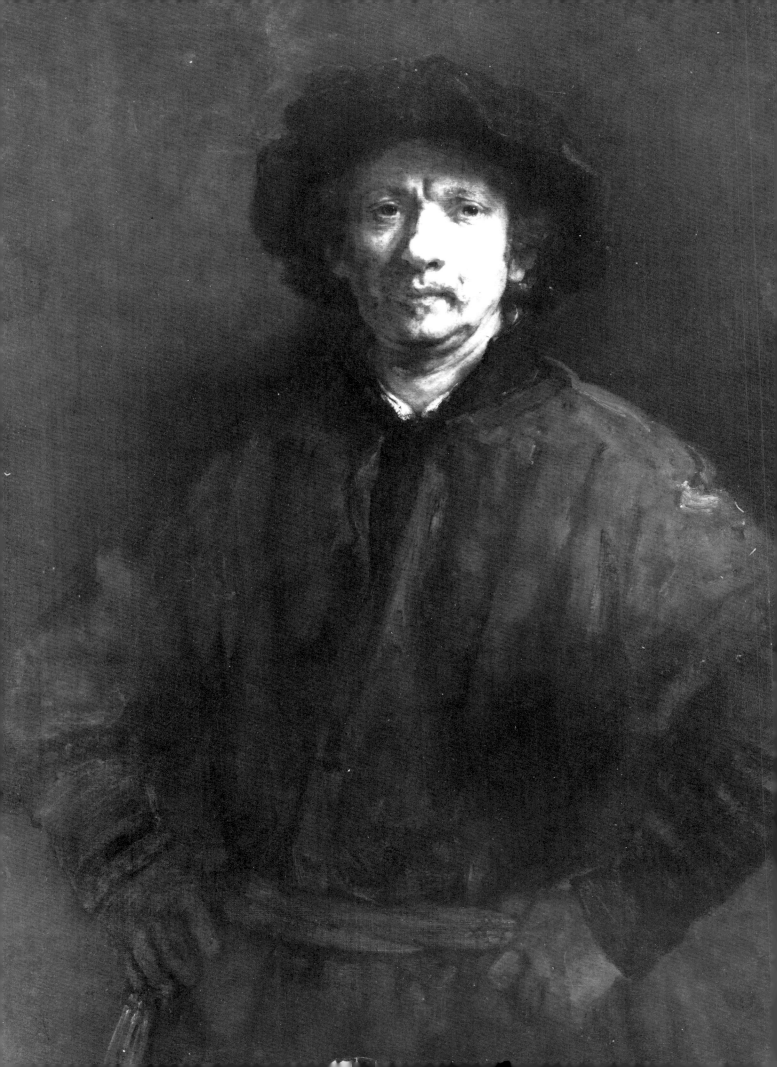

XIX *overleaf*
Salvation through work. 1663.

XX *page 107*
The crumbling mask. 1660.

92 *left*
Hands on hips, the forty-six-year-old artist confronts the world. But forces beyond his control were already working against him.

93 *below*
The curious inscription in the vision which has appeared to Faust in Rembrandt's etching has never been deciphered. It is probably connected with the interest in the Cabala which he shared with Manassah ben Israel.

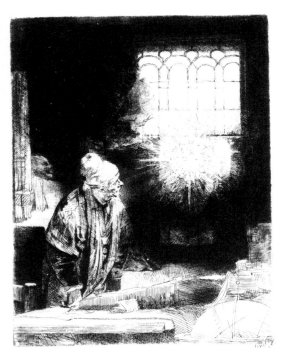

Burgh family home, 'Little Kostverloren' near Oudekerke where they were both guests. This was the time of Spinoza's excommunication when he was very poor, and the rather shabby coat with a fur collar and well-used hat would be appropriate. But perhaps the most powerful argument is not circumstantial but emotional: the young Talmudic scholar's sad expression and haunting meditative eyes.

Whatever their other connections, the long-famous artist and the dangerously radical young scholar could not have been friends. They were poles apart. As W. R. Valentiner says, Spinoza and Rembrandt 'represent two opposing conceptions in the Dutch culture of the seventeenth century: the rationalistic and the intuitive.' Spinoza himself might have been defining the differences between them when he said: 'Men of great imaginative power are less fitted for abstract reasoning, whereas those excelling in intellect and its use keep their imagination more restrained and controlled, holding it in subjection, so to speak, lest it should usurp the place of reason.'

Their dissimilar minds led to other differences. Rembrandt was a Christian, and whatever his doctrinal irregularities he believed that God had sacrificed his Son to save humanity; Spinoza believed this would have meant a disruption of the order which governs everything. Spinoza on the other hand lived strictly according to his beliefs; in his *Ethics* he vigorously attacked the idea of revenge: Rembrandt, as we know from the fate of Geertge Dircx, was quite capable of revenge.

Another barrier to any real understanding between the two men was Rembrandt's friendship with the two orthodox Chief Rabbis. The implacable Molteira was Spinoza's main enemy – the man's unbending will can still be felt in the Uffizi portrait [89], with its lowered eyes and powerful, clasped hands. It was Molteira who had offered Spinoza an annual income of 1000 guilders to retract his radical opinions and restore peace to the Synagogue. And when he would not it was Molteira who had read the terrible words of the excommunication (so terrible that Uriel d'Acosta had committed suicide after they had been spoken to him): 'Cursed be he by day and cursed be he by night; cursed be he when he lies down and cursed be he when he rises up; cursed be he when he goes out, and cursed be he when he comes in. The Lord will not pardon him: the anger and wrath of the Lord will rage against him and will bring upon him all the curses which are written in the Books of the Law.'

Amsterdam – the same city with its unprecedented wealth and unique social conditions – had evoked different responses in two quite different geniuses. 'Not to spend one's life in sorrow and sighing, but in calmness, enjoyment and cheerfulness, thus constantly rising to higher spiritual levels': this was Spinoza's philosophy for life, and although circumstances prevented him from achieving his ideal there was an equilibrium and serenity about his short life. Rembrandt walked a rougher path.

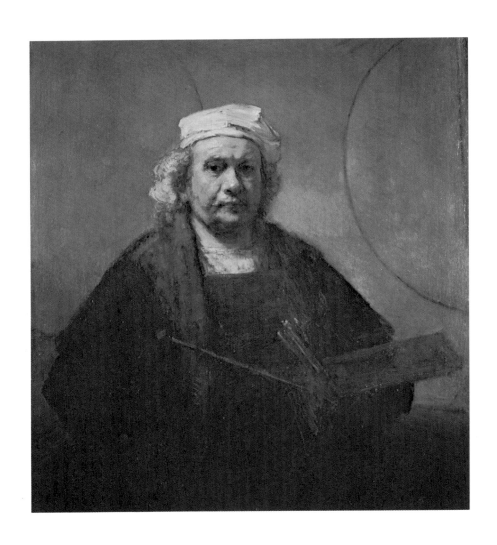

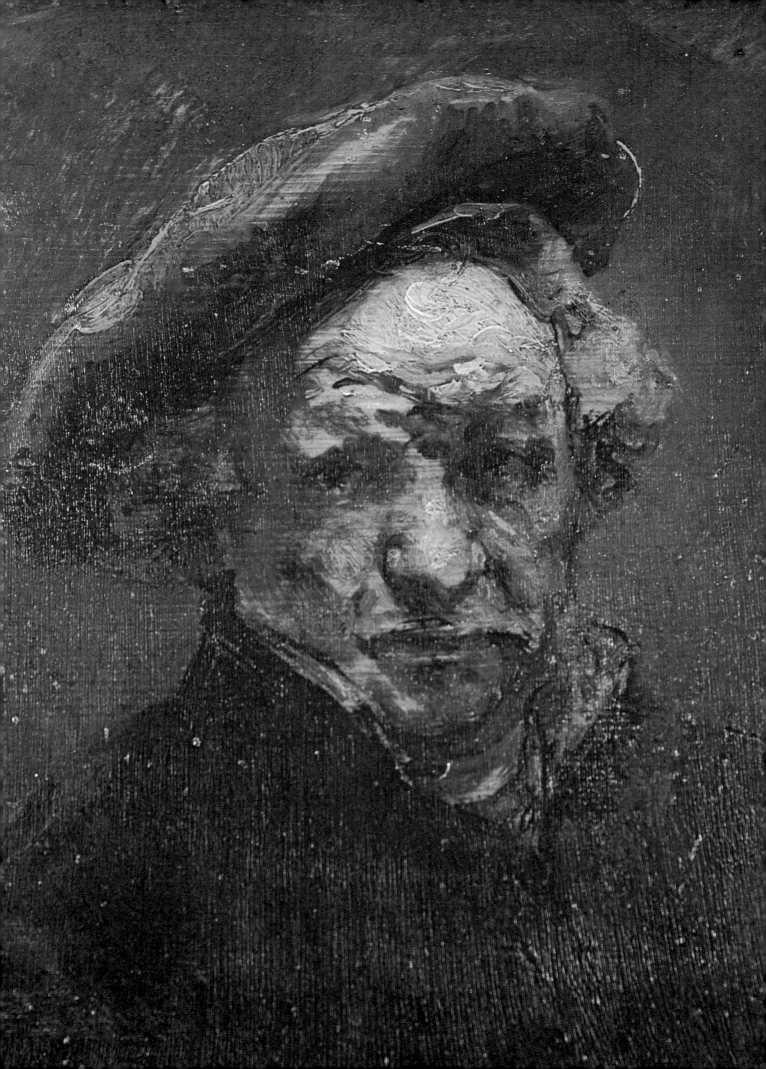

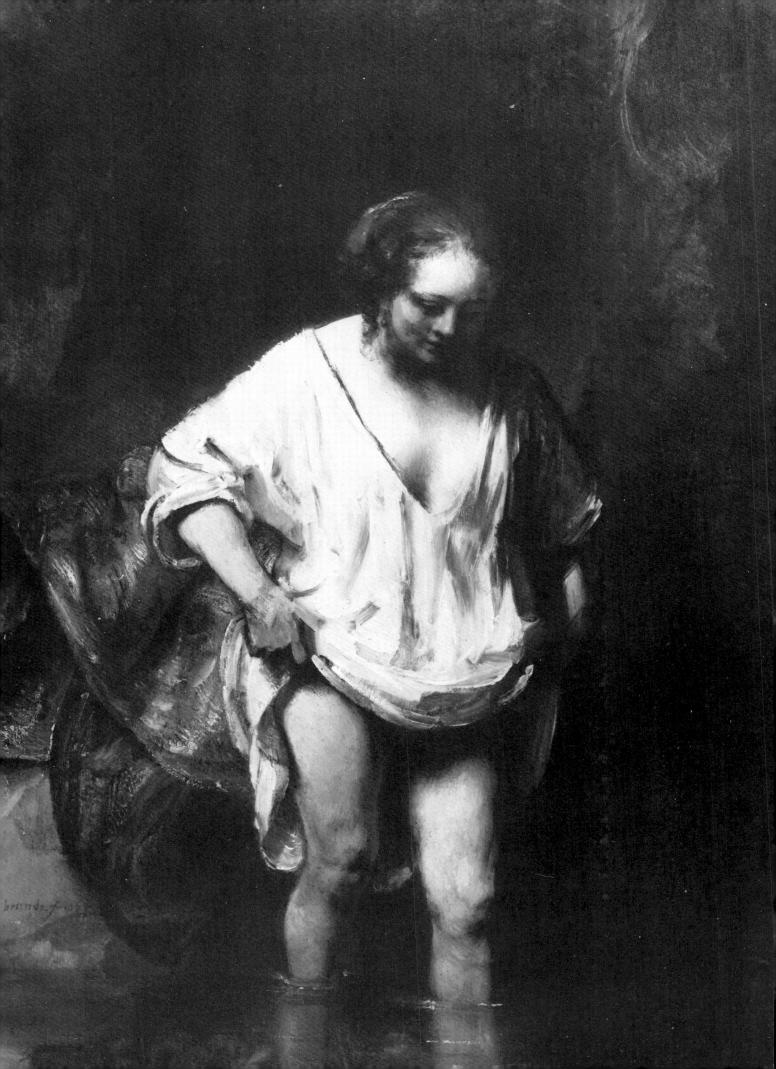

Chapter 10

Losses, and gains

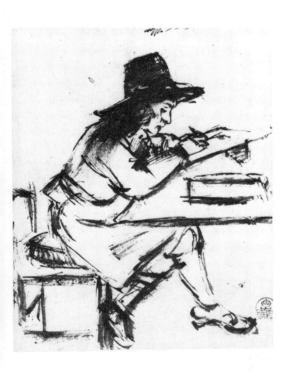

1653 WAS THE MOST disastrous year of Holland's first major economic depression. The country's wealth was founded upon trade: the merchant adventurers, 'the beggars of the sea', had through their energies stimulated the creation of the largest merchant fleet in the world. More than 2000 ships, many with a capacity of 1000 tons, connected the ports of the world: over half of Europe's trade was carried in Dutch ships. In 1651 England had passed the Navigation Acts which effectively gave her merchant fleet the monopoly in English trade, and other countries soon followed with similar protective tariffs. War, as usual, followed economics and Holland also suffered reversals in the First Anglo-Dutch War.

The result among the businessmen of Amsterdam was panic. After fourteen years Rembrandt still owed a capital sum of 7000 guilders on the purchase price of his house in the Breestraat. For more than five years he had made no repayment of interest on the loan, and for three years he had even allowed the former owner Christoffel Thijsz to pay the taxes on the property. In February 1653, through a notary, Thijsz presented Rembrandt with an account for 8470 guilders. The artist went to see his creditor at his country house Saxenburg outside Haarlem (the evidence for this is a contemporary etching of the place made by Rembrandt) but to no avail. Rembrandt stubbornly refused to do anything until the deeds were adjusted and made out in his name (he was not, of course, the full owner). Thijsz agreed to this, but only on condition that repayment was made in full. Soon afterwards he received his money.

Repayment marked the end of Thijsz's problems, and the beginning of Rembrandt's. With no resources, and no assets that he wished to liquidate, he had made the Faustian bargain of substituting one debt (or rather several debts) for another. To discharge his debt to Thijsz, Rembrandt borrowed 4000 guilders from Dr Cornelis Witsen, the Burgomaster of Amsterdam, a further 4000 from Isaac van Heertsbeeck and, against a guarantee from his friend Lodewijk van Ludick, 1000 guilders from Jan Six.

Shortly before his financial debacle began Rembrandt had painted a portrait of his nurse-housekeeper [XII], the young

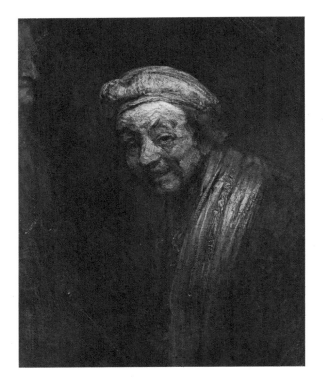

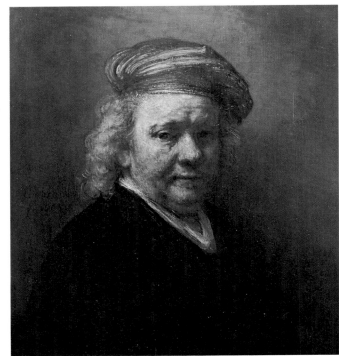

XXI The old clown. 1665.

XXII Emptiness. 1669.

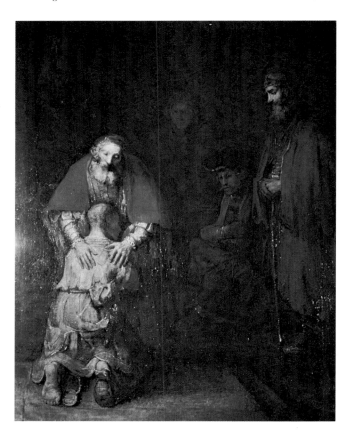

XXIII *above* A parable: the Return of the Prodigal Son. 1669.

XXIV *opposite* The final image. 1669.

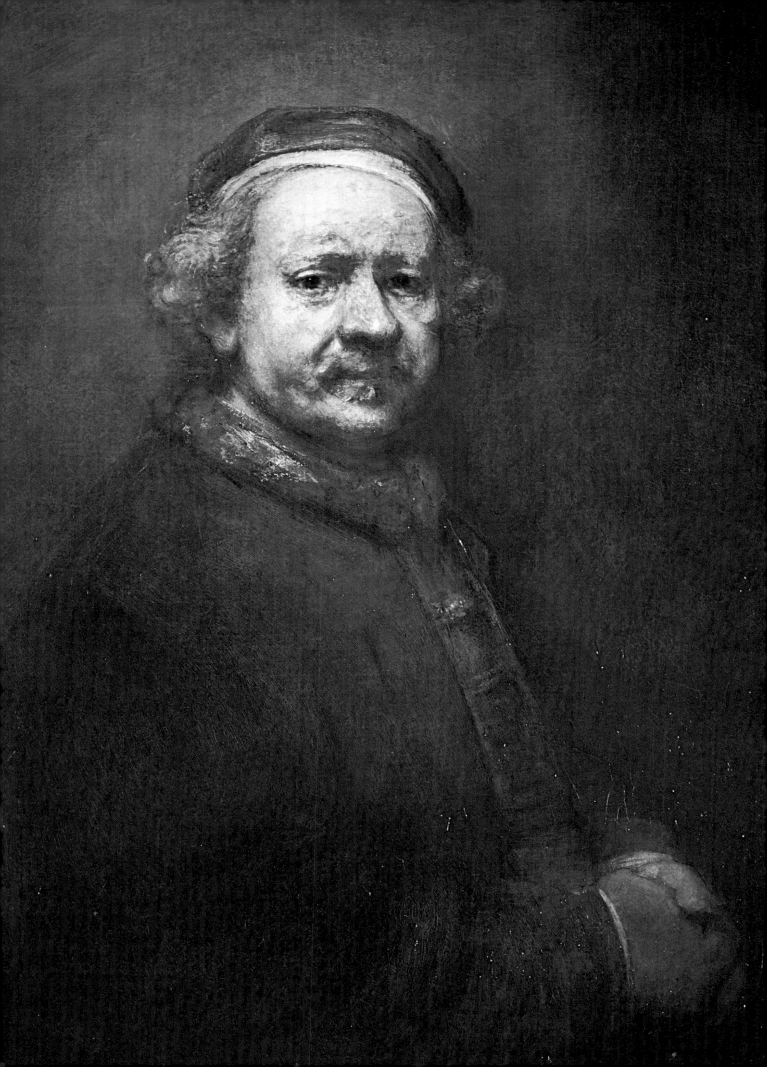

woman who had replaced Geertge Dircx. It is a magnificent portrait which evokes the personality of a warm and tender woman. His treatment of the subject, and the inclusion of the jewellery, recalls the portrait of Saskia. He intended that it should.

Hendrickje Stoffels was twenty years younger than Rembrandt, the daughter of a sergeant from Bredevoort. Houbraken describes her as 'a peasant woman . . . small in figure, but well shaped of face and plump of body'. The artist was to paint more strictly accurate portraits of the woman who was to mean more to him, perhaps, than any other; but this first statement of his love is a very complex and important painting. Perhaps only the eyes are a literal 'likeness', but the main intention of his careful moulding of the face is to show the warmth and tenderness of her personality – the reason he loves her.

The definite similarity in treatment and feeling to portraits of Saskia is more revealing still. Hendrickje had been living with him for at least four years, and her role had changed from that of servant to one of companion and lover. He never married Hendrickje, he could not, but this painting affirms that she is his wife as certainly as any contract or religious service. The similarity to portraits of his first wife is not nostalgia, or an inadvertent slip – the women were too radically different for that. Quite intentionally he is saying that one has supplanted the other: for Hendrickje, and for himself, it is an exorcism.

Hendrickje, with her unselfishness and quiet strength, supported Rembrandt throughout the changes in his fortunes. And she herself suffered because he could not marry her. In the spring of 1654 Hendrickje became pregnant. As the months went on the fact became obvious to their neighbours in the Breestraat and the inevitable gossip began. The situation was brought to the notice of the Church and three times between the 25th June and 23rd July she was summoned to appear before the Council of the Reformed Church. Hendrickje ignored them, but when a fourth summons arrived she agreed to attend. It is not difficult to imagine her nervousness, or the appearance of the Council she faced – bigots of all times have a curiously consistent plumage.

It is oppressive in Amsterdam in late July, and buildings used for Church administration are invariably airless. But Hendrickje was not without courage. She stood before the old men, twenty-eight years old and seven months pregnant, while they accused her of living *in Hoererij* (in whoredom) with Rembrandt. The record of the occasion stated that she 'confesses to fornication with Rembrandt the painter, is gravely punished for it, admonished to penitence, and excluded from the Lord's Supper.'

In the autumn her child was born. It was a little girl and on the 30th October, in memory of another time, they christened her Cornelia. Unbaptized children were believed by the Calvinists to contain the seeds of evil, and the Church Council lifted the ban on Hendrickje so that the service could take place.

96 *below*
The frontispiece which Rembrandt etched for Jan Six's tragic poem 'Medea'.

97 *bottom*
Jan Six poses carefully for Rembrandt during his period as a dilettante of the arts. With a considerable fortune and the best connections – and having ended his friendship with Rembrandt because it might be compromising – it still took him until his seventy-third year to become burgomaster of Amsterdam.

98 *right*
The conflicts of puberty have never been more successfully analysed than by Rembrandt in this painting of his son Titus.

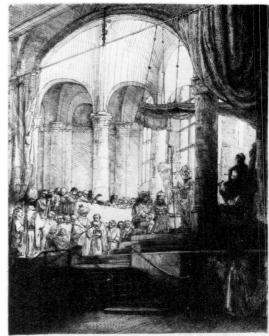

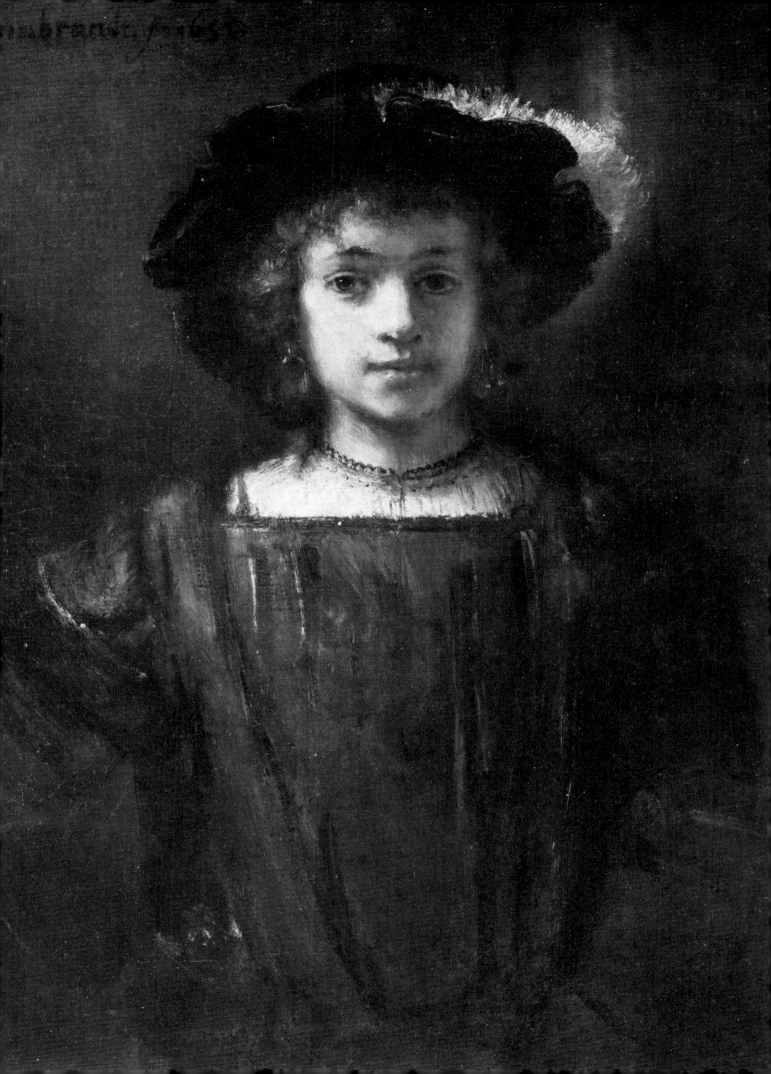

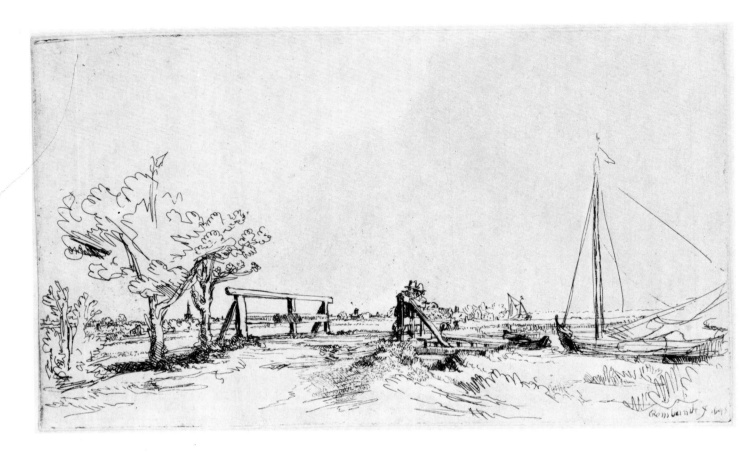

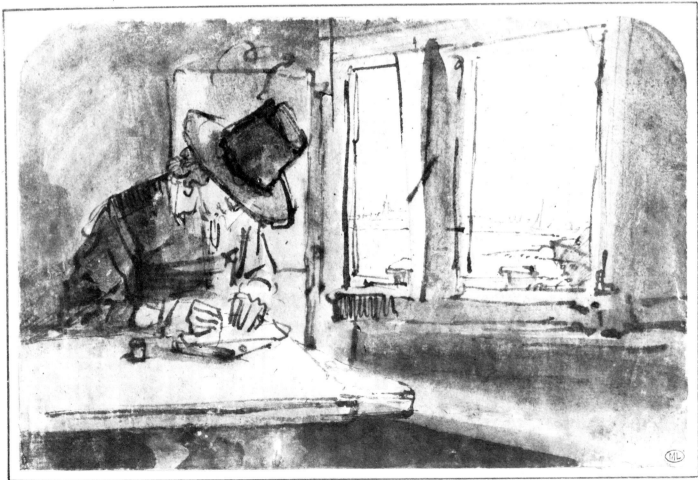

Titus was by this time thirteen years old. From the start he had not been a robust child, spending more time in the house than most Dutch children of the period. It is possible that he had a tutor who visited him in the Breestraat, because many of his father's drawings of the boy show him writing at his desk or poring over a book. The earliest identified painting shows him in this typical pose at his desk [XIV]. The little boy's concentration has wandered, if it was ever there at all, and he has the resigned far-away look of every intelligent child repeating the tedious rituals of 'learning'. Another painting, also done in 1655, shows a similarly unchanging aspect of middle-class childhood [98]. Titus has been made to look nice for some occasion, perhaps the baptism of Cornelia or the arrival of relations. It is a great painting, not just for its beauty – as a portrait of the artist's son it is very beautiful – but because Rembrandt has caught the moment just before puberty when the boy is no longer a child, or yet an adolescent. The uncertain smile says more about the physical and psychological conflicts involved than any crude scientific analysis ever could.

At this time Rembrandt's family in Leyden fell upon hard times. A brother was 'hopelessly indigent' and his sister 'insolvent', according to the records. The sister is probably Lysbeth who never married, but it is difficult to see how the inheritance from their parents (including other property in addition to the mill) had been squandered by such careful and unpretentious people. The portrait of Adriaen made in 1650 [IV] may give some hint. It is the face of a man whose eyesight is failing. No doubt Rembrandt did what he could, but his own financial affairs were in an increasingly bad state.

Incredibly, already at least 9000 guilders in debt, Rembrandt began negotiations to purchase another house towards the end of 1655. The only explanation must be that the new house was smaller and cheaper to run, and in buying it Rembrandt hoped to extricate himself from his financial problems. The property, which belonged to Otto van Cattenborch, the brother of the art dealer Dirck, was situated in the Hooghstraat. Another art dealer, and a close friend of the artist, Abraham Francken [102] acted as a witness to the agreement. For some reason nothing came of the negotiations, but under the agreed terms Rembrandt would have taken out a mortgage for 4000 guilders, while making over to Otto van Cattenborch etchings and other work to the value of 3000 guilders. A further requirement was that he should make a portrait of van Cattenborch of the same quality as his study of Jan Six.

Rembrandt's famous painting of Jan Six [XIII], which some art critics have called the greatest portrait ever made, had been completed earlier that year. It is not surprising that van Cattenborch hankered after a portrait of the same quality. The artist shows Six, deep in thought, absent-mindedly pulling on a glove. Coming from an old Huguenot family, who had an extensive fortune deriving from a dye-works and silk mills, Six

99
The etching of 'Six's Bridge' which in happier times Rembrandt is said to have completed within an hour for a wager.

100
Rembrandt made this study of Jan Six writing at the window of the family house at Ijmond before his financial problems and unconventional manners became an embarrassment, and friendship turned sour.

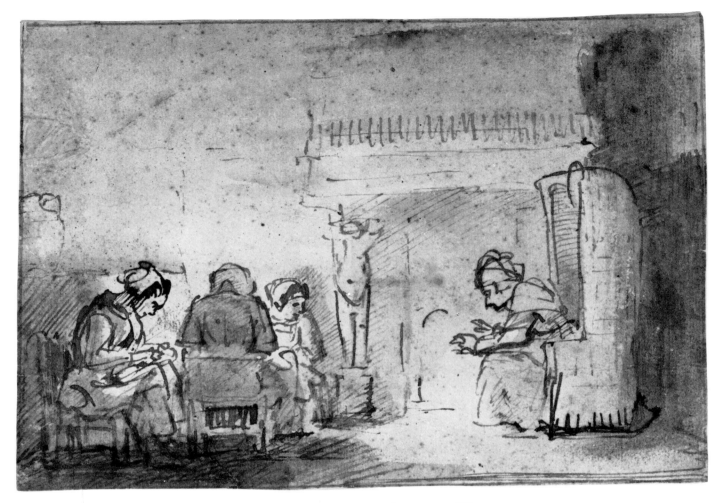

The great house in the Breestraat was full of memories for Rembrandt. In this drawing women sit sewing around a fire in the room where Saskia had her sick-bed.

had been able to devote his time to the arts. He had met Rembrandt as early as 1641 when the latter had painted his mother, Anna Wymer, at their house near the Anthoniesmarkt. Their relationship had developed, and the blunt-mannered artist and the rather effete dilettante had spent a good deal of time together over the years.

Rembrandt made his first portrait of Six, an etching, in 1647. It shows the image he liked to present to the world – the sensitive scholar and poet. It cannot have been comfortable posing in an open window [97]. The following year Six published a tragic poem entitled *Medea*, and asked his friend to produce a frontispiece. With a typical perversity, perhaps not unrelated to the pretentions of Six, Rembrandt made an etching [96] of the wedding of Jason and Creusa – a scene which is not described in the poem.

Jan Six shared with Rembrandt a passion for collecting, not just drawings and paintings, but all kinds of other curios and *objets d'art* as well. They must have often visited the auction rooms together, although the self-made artist could scarcely have competed with the inherited wealth of his friend. Among Rembrandt's own works owned by the Six family was his 'Portrait of Saskia in a Red Hat'. During the earlier years of their friendship Rembrandt was a regular guest at the family estate at Jaaphannes on the Diemerdyke. It is during one of these visits

116

that he is supposed to have made the famous etching 'Six's Bridge' [99] in less than an hour in order to win a bet.

In 1652 Jan Six abandoned what had been, in any case, only a part-time involvement in the family businesses and began a career in the public service which was, finally, to lead him to the position of Burgomaster. A wealthy dilettante can afford unconventional friends, but an ambitious public servant cannot. Six became increasingly distant towards his old friend, and sitting for the magnificent portrait which Rembrandt made of him was almost their last contact. With extraordinary pettyness (Six was a rich man) he handed over Rembrandt's debt to a merchant although it was secured by Lodewijk van Ludick. But then it was not a business transaction for Six – he was washing his hands of his friend.

102 *above*
The most loyal of Rembrandt's friends during his worsening financial difficulties were not necessarily the most wealthy. Abraham Francken lived in modest premises in the Angelierstraat, but he gave his friend what help he could.

103 *right*
As in so many other cases Rembrandt was far in advance of his time to consider the carcase of a slaughtered ox a suitable subject for a painter. The idea that such a subject could be treated sympathetically – or needed to be – did not find general acceptance until this century.

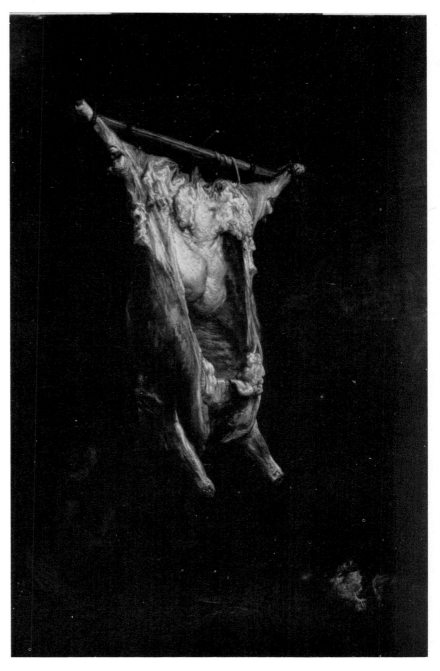

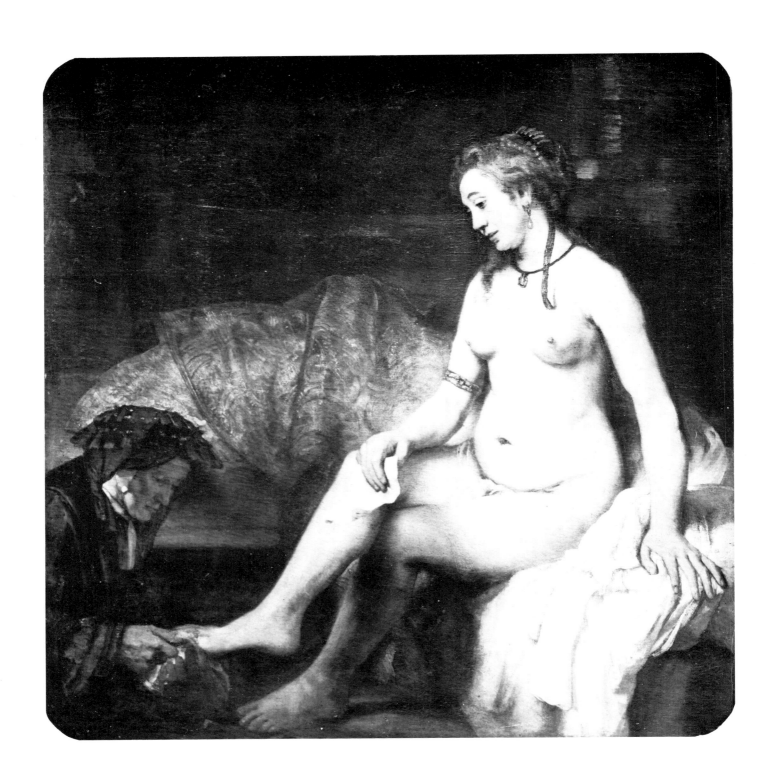

Hendrickje, like Saskia, modelled constantly for Rembrandt. But there is a fundamental difference. In all the paintings in which Hendrickje appears she is both model and inspiration. 'Bathsheba at her toilet' [104] is a very striking nude study, but then so is Rubens' version of the same subject. The difference between the Rubens and the Rembrandt nude, or for that matter between this Rembrandt nude and the Saskia-inspired Danaë or the Geertge-inspired Susannah of his earlier periods, is depth of feeling. He has made Bathsheba a 'real' person—a thinking, feeling woman. Since she is stark naked, and not unappealing sexually, this is a remarkable achievement. It is an achievement he could make only because of his relationship with Hendrickje which combined, as never before in his life, affection and respect with physical and emotional love. (This is not fanciful. Look at Danaë [63] and Susannah and the Elders [VII], and then look at Bathsheba again.)

This increasing concern for the 'inner life' marks a profound change in Rembrandt's art. The motif he uses to express the idea is blindness: 'Tobit and his Wife spinning at her Wheel' (the fifth study of the character he had made), 'Aristotle contemplating the Bust of Homer', 'Jacob blessing his Grandchildren' [91] all feature blind people. Their most important link with the world has been severed, but the inner life continues. Illness has increased their spiritual strength, just as sorrow has deepened their perception, their insight.

At this time Rembrandt achieved another artistic short-circuit. The work of Chaim Soutine and Francis Bacon have educated us to find nothing strange in the idea of painting a carcase [103]; it is difficult to understand that Rembrandt's 'Slaughtered Ox' was revolutionary in seventeenth-century Holland. Not for the subject matter, which had been dealt with by earlier genre painters (Joachim Beukelaer), but for the sympathy with which Rembrandt has depicted it. Such is the anachronism that less than a hundred years ago the Louvre was able to buy the picture for 5000 francs because no other gallery wanted anything so ugly. How they misunderstood. It took Chaim Soutine, writing about a painting of his own 250 years later, to express what Rembrandt meant: 'Once I saw this butcher cut the throat of a goose and bleed it. I wanted to cry out . . . I can still feel that cry there . . . When I painted the carcase of beef, I was still trying to let that cry out.'

As Rembrandt's art moved further away from the tastes of the time, sales and commissions became fewer and his financial position weakened. On the 17th May, 1656 in a last bid to save his house in the Breestraat he transferred the deeds to Titus who was not yet fifteen. To do this he had to appear before the Court of Orphans, and make a declaration that he remained responsible for all his debts. His interview with the board must have been similar to Hendrickje's ordeal before the Church Council and, like her, he had to go alone. It was a brave attempt to keep their home, but it would be to no avail.

104
To understand what had changed in Rembrandt's life following his relationship with Hendrickje Stoffels it is only necessary to compare this 'Bathsheba' which she inspired and modelled for, with the Saskia-inspired 'Danaë' and the Geertge-inspired 'Susannah'.

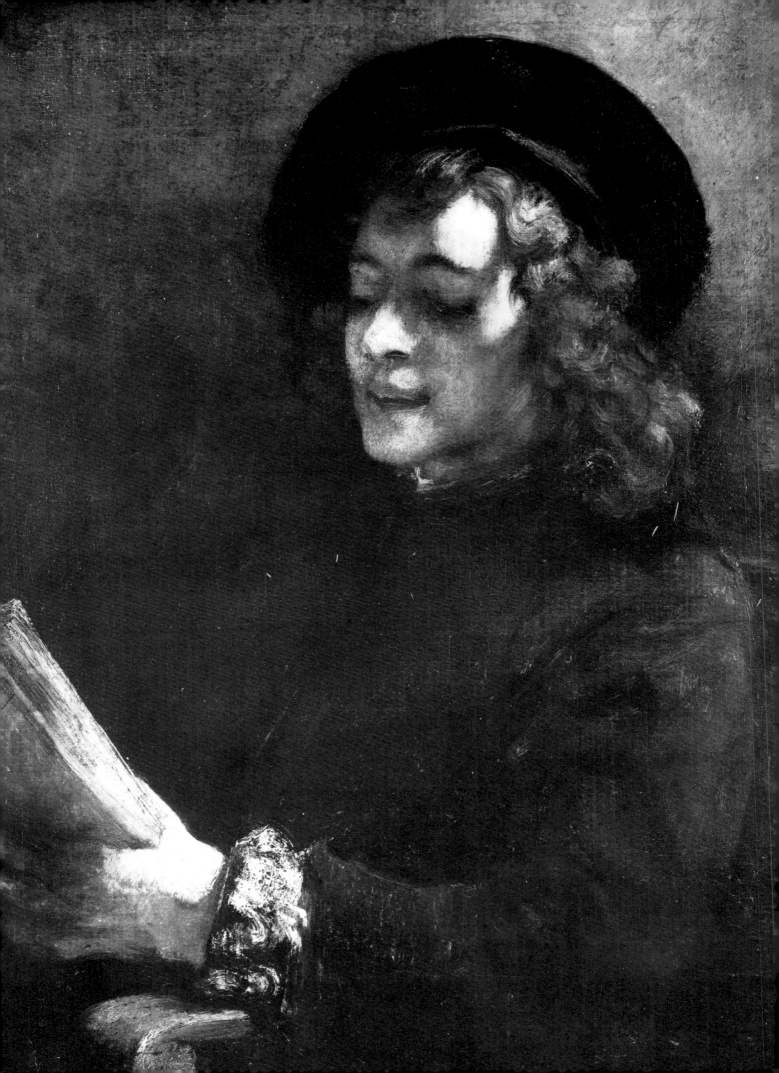

Chapter 11

Removal

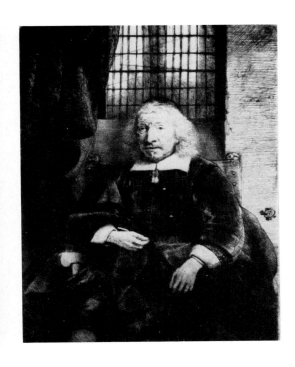

When Rembrandt's creditors learned that he had transferred the deeds of his house to Titus they panicked. This last attempt to save the great house in the Breestraat merely had the effect of hastening the final, inevitable financial collapse. In July he was forced to apply to the city council of Amsterdam for a *cessio bonorum*, or 'cession of goods'. This meant that the debtor agreed to liquidate all his property and surrender it to his creditors. Less degrading than bankruptcy, a *cessio bonorum* (*bodelafstand*) was often applied for by merchants because of 'losses at sea or in trade' and if granted it allowed the debtor reasonable freedom.

A tribunal made up of the leading figures in Amsterdam's business life considered the case, and listened to the evidence of both debtors and creditors. The son of Nicolas Tulp was among the commissioners who finally accepted Rembrandt's honesty and the evidence of his good faith: on the 20th July they appointed a receiver to handle the liquidation of his property.

On the 25th and 26th July agents of the Chamber of Insolvency made an inventory of every possession in the artist's house. Of the few scraps of documentary evidence which have come down to us this inventory is by far the most important. First of all it is an invaluable record of the artist's tastes and personal interests. Because although it is probable that Rembrandt dealt in art from time to time and would therefore possess some objects in which he had no particular interest, the greater part of the contents of the house represents the accumulation of a lifetime's collecting. There were paintings by seventeenth-century Dutch artists including Jan Pynas, Hercules Seghers, his former colleague Jan Lievens, Jan Porcellis, and his old master Pieter Lastman. Rembrandt's paintings also included the works of the early Flemish school and by the masters of the Italian Renaissance. The list of artists is dazzling: Giorgione, Raphael, Palma Vecchio, Jacopo Bassano and Jan van Eyck. His collection of graphic art was vast: there were prints by Mantegna, Schongauer, Cranach, Dürer and Holbein; countless portfolios of drawings by 'the leading masters of the world', including erotica by Raphael, Rosso, Annibale Caracci and Giulio Bonasone. Among the sculpture was a head by Michelangelo, and numerous busts of the ancients (Homer, Socrates,

105 *left*
Rembrandt made studies of his son's sensitive and rather fragile face in all its various moods. But Titus was not lacking in astuteness, and he had enough rudimentary business sense to help his father when he most needed it.

106 *above*
Thomas Haaring, known as 'old Haaring', was bailiff to the Court of Insolvents which dealt with Rembrandt's case. He carried out his rather distasteful task with as much humanity as possible.

Aristotle, Caesar, Augustus, Tiberius, Caligula, Nero, etc.).

Rembrandt's personal art collection is more than concrete evidence that for years he had lived beyond his means. Nor is the inventory simply an interesting record of his artistic tastes, indeed the fact that the collection is so diverse and contains so much more than one would expect even the most catholic collector to gather together is a clue to its true significance. Kenneth Clark calls Rembrandt the 'supreme self-educator', an artist with an 'excavator's instinct' which enabled him to study the work of his predecessors, borrowing and assimilating, and in this way constantly developing his own art. Rembrandt's art collection fulfilled a definite function – just as he bought views of Turkish buildings, and scenes from the lives of the Moguls [112] for information of other times and places, so he invested in works of art that used effects which he could adapt and use for his own purposes. Rembrandt was constantly innovating and developing his art through what he learned – viewed in this way his collection has very little to do with extravagance.

A large number of Rembrandt's own drawings and etchings were detailed in the inventory, together with seventy of his paintings (of which no more than a dozen have been located). The bizarre array of other *objets d'art* and curiosities which are listed proves that whatever other purposes the artist may have had, Baldinucci's description of Rembrandt as a compulsive collector was not exaggerated. A random selection of items from the inventory conjures up images of the prop department at Twentieth Century-Fox: an engraved shield, land and sea creatures and 'things of that sort', a giant's helmet, assegais, Indian robes, a plaster cast of the head of a Negro, stags' horns, crossbows, thirteen bamboo wind instruments and fifes, a child urinating, the skins of a lion and lioness, a drawer in which there are six fans and a bird of Paradise – and so on.

The agents of the Chamber of Insolvency were meticulous in their work and with the help of Rembrandt and Hendrickje they itemized everything in the house. Debtors who had been granted a *cessio* were permitted to keep only a few possessions: clothes, the necessities of their occupation and sufficient furniture to live simply. While the agents made the inventory, these exempted items – the personal possessions of Rembrandt, Hendrickje and Titus – were probably collected together in the 'living-rooms' of the house in the Breestraat. In her sorrow and confusion Hendrickje had forgotten to move one or two things. With an insensitive pettiness as typical of bureaucracy then as now the agents duly recorded (in a list including Raphaels and a Michelangelo) the fact that nine white cups and two earthenware plates had been left in the passage and were therefore to be sold. Hendrickje had also forgotten the laundry, and while she and Rembrandt tried to comfort each other in the shipwreck confusion of the upper rooms a clerk included in the sale: three men's shirts, six handkerchiefs, twelve napkins, three tablecloths and 'several collars and cuffs'.

107
A poet who was also a grocer, Jeremias de Dekker was a man of staunchly individual views and he continued to champion Rembrandt and hail his genius when the rest of fashionable society had turned their backs on him. In gratitude the artist painted several portraits of de Dekker, of which only one is known to have survived.

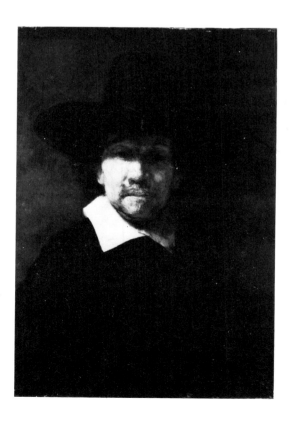

108
At a time when his own psychological
strength was being tested to its limits,
Rembrandt used the biblical story of David
harping before Saul to explore the nature of
mental illness.

The compilation of the inventory was only the beginning. It was, finally, to be four years before the family were to know domestic peace again. In September three new creditors began pressing Rembrandt for repayment: he owed one 848 guilders, another 1605 guilders, and the third such a large amount that he had to promise him the income derived from the sale of future paintings in case the proceeds from the sale were insufficient to cover the debt. The law, as always, moved so slowly that it was December of the following year (1657) before the first sale of his possessions took place. The chamber of Insolvency authorized the bailiff Thomas Jacobsz Haaring [106] to hire an inn called the Keizerkroon in the Kalverstraat for the auction. A room was booked for Rembrandt, and for three weeks, day by day, he was obliged to witness the sale of his paintings and *objets d'art*. For nearly eighteen months he had lived in anticipation of that sale.

In February the house and furniture were put up for auction and sold, although disagreement among major creditors meant that the sale was not authorized for a considerable time after that. The house fetched 11,218 guilders – 2000 guilders less than he had paid for it, and nearly 10,000 guilders less than he owed his creditors. Two weeks later the last of the furniture was

 E Lurateur ober den Insol=
venten Boedel ban Reinbiant ban Rijn / konstigh
Schilder / sal / als by de E. E heeren Commissari=
sen der Desolate Boedelen hier ter Stede daer toe ge=
authoriseert / by Executie berkopen de boidere Papier
kunst onder den selben Boedel als noch berustende/
bestaende inde konst ban berscheyden der boornaemste so Italiaensche/
Fransche/ Duytsche ende Nederlandtsche Meesters / ende by den selben
Rembiant ban Rijn met een groote curieusheyt te samen bersamelt.

Gelijck dan mede een goede partye ban
Teeckeningen ende Schetsen banden selben Rembiant ban Rijn selben

**De berkopinge sal wesen ten daeghe/
ure ende Jaere als boben / ten huyse ban
Barent Jansz Schuurman / Waert in
de Keysers kroon / inde kalber straet/
daer de berkopinge boor desen is geweest,**

Segget boort,

disposed of and in September Haaring hired the Keizerkroon again for the final sale – the prints and drawings. But the Artist's Guild was afraid that such a major sale would swamp the art market and they used their influence to speed up the proceedings and minimize publicity. A terrible blow for Rembrandt, this action was directly responsible for keeping him insolvent: one of the greatest sales of graphic art of all time realized the absurd sum of 600 guilders – in the early 1640s he had received as much for a single portrait.

In the four years following the inventory Rembrandt, Hendrickje, Cornelia and Titus led a miserable existence. At first in the knowledge that many of the things they used daily, and certainly most of the possessions they cherished, were earmarked to be sold. Later, after the first sales, they lived on in the great empty house in the Breestraat constantly reminded of all they had lost. Cornelia was only three years old at the end of 1657, the worst year, and not yet old enough to understand; we can imagine, although we have no record, of the effect it had upon Hendrickje and the sensitive Titus. But in that year Rembrandt painted a self-portrait, a direct statement of his emotions. There is no posing and he uses no props: the expression is resigned and

109 left
The poster announcing the sale of Rembrandt's prints and drawings. Because of the machinations of the Artists' Guild who feared that the market might be flooded, what must have been one of the greatest auctions of graphic art ever held realized only a paltry 600 guilders.

110 below
The inn called the Keizerkroon where 'old Haaring' held the first sale of Rembrandt's furniture and curios, and later the auction of his prints and drawings.

De keizerskroon te Amsterdam
geteken Ano 1725.

hurt, but completely without self-pity [XVII]. The eyes do not look at us, but rather to the past or to another reality. But he has not forgotten the importance of capturing the moment, of recording the image with absolute truth.

It is not coincidence that in the same year as this self-portrait Rembrandt painted 'David harping before Saul' [108]. The terminology may not have been created until two hundred years later, but it is a painting about schizophrenia. Because he has recognized in himself the tendency of the human mind to distance itself from a reality which is too painful, Rembrandt can understand a disease of the mind which is caused by essentially the same mechanism. Saul, who has outbursts of violence, has David to play the harp for him to soothe the 'evil spirit'. But God has withdrawn his favour from the king bestowing it instead on David, and in his grief and jealousy Saul will attempt to 'smite David even to the wall' with his spear. In a brilliantly intuitive painting Rembrandt has understood the nature of Saul's illness, and shows him in the moment of balance when grief becomes violence – already the muscles of his hand tense ready to grasp the weapon. But the painting contains one final surprise. The curtain which divides David and Saul is an image which has been used by twentieth-century psychologists when attempting to describe the detachment from the environment which occurs in schizophrenia.

Although a number of his 'friends' deserted Rembrandt at this time, finding the protracted liquidation of his property and reduced circumstances an embarrassment, there were many others who did not. Lodewijk van Ludick, who had guaranteed Jan Six's loan, remained loyal although his money was returned to him in such small amounts as to make it virtually irrelevant. The pharmacist Abraham Francken was another who valued friendship above money and was a regular visitor at the now echoing house in the Breestraat. Many years later he was to become Cornelia's guardian, finally giving her away in marriage.

Among those who rallied round Rembrandt and Hendrickje during the financial collapse was the writing master Lieven Willemsz van Coppenol [114] who ran a school on the Singel. A mutual friend was the poet Jeremias de Decker [107] who continued to praise Rembrandt's art in his poems when it was far from fashionable to do so. In gratitude Rembrandt painted his portrait. The likeness so impressed de Decker's friend, the poet Jan van Petersom, that he wrote: 'O Rembrandt, you paint de Decker so that his soul shines through his face . . .' De Decker was also pleased, and wrote a poem for Rembrandt in which he he says that he is a greater artist than even Raphael or Michelangelo.

But as important as the support of his friends was to Rembrandt it cannot compare with the selfless devotion and loyalty of Hendrickje. Whether as the goddess Flora, or as Venus with Cupid (Cornelia), no woman was ever painted with more

III
Many exotic animals were brought back in Amsterdam's trading vessels along with more marketable commodities. This drawing of an elephant was among Rembrandt's 'paper art' which was auctioned.

love and tenderness. She suffered insults and humiliation for him, and although he could not marry her she bore his child. Hendrickje was in her early twenties when she entered his household [XVI]. There must have been so much about Rembrandt and his work that she did not understand, except intuitively. But she loved him, and because he needed her she gave the rest of her life to him.

Titus posed for his father as often as Hendrickje during these years. Frail and rather delicate, there is more of Saskia in him than Rembrandt. Perhaps poor health had prevented him from mixing much with other children; the portraits of him at seventeen [105] have the serious, detached expression of one who has not really had a childhood. For a time he studied art under his father, but he had little talent. In his expression in several of the portraits there is, somehow, an awareness that he is not all that his father would wish, a quiet acceptance that he is a disappointment. Yet Rembrandt loved him dearly, and he was a dutiful son.

On the 15th December 1660 Titus and Hendrickje went to see a notary. Here they registered a business partnership with clearly stated aims and intentions. For two years they had operated an art business selling paintings, drawings, etchings and other *objets d'art*. It was now their intention to continue the business on the following basis: they had put all they had into the company (naturally, more in the case of Titus) and would continue to do so – each receiving half the profits and bearing half the losses.

112
Several copies of Mogul miniatures were among the items sold at the Keizerkroon. Rembrandt had made them for pleasure, and as an exercise in a different technique.

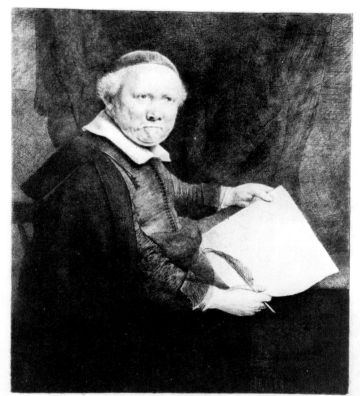

113 *above*
The vulture-like head of Galba in a drawing of one of the numerous busts of Roman emperors which came up for auction at the Keizerkroon.

114 *right*
Lieven Willemsz van Coppenol was a mutual friend of Rembrandt and Jeremias de Dekker. Formerly a master at the French School, his passion was calligraphy and he gave displays of his skill in public. Over the years Rembrandt made several etchings of his friend, and on some of them van Coppenol inscribed poems.

The notary must have smiled as he began to see their intention. As such an enterprise clearly needed an assistant, Titus and Hendrickje stated their intention to employ Rembrandt in this capacity since, of course, he was better qualified in all aspects of art than anyone else in Amsterdam. He would be allowed to live in their house, his full board and lodging paid for by them, provided he permitted them to act as his agents and to pay into the company any earnings from his work. Rembrandt would have no involvement in either the business or the housekeeping.

In other words the artist who had been the most popular in Amsterdam was to be the employee of his seventeen-year-old son and a woman considered to be his servant. In effect, this clever subterfuge freed Rembrandt once and for all from pursuit by his creditors, and no one could now touch any part of his property. It was not a humiliation for Rembrandt, but a refuge created for him through the love, and shrewdness, of Titus and Hendrickje.

On the 18th of December, 1660 the new owner took possession of the house in the Breestraat. Rembrandt closed the door for the last time nearly twenty years after he had purchased it. But after four years of humiliation and uncertainty it was more a release than a parting.

127

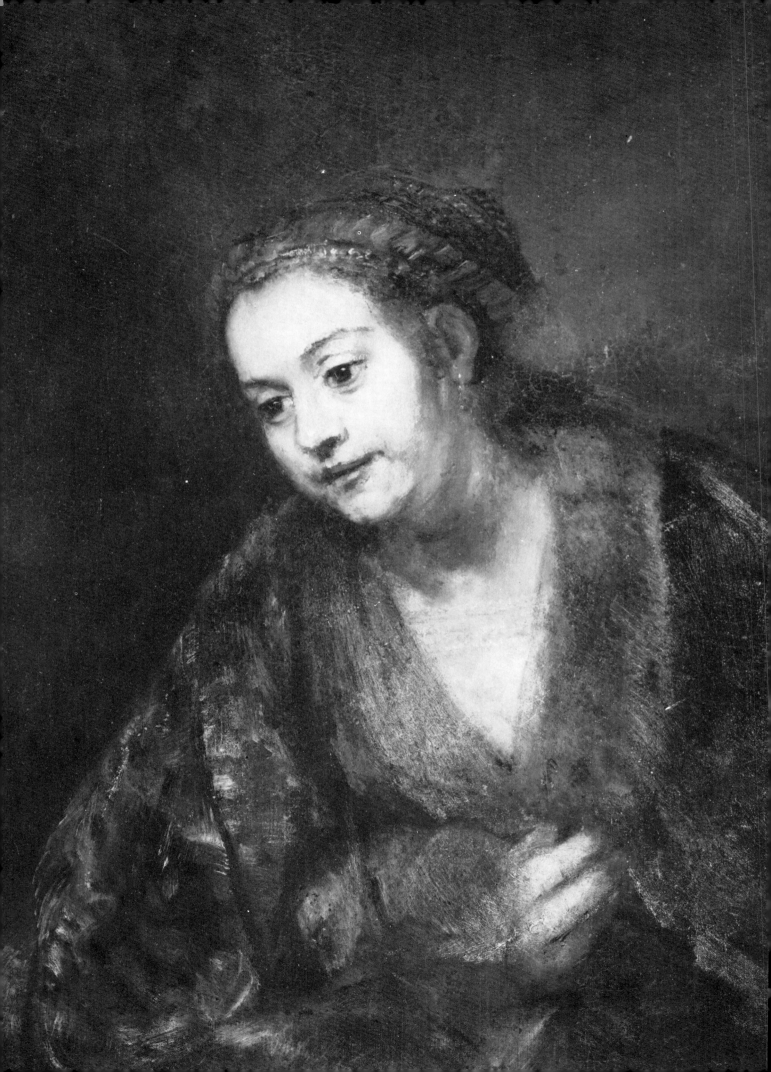

Chapter 12
Bearing the unbearable

BEYOND the Keizergracht, the outermost of Amsterdam's three great canals, was a district called the Jordaan. It was to this area of small, simple houses that Rembrandt moved at the end of 1660. Most of the property was rented, and Titus and Hendrickje took out a lease in the name of their company. The new house was situated in the Rozengracht, opposite the New Doolhof—a small ornamental garden administered by the father of the painter Johan Lingelback. The Rozengracht was an unfashionable backwater, where people kept to themselves. It was peaceful compared with the Breestraat; if people did not spend their time socializing it was not through unfriendliness, but because they had neither the time nor the money to spare in the quiet struggle for survival.

Although much reduced in circumstances, it is wrong to suppose that the family now sank into abject poverty as some biographers have suggested. Rembrandt still had pupils, although these were fewer now that he was less fashionable. He also continued to receive commissions, and when Govaert Flinck died before he could begin a painting for the new Town Hall the authorities asked Flinck's former master, Rembrandt, if he would undertake the work.

The new Town Hall had been inaugurated five years earlier, but the great gallery which surrounded the main chamber had yet to be decorated. It was decided to commission eight paintings to hang in the lunettes of the vaulting. The commission which Rembrandt took on after the death of Flinck was the Revolt of the Batavians under Julius Civilis. The seventeenth-century Dutch considered themselves 'Batavian' in the same way that twentieth-century Englishmen style themselves 'Anglo-Saxon': a rather apocryphal account in Tacitus re-interpreted by the contemporary poet Vondel was Rembrandt's textual source.

The 'Conspiracy of Julius Civilis' was the largest painting that he ever made. The vast canvas (20 feet by about 18) was subsequently cut down—possibly by Rembrandt himself—and the original composition can only be inferred from a working drawing which survives [119]. The reason it was butchered in this way, and hung in the Town Hall for less than a year, was because it appalled the city fathers. Instead of giving them the

115 *left*
Hendrickje's health was slowly deteriorating. In this portrait she has the slightly detached expression of the sick, and her eyes are feverish.

116 *above*
The little rented wooden house in the Rosengracht was very different from the great stone mansion in the Breestraat. The trees of the New Doolhof ornamental garden are visible through the open door and windows.

Rembrandt's painting of the board of the
Clothmaker's Guild ('De Staalmeesters' or
'The Syndics') is an expression of the
society's belief in corporate endeavour. The
fact that four of the five 'staalmeesters' were
of different religious persuasions owes as
much to hard-headed commercial astuteness
as to the spirit of tolerance.

118 *below left*
Amsterdam's new town hall was built in the
Classical style which Rembrandt hated.
Although his dealings with the civic
authorities had never been pleasant, he made
a sketch of the old medieval building when it
was being demolished.

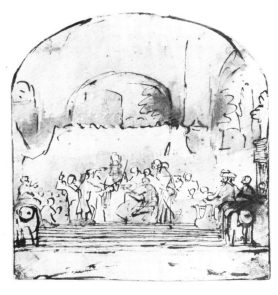

119
The cartoon for the original full-size painting
of 'The conspiracy of Julius Civilis' was
drawn on the back of an invitation to the
funeral of Rebecca de Vos. The vast finished
canvas was cut down—possibly by
Rembrandt himself—after it had been
rejected by town hall officials. They had
expected an analogy of William of Orange's
heroic revolt against Spain, and the artist
had provided them with the plotting of a
brutal and barbaric insurrection.

romantic and noble freedom-fighters they had expected,
Rembrandt used all his skill and dramatic invention to present
them with what he considered a more truthful representation of
the men who conspired against Rome.

All the characters are brutish and coarse, but they are
dominated by the cruel, one-eyed figure of Julius who positively
leers out of the picture. The atmosphere of lurking evil is
emphasized by the light: a phosphorescent green emanating
from the table cloth, which glows like a gangrenous corpse on a
battlefield. The public, who always like to be shocked, were
fascinated by the painting. But the town councillors were
outraged on their behalf and the violent masterpiece was soon
replaced by another artist's third-rate interpretation of the
scene, which still hangs in Amsterdam's town hall.

The rejection of his painting was irritating for Rembrandt,
particularly since he had promised to repay part of his debt to the
long-suffering Lodewijk van Ludick out of the proceeds. But as
an artist the reception of the 'Conspiracy of Julius Civilis' was
irrelevant—he was beyond such concerns now. While working on
the commission he painted a study of a negro which epitomizes
his attitude at the time. It was not a painting he could ever hope
to sell, but that did not matter: it was the subject which was
important. At this time trafficking in slaves was becoming
increasingly common, and in the face of new competition in
traditional carrying enterprises Dutch merchants eagerly
invested in the profitable human misery of the 'triangular trade'.
Usually it was only profits and rich cargoes from the New World
which found their way back to Europe, but occasionally a slave
who was more or less fortunate than his fellows would find
himself as a servant to a rich family. In his painting Rembrandt
makes the negro the representative of his race: while evoking our
sympathy for the man's condition he also questions the morals of
a society whose economic needs have caused it [120].

On the 7th August Hendrickje went to see a notary.
Rembrandt waited for her, sick with apprehension. She was ill
and considered it wise to make her will. The notary described her
as 'sick in appearance though still on her feet and active' [115].
The terms she recorded are yet another indication of her simple
generosity. Having almost nothing herself the whole point of the
will was to protect Rembrandt by preserving the art business in
case of her death. To this end she made Cornelia her heir, and
should Cornelia herself die everything was to go to her half-
brother Titus. It is possible that Hendrickje, like Saskia, was
consumptive. Whatever the cause her health gradually de-
teriorated.

Since 1652 when Rembrandt had painted 'Aristotle con-
templating the Bust of Homer' for the Sicilian nobleman Don
Antonio Ruffo he had kept up a correspondence with him in
Messina. In 1661 Ruffo, who was obviously building up a gallery
of 'great men' in the Italian manner, bought 'Alexander the
Great' and commissioned a 'Homer'. Unfortunately Ruffo was

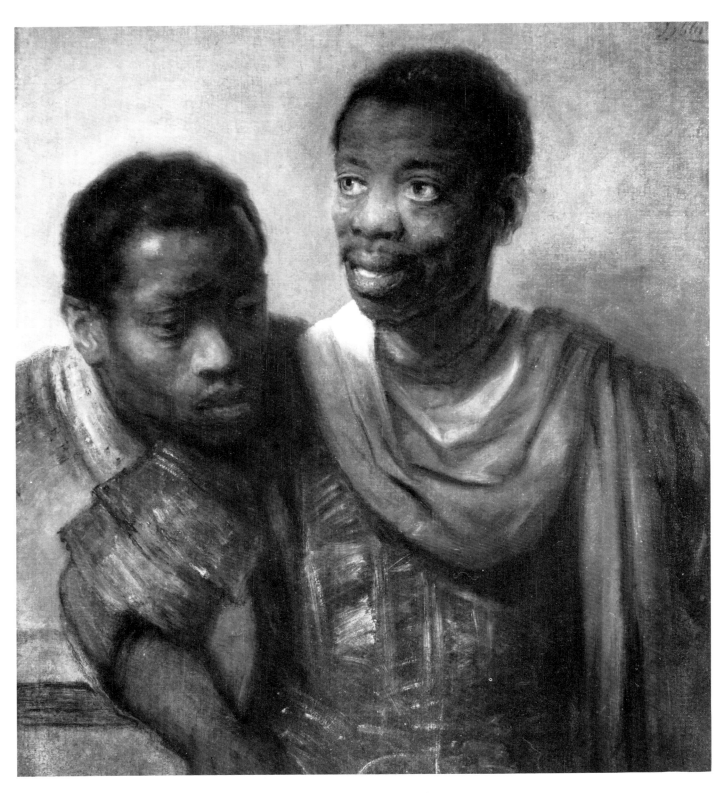

not pleased with either painting. He complained the 'Alexander' was merely an enlarged version of an existing canvas of a head. Rembrandt sent a truculent reply to the effect that if Don Antonio would pay an additional 500 guilders he would paint it again. Ruffo also criticized 'Homer' on the grounds that it appeared unfinished. Houbraken records the artist's reply to that comment 'a painting is completed when the master has achieved his intention by it'. However Rembrandt did, finally,

make some changes and their relationship did not suffer. Ruffo continued to collect Rembrandt's work for many years.

A less troubled commission than 'Homer' came in the same year. It was for a group portrait, this time from the Clothmaker's Guild. Known as 'The Syndics' it is one of Rembrandt's best known works, Kenneth Clark calls it 'one of the summits of European painting' [117]. It was also well received at the time. No doubt the careful businessmen of the Guild made it quite clear from the beginning that they did not want to be portrayed in the same way as the harquebusiers of Captain Frans Banning Cocq. But in any case Rembrandt had moved a long way from the High Baroque of the 'Night Watch'. With the penetrating insight which distinguishes all his later work he recognizes the true significance of the Clothmaker's Guild.

We have seen that the burghers of seventeenth-century Holland had an insatiable appetite for group portraits, and Rembrandt himself had produced examples in the genre. Previously, second-rate artists had deployed individuals in dull ranks reminiscent of photographs of the school hockey team, while first-rate artists had made them into interesting geometric shapes. But no one had ever shown why the group existed, how it operated: no artist had ever used a painting of a group to analyse what a group is. In 'The Syndics' each individual obviously has his own contribution to make and we are aware that together they are a formidable organism. The device which Rembrandt uses to form a psychological link between the individuals and to invite dialogue between us and them (both individually and as a group) is to have us entering the room where they are having their meeting. It is as if the frame of the picture is the door we have entered: there is nothing artificial or contrived in the way they have all looked up, only the tension of enquiry.

In the autumn of 1662 Rembrandt took an extraordinary action. He sold Saskia's tomb in the Oude Kerk. It had not been a good year financially, but there had been worse years and he had never thought of doing such a thing before. In fact he sold one grave in order to buy another in the Westerkerk a short walk from the house on the Rozengracht. The winter of 1662 was Hendrickje's last. She grew weaker all the time and the damp cold from the canal did not help a disease that was probably tuberculosis. She was too weak to rally even with the coming of the beautiful Dutch spring, and Rembrandt did not need the doctors to tell him that it was hopeless. In July Titus, broken-hearted, went out to call the predicant and to follow the traditional custom of telling the neighbours that someone was on the point of dying. Rembrandt stayed with Hendrickje in their little bedroom until the last. It is unlikely that they talked, probably Hendrickje could not in any case. Although there is little they could have said, nothing they had not given each other. Afterwards he prepared her for burial, it was usual for the next of kin to wash and dress the dead. He would have wanted to do that for her.

120 *left*
Rembrandt painted these negroes not as a curiosity but with compassion: he makes them the epitome of their race.

121 *below*
Rembrandt's drawing of The Westerkerk.

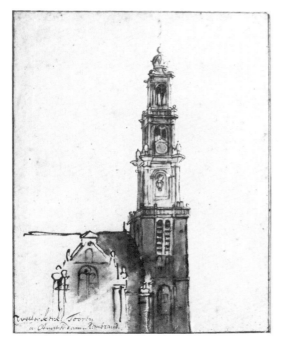

gereken: door Rembrant van Rhijn naer sijn selver
soo als hij in sijn schilderkamer gekleet was

Chapter 13

The victor

AFTER HENDRICKJE's death Rembrandt became even more introspective, withdrawing from the world, and concentrating totally on his art. He had never cared much for social graces or the opinion of others and now, alone but for Titus and Cornelia and living on the Rozengracht, nothing mattered but his painting. Houbraken recorded that 'in the autumn of his life Rembrandt kept company mostly with common people and such as practised art'.

Baldinucci had this period in mind when he called him 'umorista di prima classe'—a very temperamental man. As for his appearance 'the ugly and plebeian face with which Rembrandt was ill-favoured was accompanied by untidy and dirty clothes, since it was his custom, when working, to wipe his brushes on himself, and to do other things of a similar nature' [112]. Houbraken said that he was quite content to eat bread and cheese, or a pickled herring. All of which points to a phenomenal application to work which Baldinucci sums up: 'When Rembrandt worked he would not have granted an audience to the first monarch in the world who would have had to return again and again until he found him no longer engaged.'

Rembrandt had always worked like this, but the last years were a desperate struggle to record all that he had learned of life and art as if he was determined to make some sense of it all. It is a tribute to his willpower and the breadth of his genius that he did say it all—there is no suggestion of unfulfilled promise in Rembrandt's work. Not yet sixty, but looking like a man well into his seventies, he took everything that life could deal him and he fought back by constantly developing his art until the very day he died.

Practically, of course, Titus had to take charge of Cornelia's education, as well as running the house and the art business. Rembrandt gave him power of attorney and in 1665, together with his father and the old family friend Abraham Francken, he applied to the States General for permission to become of age. As a minor he was restricted in his business dealings, and having listened to the young man's plea the authorities grudgingly gave their assent.

Titus worked hard to further his father's interests, and portrait

122 *left*
After the death of Hendrickje Rembrandt became increasingly introspective. His consuming passion was to press his art to its limits, and only the presence of Titus and his daughter Cornelia could be tolerated.

123 *above*
The 'spiteful Walloon' Gérard de Lairesse who visited the artist at his studio in the Rozengracht.

135

commissions continued to arrive. These must have seemed a dreadful irrelevance to the old man whose art was moving in quite another direction. But he had a responsibility to Cornelia and Titus – whose work, he well knew, could never provide them with sufficient income. One portrait he made at this time was of the Walloon painter Gérard de Lairesse [123]. Later, when Lairesse had become blind both physically and artistically he wrote: 'I do not want to deny that once I had preference for (Rembrandt's) manner, but at that time I had hardly begun to understand the infallible rules of art.' He went on to criticize Rembrandt because, unlike Rubens and Van Dyck, he came from the bourgeois class.

In the same year Rembrandt completed the painting known as 'The Jewish Bride' [126]. There is no record of who the couple were, or even if they were Jewish (it is possible that the portrait shows the Sephardi poet Miguel de Barrios and his wife Abigael de Pina). But that information is, in a sense, irrelevant because it is the emotions which the artist expresses through them which are important. The painting is his supreme statement about love: love which has transcended the physical yet remains physical, love which is both passionate and infinitely tender, the love of Hendrickje and Rembrandt. The man's hand, which she presses lightly against her breast, unites them completely.

124
'Christ at Emmaus' is a very early painting, finished in 1628 when Rembrandt was only twenty-two. Throughout his life Christ remained a potent and sustaining force, and a source of inspiration in his art.

The 'Jewish Bride' is one of Rembrandt's greatest colouristic creations. Towards the end of his life he concentrated almost entirely on the medium of paint, and colour began to dominate his work. But he did not use colour decoratively like the classical painters. For Rembrandt colour took on an almost mystical importance; it became a living force—like the plasmas in which modern physicists are so interested—which formed the relationship between everything. He also reasserted the Baroque device of chiaroscuro in his work, and this too is imbued with mystical significance: the dark is infinity, the unknown. Sometimes his attitude towards darkness is reminiscent of Manichaeism, where it represents the negative force and is evil and threatening. In 1797 Adam Bartsch wrote: 'Rembrandt's technique is a kind of Magic. No-one knew better than he the effects different colours have on each other . . . He loved contrasts of light, and dark, pushing them far beyond intelligence.'

Rembrandt was still highly thought of abroad if his popularity at home had waned. Cosimo de Medici visited the old man at his studio in 1667, although the brainless young peacock can hardly have been stimulating company. No doubt Titus arranged the meeting, and although Cosimo liked none of the paintings he saw at the studio, during his stay he probably bought one of the two self-portraits which are now in the Uffizi.

The following year, in February, Titus married Magdalena, daughter of the silversmith Jan van Loo. The ceremony would have been very simple compared with the elaborate affair which

125
'Cottages beneath high trees' is one of the last landscapes drawn by Rembrandt—it is also one of the most economical and powerful. He could take the drawing of landscape no further, in a sense it has no further to go.

Saskia's relatives had organized so many years before. But it must have had the unreality of a pageant for the increasingly introspective Rembrandt. Only his great love for his son could have moved him to wash, and shave carefully, and dress in respectable clothes. But the van Loos were old family friends, and they would have understood the difficulties and the reasons for Rembrandt's detachment.

Following their marriage Titus and Magdalena lived over the Apple Market on the Singel. Rembrandt was left with Cornelia, who was now fourteen. She must have been a lonely little thing, experiencing the pain and confusion of puberty with only her semi-recluse father to confide in. His obsessive devotion to his work would have been a terrible mystery to her, and the smells of the paints and pigments like the emanations from a sorcerer's workshop. But father and daughter were very close: later she was to name her own children Rembrandt and Hendrickje. Their relationship can only have been strengthened by the taunts of 'illegitimate' which were an easy and inevitable weapon for other children to use.

Fate had one final shock for Rembrandt. Just seven months after his marriage, with Magdelena three months pregnant, Titus died. A self-portrait probably completed at this time sums up Rembrandt's reaction [XXI]. Standing before a bust of the Roman god Terminus who presides over boundaries, the final limits, he laughs. It is the ravaged face of an old clown who has removed his mask. He has seen the pointlessness at the heart of events, and he has born the unbearable. What more? he asks, what more? And he laughs.

The portrait is painted with savage intensity. The *Confessions* of Saint Augustine and of Jean-Jacques Rousseau pale in comparison as self-characterization beside the later self-portraits of Rembrandt. He brings all the power of his mature art to bear because it is now a sacred duty to complete the remorseless catalogue of his changing image in the mirror.

Six months after the death of Titus a daughter, named Titia after him, was born. Rembrandt attended the baptism of his granddaughter on the 22nd March, 1669. Another self-portrait made at about this time shows signs of senility [XXII]: it is the face of a man who is spent, and no longer cares. But to end on a note of hopelessness would have been a negation of all his work; it would have rendered his life futile. Summoning his last reserves of strength Rembrandt painted a more suitable testament – 'The Return of the Prodigal Son' [XXIII]. It is a timeless picture, full of hope, symbolizing as it does Christ's message of the infinite mercy of God – the spiritual homecoming of all mankind.

Rembrandt died in his house on the Rozengracht on the 3rd October, 1669. Four days later he was buried next to Hendrickje in the Westerkerk. At the time of his death he had completed one final self-portrait [XXIV]. Intensely human and vulnerable it is at the same time calm and hopeful. It is the face of a man who has prevailed against life, and wants to show us that he has.

126
Above all, Rembrandt is concerned with making sense of the senseless: he is anxious to pass on a message of hope. 'The 'Jewish Bride' is his supreme statement about love.

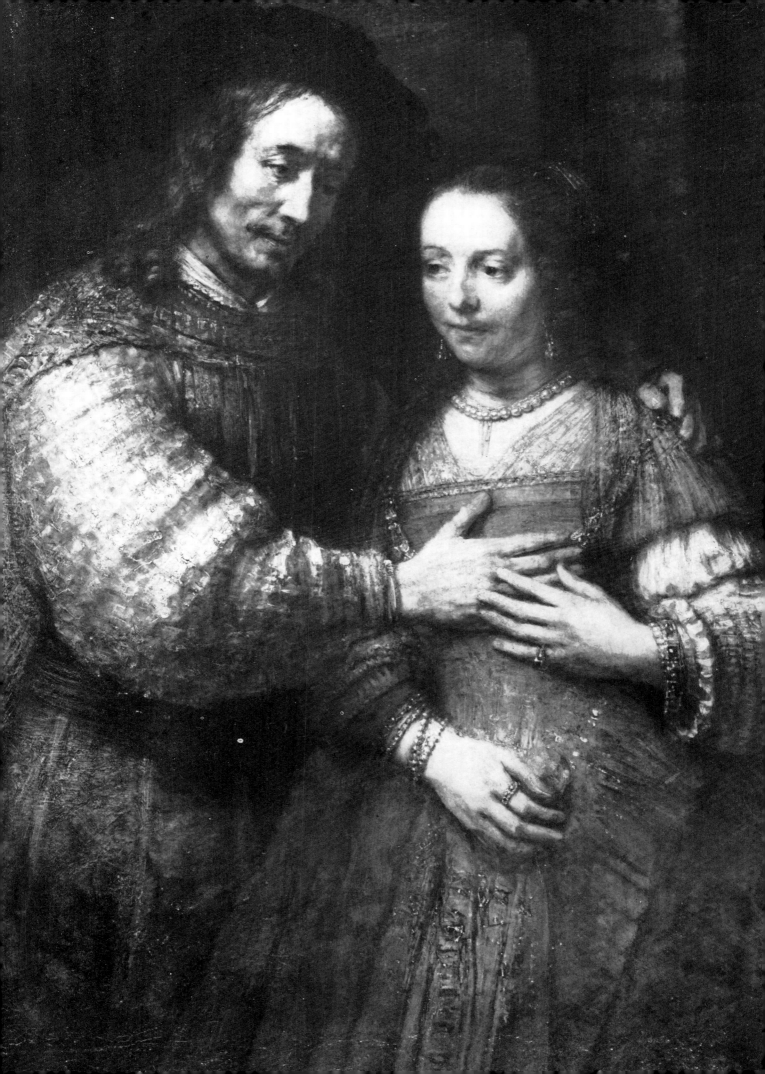

Further reading list

BENESCH, Otto, The Drawings of Rembrandt – 6 Vols: Vols I–II, The Leiden Years. The Early Amsterdam Period, 1625–40; Vols III–IV, The Middle Period, 1640–50; Vols V–VI, The Late Period, 1650–69. (London: Phaidon Press, 1954, 1955 and 1957.)

BLOOM, Herbert I., The Economic Activities of the Jews of Amsterdam in the Seventeenth and Eighteenth Centuries. (New York: Kennikat Press, reissued in 1969.)

BOXER, Charles R., The Dutch Seaborne Empire, 1600–1800. (London: Hutchinson & Co., 1965.)

BREDIUS, Abraham, Rembrandt, The Complete Edition of the Paintings. Revised by H. Gerson. (London: The Phaidon Press, 3rd edition 1969.)

CLARK, Kenneth, Rembrandt and the Italian Renaissance. (London: John Murray, 1966.)

GERSON, H., Seven Letters by Rembrandt. (Hague: L. J. C. Boucher, 1961.)

GEYL, Pieter, The Netherlands in the Seventeenth Century – 2 Parts: Part 1, 1609–48. (London: Ernest Benn, 1961); Part 2, 1648–1715. (London: Ernest Benn, 1964.)

GOLDSCHEIDER, Ludwig, Rembrandt, Paintings, Drawings and Etchings. (London: Phaidon Press, 1960.)

HOLLSTEIN, Friedrich W. H., Dutch and Flemish Etchings, Engravings and Woodcuts. Compiled by Christopher White and Karel G. Boon. Vol 18: Rembrandt – Text. (Amsterdam: Vangendt & Co., 1969); Vol 19: Rembrandt – Plates. (Amsterdam: Vangendt & Co., 1969.)

Journal of the History of Ideas – Vol 14, 1953, pages 203–20: Rembrandt and his Contemporary Critics. (New York: Journal of the History of Ideas, Inc., 1953.)

LANDSBERGER, Franz, Rembrandt, The Jews and the Bible. (Philadelphia: The Jewish Publication Society of America, 1946.)

ROSENBERG, Jakob, Rembrandt: Life and Work. (London: Phaidon Press, revised edition 1964.)

VALENTINER, W. R., Rembrandt and Spinoza, A Study of the Spiritual Conflicts in Seventeenth Century Holland. (London: Phaidon Press, 1957.)

WHITE, Christopher, Rembrandt and His World. (London: Thames & Hudson, 1966.)

ZUMTHOR, Paul, Daily Life in Rembrandt's Holland. (London: Weidenfeld & Nicolson, 1962.)

Text acknowledgments
The author and publisher would like to thank the following for permission to reproduce copyright material.

G. Knuttel Wzn, *Rembrandt, de meester en zijn werk*, Amsterdam 1956, translated by D. W. Bloemena for Weidenfeld & Nicolson; Élie Faure, *Historie de l'Art*, Paris 1909, quoted in Horst Gerson, *Rembrandt's Paintings*, published by Weidenfeld & Nicolson; Raymond Chandler, *Farewell My Lovely*, © Helga Greene; Jakob Rosenberg, *Rembrandt: Life and Work*, published by Phaidon Press Ltd.; Kenneth Clark, *Civilization*, BBC and John Murray, © Kenneth Clark; W. R. Valentiner, *Rembrandt and Spinoza*, Phaidon Press Ltd. Every reasonable effort has been made to trace all persons having any rights in quotations (e.g. the translation of the poem by Constantyn Huygens) and the appropriate acknowledgment will be made in further editions upon written notification to the publishers.

We are indebted to Horst Gerson, *Rembrandt's Paintings*, published by Weidenfeld & Nicolson, for the quotations by Francis Bacon and Oskar Kokoschka. For permission to quote the sixth of Rembrandt's seven letters to Constantyn Huygens we are indebted to the Musée de Mariemont, Belgium; for the extract from the seventh letter, to the British Library, London.

The illustrations

Because this is a biography and not an art book, and Rembrandt's work has been included principally as illustration, the designer has treated it as any other illustrative material, cropping or taking details wherever necessary. The bibliography lists books where representations of all the work can be found, although even the best colour reproduction cannot do justice to Rembrandt and the author hopes that the following list will help readers to see the art itself.

Photographic acknowledgments

Black and white

Number	Location	Photographic source
1	Kenwood, London	Greater London Council as trustees of the Iveagh Bequest, Kenwood.
2	Westerkerk, Amsterdam	Westerkerkgemeente, Amsterdam.
3	Galerie Berggruen, Paris	Hamlyn Group Picture Library.
4	Galerie Berggruen, Paris	Hamlyn Group Picture Library.
5	Galerie Berggruen, Paris	Hamlyn Group Picture Library.
6	Galerie Berggruen, Paris	Hamlyn Group Picture Library.
7		National Film Archive, London – London Films.
8		Camera Press, London – Karsh.
9		Rembrandt-Huis, Amsterdam.
10	National Gallery, London	National Gallery, London.
11	Musée Bonnat, Bayonne	Photo Étienne, Bayonne.
12	British Museum, London	Hamlyn Group – John Freeman.
13	Leiden University Library	Leiden Universiteitsbibliothek.
14	Leiden University Library	Leiden Universiteitsbibliothek.
15	Rijksmuseum, Amsterdam	Rijksmuseum, Amsterdam.
16	British Museum, London	Thames & Hudson, London.
17	Gemeentelijke Archiefdienst, London	Gemeentelijke Archiefdienst, London.
18		Mansell Collection, London.
19	Private Collection	Museum of Fine Arts, Boston.
20	British Museum, London	British Museum, London.
21	Herzog Anton Ulrich Museum, Brunswick	Museumsfoto B.P. Keiser
22	British Museum, London	Hamlyn Group – John Freeman.
23	British Library, London	Thames & Hudson, London.
24	Museum of Fine Arts, Boston	Museum of Fine Arts, Boston.
25	Museum of Fine Arts, Boston	Museum of Fine Arts, Boston.
26	Leiden University, Leiden	Leiden Universiteitsbibliothek.
27	British Museum, London.	Thames & Hudson, London.
28	Rijksmuseum, Amsterdam.	Rijksmuseum, Amsterdam.
29	British Museum, London	Thames & Hudson, London.
30	British Museum, London	Hamlyn Group – John Freeman.
31	British Museum, London	Hamlyn Group – John Freeman.
32	National Gallery, London	National Gallery, London.
33	Leamington Art Gallery	Leamington Art Gallery.
34	Museum of Fine Arts, Boston	Museum of Fine Arts, Boston.
35	Private Collection	
36	British Museum, London	Hamlyn Group – John Freeman.
37	British Museum, London	Hamlyn Group – John Freeman.
38	Musée du Louvre, Paris	Cliché des Musées Nationaux, Paris.
39	Bibliothèque Nationale, Paris	
40	Walker Art Gallery, Liverpool	Walker Art Gallery, Liverpool.
41	British Museum, London	Hamlyn Group – John Freeman.
42	British Museum, London	Hamlyn Group – John Freeman.
43	Musée du Petit Palais, Paris	Photo Bulloz, Paris.
44		Hutchinson Publishing Group, London.
45	British Museum, London	Hamlyn Group – John Freeman.
46	Rijksmuseum, Amsterdam	Rijksmuseum, Amsterdam.
47	Mauritshuis, The Hague	Stichting Johan Maurits van Nassau, The Hague.
48	Collection of Lord Roseberry	Sotheby Parke Bernet, London.
49	Musée du Louvre, Paris	Cliché des Musées Nationaux, Paris.
50	Metropolitan Museum of Art, New York	Metropolitan Museum of Art, New York.
51	Norton Simon Foundation, Los Angeles.	Norton Simon Foundation, Los Angeles.
52	Graphische Sammlung Albertina, Vienna	Graphische Sammlung Albertina, Vienna.
53	British Museum, London	Hamlyn Group – John Freeman.
54	Kupferstichkabinett, Staatliche Museen, Berlin	Bildarchiv Preussischer Kulturbesitz, Berlin – Jorg P. Anders.
55	British Museum, London	Hamlyn Group – John Freeman.
56	Nationalmuseum, Stockholm	Nationalmuseum, Stockholm.
57	Kupferstichkabinett, Staatliche Museen, Berlin	Bildarchiv Preussicher Kulturbesitz, Berlin.
58	Metropolitan Museum of Art, New York	Metropolitan Museum of Art, New York.
59	Rijksmuseum, Amsterdam	Rijksmuseum, Amsterdam.
60	Gemeentelijke Archiefdienst van Amsterdam	Gemeentelijke Archiefdienst van Amsterdam.
61	Musée de Mariemont, Belgium	Musée de Mariemont, Belgium.
62	British Museum, London	Hamlyn Group – John Freeman.
63	Hermitage Museum, Leningrad	Hamlyn Group Picture Library.
64	Norton Simon Foundation, Los Angeles	Norton Simon Foundation, Los Angeles.
65	British Museum, London	Hamlyn Group – John Freeman.
66	Graphische Sammlung Albertina, Vienna	Graphische Sammlung Albertina, Vienna.
67	Gemäldegalerie, Staatliche Museen, Berlin	Bildarchiv Preussischer Kulturbesitz – Jorg P. Anders.
68	British Museum, London	Hamlyn Group – John Freeman.
69	Rijksmuseum, Amsterdam	Rijksmuseum, Amsterdam.
70	Gemäldegalerie, Staatliche Museum, Berlin	Bildarchiv Preussischer Kulturbesitz, Berlin – Jorg P. Anders.
71	Teylers Stichting, Haarlem	Teylers Stichting, Haarlem.
72	Private Collection	Rijksmuseum, Amsterdam.
73	Rijksmuseum, Amsterdam	Rijksmuseum, Amsterdam.
74	British Museum, London	Hamlyn Group – John Freeman.
75	Musée du Louvre, Paris	Cliché des Musées Nationaux, Paris.
76	Statens Museum for Kunst, Copenhagen	Hans Petersen, Copenhagen.
77	British Museum, London	Hamlyn Group Picture Library.
78	Gemäldegalerie, Staatliche Museen, Berlin	Bildarchiv Preussischer Kulturbesitz, Berlin.
79	Graphische Sammlung Albertina, Vienna	Graphische Sammlung Albertina, Vienna.
80	Fogg Art Museum, Harvard University, Cambridge, Mass.	Fogg Art Museum, Harvard University, Cambridge, Mass.
81	Gemäldegalerie, Staatliche Museen, Berlin	Bildarchiv Preussischer Kulturbesitz, Berlin – Jorg P. Anders.
82	British Museum, London	Hamlyn Group – John Freeman.
83	British Museum, London	Hamlyn Group – John Freeman.
84	Gemäldegalerie, Staatliche Museen, Berlin	Bildarchiv Preussischer Kulturbesitz, Berlin – Jorg P. Anders.

Number	Location	Photographic source
85	British Museum, London	Hamlyn Group – John Freeman.
86	Bibliothèque Nationale, Paris	Bibliothèque Nationale, Paris.
87	British Museum, London	Hamlyn Group – John Freeman.
88	Cleveland Museum of Art	Cleveland Museum of Art.
89	Uffizi Gallery, Florence	Alinari, Florence.
90	Staatliche Kunstsammlungen, Dresden	Staatliche Kunstsammlungen, Dresden.
91	Staatliche Kunstsammlungen, Kassel	Staatliche Kunstsammlungen, Kassel.
92	Kunsthistorisches Museum, Vienna	Kunsthistorisches Museum, Vienna.
93	Leeds City Art Gallery	Art Gallery and Temple Newsam House, Leeds.
94	National Gallery, London	National Gallery, London.
95	Staatliche Kunstsammlungen, Dresden	Staatliche Kunstsammlungen, Dresden.
96	British Museum, London	Hamlyn Group – John Freeman.
97	Fitzwilliam Museum, Cambridge	Fitzwilliam Museum, Cambridge.
98	Metropolitan Museum of Art, New York	Metropolitan Museum of Art, New York.
99	British Museum, London	Hamlyn Group – John Freeman.
100	Musée du Louvre, Paris	Cliché des Musées Nationaux, Paris.
101	Statens Museum for Kunst, Copenhagen	Hans Petersen, Copenhagen.
102	British Museum, London	Hamlyn Group – John Freeman.
103	Glasgow Art Gallery	Glasgow Art Gallery.
104	Musée du Louvre, Paris	Photographie Giraudon, Paris.
105	Kunsthistorisches Museum, Vienna	Kursthistorisches Museum, Vienna.
106	British Museum, London	Hamlyn Group – John Freeman.
107	Hermitage Museum, Leningrad	Hermitage Museum, Leningrad.
108	Mauritshuis, The Hague	Stichting Johan Maurits van Nassau, The Hague.
109	British Museum, London	Thames & Hudson, London.
110	Gemeentelijke Archiefdienst van Amsterdam	Gemeentelijke Archiefdienst van Amsterdam.
111	British Museum, London	British Museum, London.
112	Musée du Louvre, Paris	Photographie Giraudon, Paris.
113	Kupferstichkabinett, Staatliche Museen, Berlin	Bildarchiv Preussischer Kulturbesitz, Berlin – Jorg P. Anders.
114	British Museum, London	Hamlyn Group – John Freeman.
115	Metropolitan Museum of Art, New York	Metropolitan Museum of Art, New York.
116	British Museum, London	Hamlyn Group – John Freeman.
117	Rijksmuseum, Amsterdam	Rijksmuseum, Amsterdam.
118	Musée du Louvre, Paris	Archives Photographiques, Paris.
119	Staatliche Graphische Sammlung, Munich	Staatliche Graphische Sammlung, Munich.
120	Mauritshuis, The Hague	A. Dingjan, The Hague.
121	Collection Amsterdams Historisch Museum	Stedilijk Museum, Amsterdam.
122	Rembrandt-Huis, Amsterdam	Rembrandt-Huis, Amsterdam.
123	Metropolitan Museum of Art, New York	Metropolitan Museum of Art, New York.
124	Musée Jacquemart-André, Paris	Photographie Bulloz, Paris.
125	Kupferstichkabinett, Staatliche Museen, Berlin	Bildarchiv Preussischer Kulturbesitz, Berlin – Jorg P. Anders.
126	Rijksmuseum, Amsterdam	Rijksmuseum, Amsterdam.

Number	Location	Photographic source
Colour		
I	Royal Collection	Reproduced by Gracious Permission of Her Majesty the Queen.
II	Ashmolean Museum, Oxford	Ashmolean Museum, Oxford.
III	Mauritshuis, The Hague	Stichting Johan Maurits van Nassau, The Hague.
IV	Mauritshuis, The Hague	Stitchting Johan Maurits van Nassau, The Hague.
V	Gemäldegalerie, Dresden	Staatliche Kunstsammlungen, Dresden – Gerhard Reinhold, Leipzig.
VI	Gemäldegalerie Alte Meister, Kassel	Staatliche Kunstsammlungen, Kassal.
VII	Gemäldegalerie, Staatliche Museen, Berlin	Bildarchiv Preussischer Kulturbesitz, Berlin.
VIII	Musée du Louvre, Paris	Réunion des Musées Nationaux, Paris.
IX		Cooper-Bridgeman Library, London.
X	British Museum, London	Hamlyn Group – John Freeman.
XI	National Gallery, London	National Gallery, London.
XII	Musée du Louvre, Paris	Réunion des Musées Nationaux, Paris.
XIII	Six Collection, Amsterdam	Six Collection, Amsterdam.
XIV	Museum Boymans van Beuningen, Rotterdam	Gemeente Rotterdam
XV		Netherlands National Tourist Office, London.
XVI	Gemäldegalerie, Staatliche Museen, Berlin	Bildarchiv Preussischer Kulturbesitz, Berlin – Jorg P. Anders
XVII	Duke of Sutherland Collection on loan to the National Gallery of Scotland	National Gallery of Scotland, Edinburgh.
XVIII	Wallace Collection, London	Wallace Collection, London.
XIX	Kenwood, London	Greater London Council as Trustees of the Iveagh Bequest, Kenwood.
XX	Musée Granet, Aix-en-Provence	Musée Granet, Aix-en-Provence
XXI	Wallraf-Richartz-Museum, Köln	Stadt Köln
XXII	Mauritshuis, The Hague	Stichting Johan Maurits van Nassau, The Hague
XXIII	Hermitage Museum, Leningrad	Novosti Press Agency, London.
XXIV	National Gallery, London	Hamlyn Group – John Webb.

Index